IMAGES
of America

CHICAGO'S GOLD COAST

IMAGES
of America

CHICAGO'S GOLD COAST

Wilbert Jones, Kathleen Willis-Morton, and
Maureen O'Brien with photography by Bob Dowey
and foreword by Richard Driehaus

ARCADIA
PUBLISHING

Published by Arcadia Publishing
Charleston, South Carolina

Library of Congress Control Number: 2012939683

For all general information, please contact Arcadia Publishing:
Telephone 843-853-2070
Fax 843-853-0044
E-mail sales@arcadiapublishing.com
For customer service and orders:
Toll-Free 1-888-313-2665

Visit us on the Internet at www.arcadiapublishing.com

*This book is dedicated to all of the early founders of the Gold
Coast who had the vision that this neighborhood would become
one of the most desirable areas to live in the country.*

CONTENTS

ACKNOWLEDGMENTS

The authors would also like to thank 1200 N. Lake Shore Drive Condo Association; Melissa Basilone; Rabbi Meir Chair Benhiyoun of Chabad House; Michael Coakes; Janice Corley; the Drake Hotel; Richard Driehaus; Paul E. Episcope; His Eminences Frances Cardinal George; Gold Coast Neighbors Association; the Graham Foundation; John Graf, author of *Chicago Mansions* (Arcadia Publishing, 2004); Leslie Hindman; His Eminences Metropolitan Iakovos; Jill Katz of JKLS Public Relations; Junior League of Chicago; Jim Kinney; Karen Kammer; Steven Levy of Sudler Management, LLC; Jan and Ramsey Lewis; executive vice president Russell Lewis and staff of the research library at the Chicago History Museum; Rae Lewis-Thornton; Julio Lopez; Allan Nicholas; Maxim's of the Nancy Goldberg International Center; Marilyn J. Miglin; Florence Molinelli; Museum for International College of Surgeons; Newberry Library; Mary and Daniel O'Brien Sr.; Potter and Bertha Palmer; James Richardson and Donald Roney of Civility Design; Jeff Ruetsche and Jessica Mickey at Arcadia Publishing; Marion Simon; Steve Skoropad; Mario Stefanini of Mario's Gold Coast Ristorante; and Bekah Webb.

FOREWORD

As a lifelong resident of Chicago, I care deeply about preserving our neighborhoods and historic homes. I am thrilled to see the wonderful changes that have occurred throughout the city in my lifetime. When growing up in Brainerd on the southwest side, my neighborhood was filled mostly with bungalows, a few English-style houses, and an example or two of French-inspired designs.

In the early 1970s, I moved downtown to the Gold Coast. I was drawn to the area by its rich history, interesting architecture, and professional community. In 1972, during a walk-through the Gold Coast, I discovered a beautiful residence with a distinctive architectural form. It was orange-red brick with a unique shape for a Queen Anne dating back to 1877.

Its angular form appealed to my architectural aesthetic. Carved stone detailing recalled the work of Victorian designer Charles Eastlake. The top of the windows were separated with three distinctive square inserts that reminded me of Viennese architect Josef Hoffmann.

A year later, I went back to find that house. I thought I recalled its location, but it eluded me. I kept looking. It could not have just disappeared; yet, there was no sign of it or evidence of it being torn down or destroyed. It remained a mystery.

What I remember seeing earlier inspired me to purchase a vintage Gold Coast property in the early 1980s. Finally, I had found the perfect place, although it needed extensive attention. Someone had painted the exterior brick off-white, which made the building appear smaller and less impressive. The beauty of the architectural scale was lost, but I could see the potential.

The contractors and I completed a top-to-bottom renovation with the help of Chicago architect John Nelson. It was quite an undertaking. The interior was entirely gutted and redesigned. We incorporated French-style architecture within the vintage design and created spaces that were more open. I wanted the home to complement my collection of European and American decorative arts.

We created a three-story grand staircase that visually connects the three floors of the residence. A linear axis from the main entrance draws attention to the entire sequence of spaces culminating with the Great Room at the east end. Two limestone porches with ionic marble columns in English style were added to the original house to define the principal entrance. We also incorporated a slate roof, architecturally designed period fencing, and gaslight fixtures to enhance the exterior elements.

During this long process, the paint was also being removed from the bricks. I walked across the street to view the progress. Then, it came to me—this was the same Queen Anne I had seen so many years ago! Now, I owned the house that earlier captivated me. What a grand Gold Coast surprise.

Today, my family and I enjoy the promise envisioned all those years ago, when the house first captured my imagination. It is an elegant and comfortable place to live and entertain. We like being close to Lincoln Park, the beaches at North Avenue, Oak Street, the Chicago History Museum, and great dining at the Drake Hotel and P.J. Clarkes.

Quiet, tree-lined streets are filled with historic brownstones, greystones, and modern Beaux Arts and Art Deco high-rises that bring character to the neighborhood. The Charnley–Persky House, Patterson–McCormick mansion, Cardinal's Residence, and the Graham Foundation,

which is located in the Madlener House, are a few examples.

There is an old saying, "If these walls could talk." Well, if these blocks could talk, they would talk about the pride and craftsmanship that went into the construction of this neighborhood so many years ago. They would talk about the many people who lived and worked here, raised families, and took care to create a special place and to preserve its beauty and character for future generations.

I invite you to explore Chicago's elegant Gold Coast neighborhood. Let this book be your guide to its treasures.

—Richard Driehaus
Gold Coast resident

INTRODUCTION

The city of Chicago is made of over 200 thriving neighborhoods. Without question, the most notable of these is the Gold Coast, located on the Near North Side of the city. It was in the late 1800s that this neighborhood became home to some of the wealthiest people in the country. Dry goods merchant and real estate developer Potter Palmer led the way.

In 1867, Palmer sold his successful dry goods store to partners Marshall Field and Levi Leiter. The store, called Field, Palmer, Leiter and Company, was renamed Marshall Field and Company (Marshall Field's), which it remained for 144 years. Marshall Field's was acquired by Macy's in 2005, and the flagship store located on State Street was renamed Macy's on State Street on September 9, 2006.

Palmer turned his financial attention to real estate building and investment. He purchased several buildings on State Street and built his signature hotel, which was named the Palmer House. In 1871, the Great Chicago Fire destroyed almost the entire city, which was mostly built of wood, including the streets. All of Palmer's buildings were lost. In 1873, he purchased three-quarters of a mile on State Street and rebuilt it. He also reconstructed the Palmer Hotel and marketed it as the first fireproof hotel in America.

After achieving much success with the rebuilding of State Street, Palmer, along with his wife, Bertha (Honoré), decided it was time to build a home that would be of quality to entertain heads of states and royalty. In 1882, they choose the Near North Side of the city, which was swampland and frog ponds. Many Chicagoans thought they were making a big mistake to build their homes in this area. Local doctors weighed in, suggesting the proposed land that Palmer wanted to use was a health risk because a cemetery was nearby, filled with 20,000 shallow graves of smallpox and plague victims.

Even the Palmers' close friends and some family members suggested they should build on the Near South Side of the city where most wealthy Chicagoans lived, especially on Prairie Avenue, which had some of the finest mansions constructed. Many famous business tycoons, such as George M. Pullman, Philip Armour, John J. Glessner, Marshall Field, John B. Sherman, and William Wallace Kimball, erected homes on Prairie Avenue. They used some of the best architects of the day, including Richard Morris Hunt, Henry Richardson, and Daniel Burnham. At the time of the 1893 World's Columbian Exposition, guidebooks described the Prairie Avenue as the most expensive street west of New York City's Fifth Avenue.

The Palmers decided not to build their home in the Prairie Avenue District. Although this was the most desirable area to live in, they noted it was becoming more congested with warehouses, factories, and a great deal of pollution from the Illinois Central trains and the Chicago stockyards. So, they decided to go to the nearby north side and build their home. Construction started at 1350 North Lake Shore Drive in 1882 and was completed in 1885. It was called the Palmer Castle because architects Henry Ives Cobb and Charles Summer Frost designed it like a German castle with 42 rooms. The initial budget was $90,000, but it cost close to $1 million to build, an enormous sum at that time.

The Palmers purchased a great deal of land on the Near North Side and decided to build homes and sell them to their wealthy friends. Heard by many of his friends, Potter Palmer said, "I'm going north to work out a new residence district."

By the early 1900s, the Near North Side became the newest chic neighborhood. Many of the new residents came from the Prairie Avenue District; they had their mansions built on the same street as the Palmers. This was the first development phase of the Gold Coast; the second was luxury apartments.

Chicago architect, builder, and developer Benjamin H. Marshall left his imprint throughout the Gold Coast, designing and constructing some of the most beautiful apartment houses for the wealthy. His vision did not go over easily. Designing apartments for the rich was unheard of; who could expect them to live stacked on top of each other and to share common areas such receiving rooms, lobbies, and other building amenities? Eventually, Marshall won them over by giving potential tenants shares in their apartment, which became the early stage of cooperative development.

In 1904, Marshall formed a partnership with architect Charles E. Fox and formed the firm Marshall & Fox, which lasted 20 years. During this span, some of Chicago's most impressive apartment buildings were constructed in the Gold Coast. One of their first was an eight-story apartment building located at 1100 North Lake Shore Drive, built in 1905. The apartments were designed to look like luxury mansions, containing only one apartment per floor and large rooms for grand entertainment. Written in French, the floor plans were modeled after the grand apartments of Paris. This marketing concept led to the nickname "Mansions in the Sky." In the 1970s, the building was torn down to make way for a 40-story apartment that bears the same address; however, most of Marshall & Fox apartments survived the wrecking ball of demolition.

Marshall & Fox continued to construct apartments in the Gold Coast throughout the early part of the 1900s. One of their signature properties was the 12-story 1550 North State Parkway property, constructed in 1913. It is considered one of the ultimate luxury buildings, containing one 20-room, approximately 9,000-square-foot apartment per floor, except for the top floor, which was a 24-room apartment. The building remains standing today, although nearly all of the apartments have been divided up into smaller units.

As time passed, more residents had a desire to move to the Gold Coast. To make room, many of the mansions that lined North Lake Shore Drive were torn down to make room for large apartment buildings. They were designed to accommodate a large quantity of people instead of spacious and luxury amenities. In 1951, when the Palmer mansion was demolished, an apartment building containing two towers of 22 floors with over 700 units was erected on its site. In 1886, architect Henry Hobson Richardson designed a granite mansion that stood at 1400 North Lake Shore Drive. It was built for Franklin MacVeagh (1837–1934), the US secretary of treasury under President Taft. Sadly, this mansion was demolished in 1922 to make room for the 23-floor, 400-unit condominium building that occupies the site today.

There were several mansions in the Gold Coast that survived demolition and were turned into museums and galleries. Mansions at 1516 North Lake Shore Drive (the Edward T. Blair home, built in 1914 by McKim, Mead & White) and 1524 North Lake Shore Drive (Eleanor Robinson Countiss home, built in 1917 by Howard Van Duren Shaw) were both turned into the International Museum of Surgical Science. The Albert Fridoline Madlener (1868–1947) home, located at 4 East Burton Place and constructed by architects Richard Ernest Schmidt and Hugh Mackie Gordon Garden, became the Graham Foundation for Advanced Studies in Fine Arts. The James Charnley (1844–1905) home at 1365 North Astor Street, built in 1892 by architects Dankmar Alter and Louis Sullivan, is the current location of the Society of Architectural Historians.

The third phase of development in the Gold Coast was commercial: providing entertainment. Private clubs and signature restaurants such as the Racquet Club of Chicago (1325 North Dearborn), Junior League Club of Chicago (1447 North Astor Street), the Pump Room (1301 North State Parkway), Tavern on Rush (1031 North Rush), and Gibsons Bar & Steakhouse (1028 North Rush) have been around for decades and continue to keep up with the changing neighborhood. On October 25, 2011, the famed Pump Room reopened after a massive, top-to-bottom renovation.

The 70-year-old restaurant opened inside of the Ambassador East Hotel. It is one of the few restaurants in the country to be immortalized in a Frank Sinatra song, the classic "Chicago." Nearly every A-list celebrity from 1938 until now has dined at the Pump Room, with Clark Gable, Sammy Davis Jr., Humphrey Bogart, Marilyn Monroe, Elizabeth Taylor, and Bette Davis in the early days, and current celebrities such as Michael Jordan and Oprah Winfrey, along with a host of business tycoons and political figures.

Just south of the Pump Room is popular Oak Street, which is at the end of the Gold Coast. On this street, there are several couture shops and high-end retailers, such as Barneys New York, Prada, Marilyn Milign, and Hermes. And, of course, at the corner of Oak Street and Michigan Avenue is the start of the Magnificent Mile, which contains some of the best stores, hotels, and restaurants in the country.

One

THE RISE OF A NEW NEIGHBORHOOD
GRAND MANSIONS AND LUXURY HOMES

The Gold Coast neighborhood is located on the Near North Side of Chicago. It expands from North Avenue south to Oak Street and from the Lake Front west to Dearborn Street. Around the late 1800s, during its early stage of conception, not many families moved to the area. A few of them were the McCormicks, the Palmers, and the Ryersons. These were wealthy families who built their homes with every modern amenity of the day. Very large homes were built; some of them took up an entire city block, easily containing 40 or more rooms. They were heavily staffed; a head housekeeper, cook, laundress, personal maid, valet, nurse, gardener, butler, and several household maids were common in such large homes.

As time passed, more wealthy families wanted to live in the Gold Coast and sought some of the most talented architects and interior designers of the period. Soon, homes began to pop up on Lake Shore Drive, each of them a beautiful piece of art. With the convenience of the construction of Michigan Avenue Bridge around 1920, access to the area was much easier, especially for the workers who had to commute and build these homes.

By the late 1920s, many Chicagoans, along with the press, agreed on one thing: the Gold Coast was the new Prairie Avenue District. It became the most desirable neighborhood. With this type of acknowledgement, the cost of property and real estate skyrocketed, turning it into the most expensive neighborhood in Chicago.

After more than 100 years since the birth of the Gold Coast, it still remains the most expensive neighborhood in Chicago, and it is the second-wealthiest neighborhood in America after New York City's Upper East Side. From an area occupied only by the adventuresome to a neighborhood with a population of over 30,000, the Gold Coast vision has truly been realized.

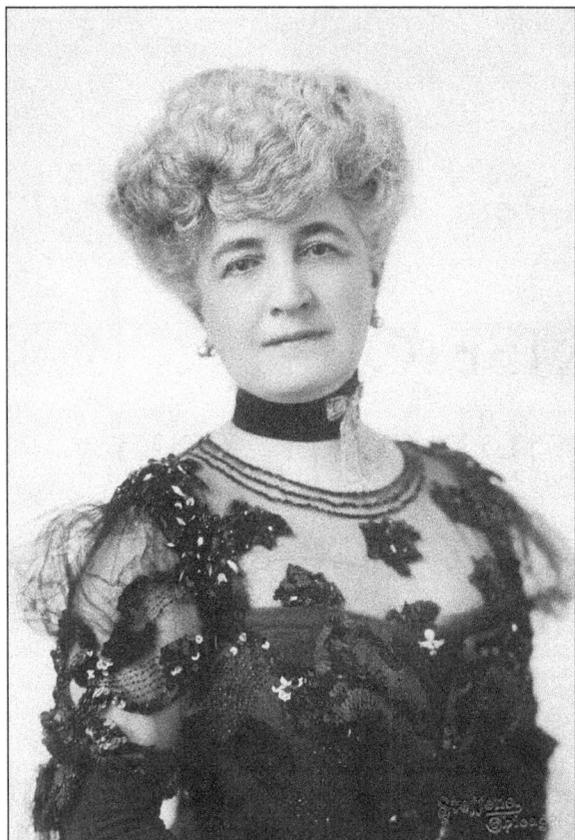

Pictured here are Bertha (Honoré) Palmer and Potter Palmer.

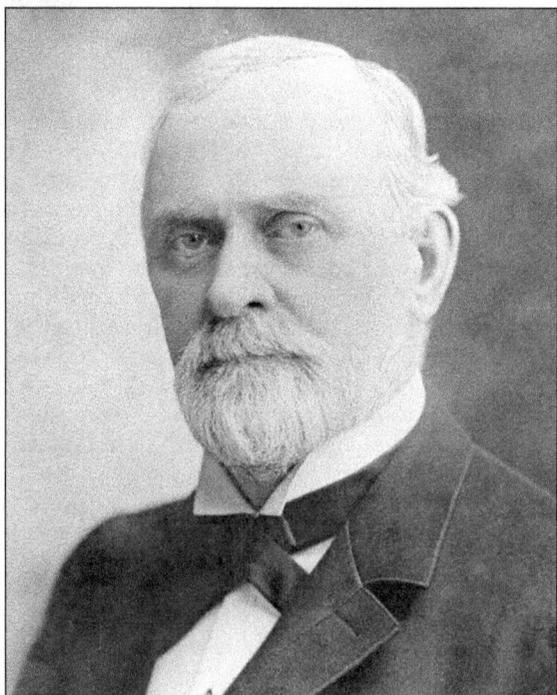

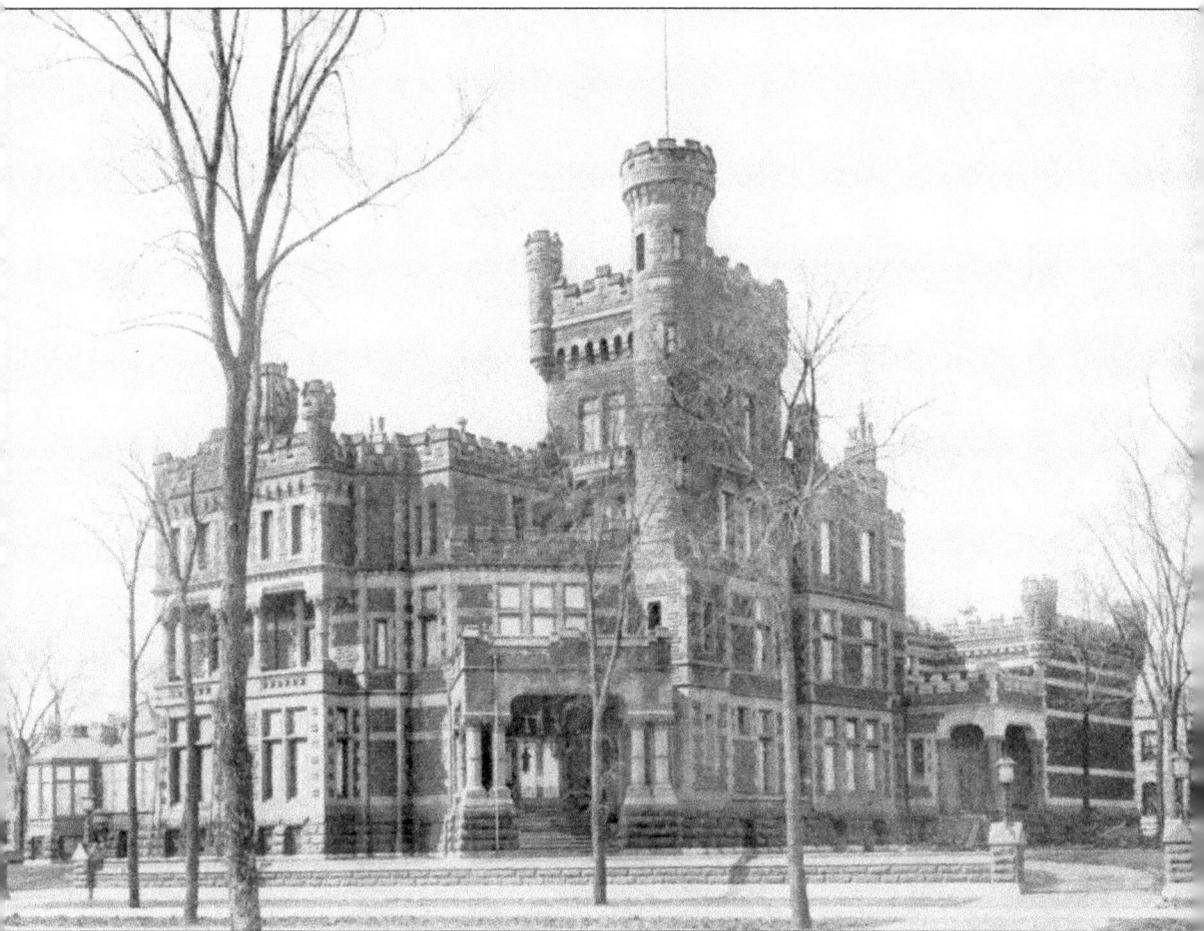

One of the first homes to be built in the Gold Coast was this mansion for Potter and Bertha Palmer in 1885 at 1350 North Lake Shore Drive, containing 42 rooms. It was designed by Henry Ives Cobb and Charles Summer Frost. This home was used for many social gatherings, including receptions during the 1893 World's Columbian Exposition. Presidents Ulysses S. Grant, William McKinley, and James A. Garfield dined here. And European royalty such as the Duke and Duchess of Vergaua, the Prince of Wales (later to become King Edward VII), and Spanish princess Infanta Eucalia also visited.

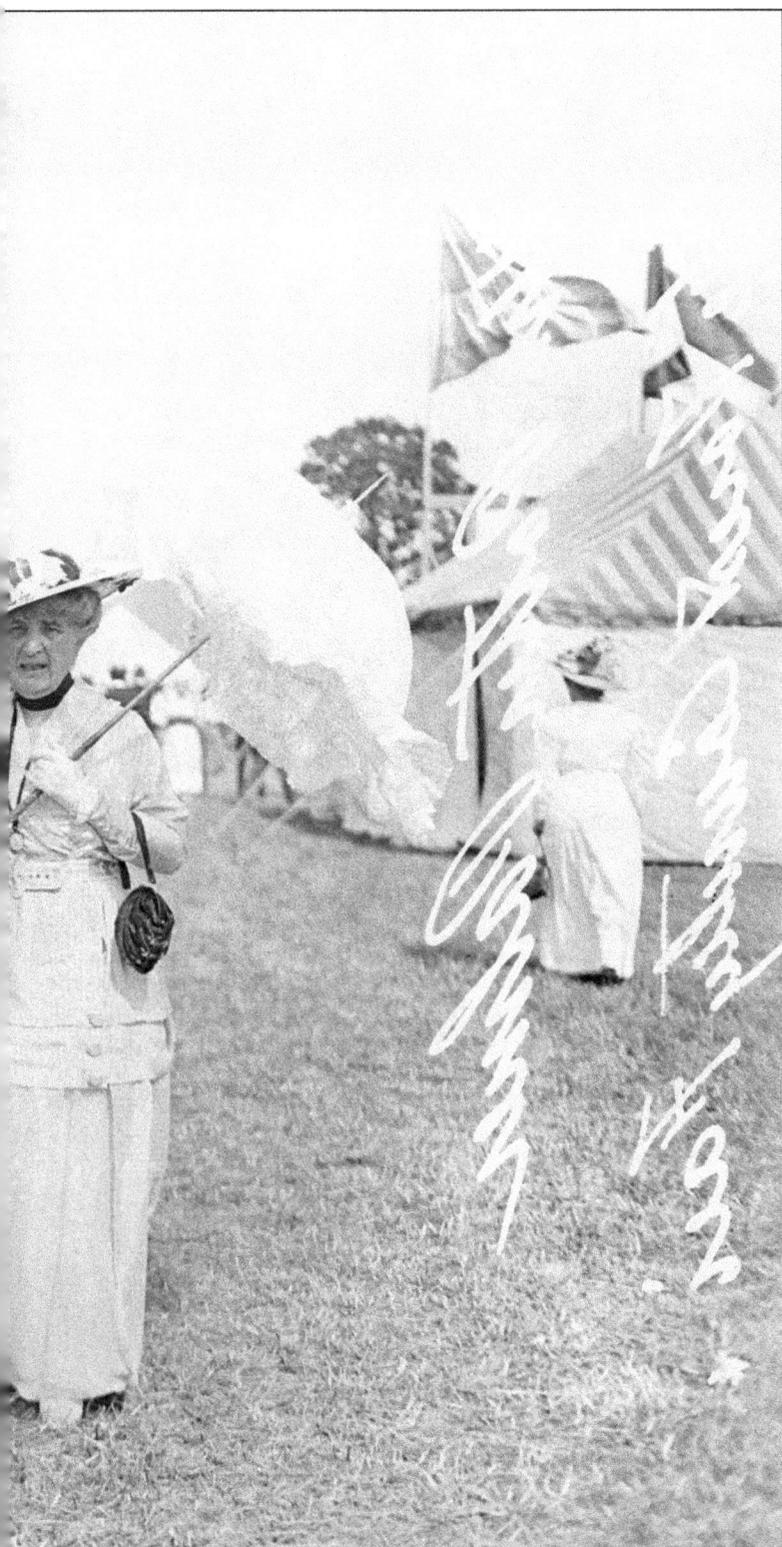

From left to right, Bertha (Honoré) Palmer; Pauline Palmer (daughter-in-law), and Ida Frederick Dent Grant (sister), take an afternoon stroll wearing the top couture of the time in 1916. Grant was the wife of Fredrick Dent Grant, the son of Pres. Ulysses S. Grant.

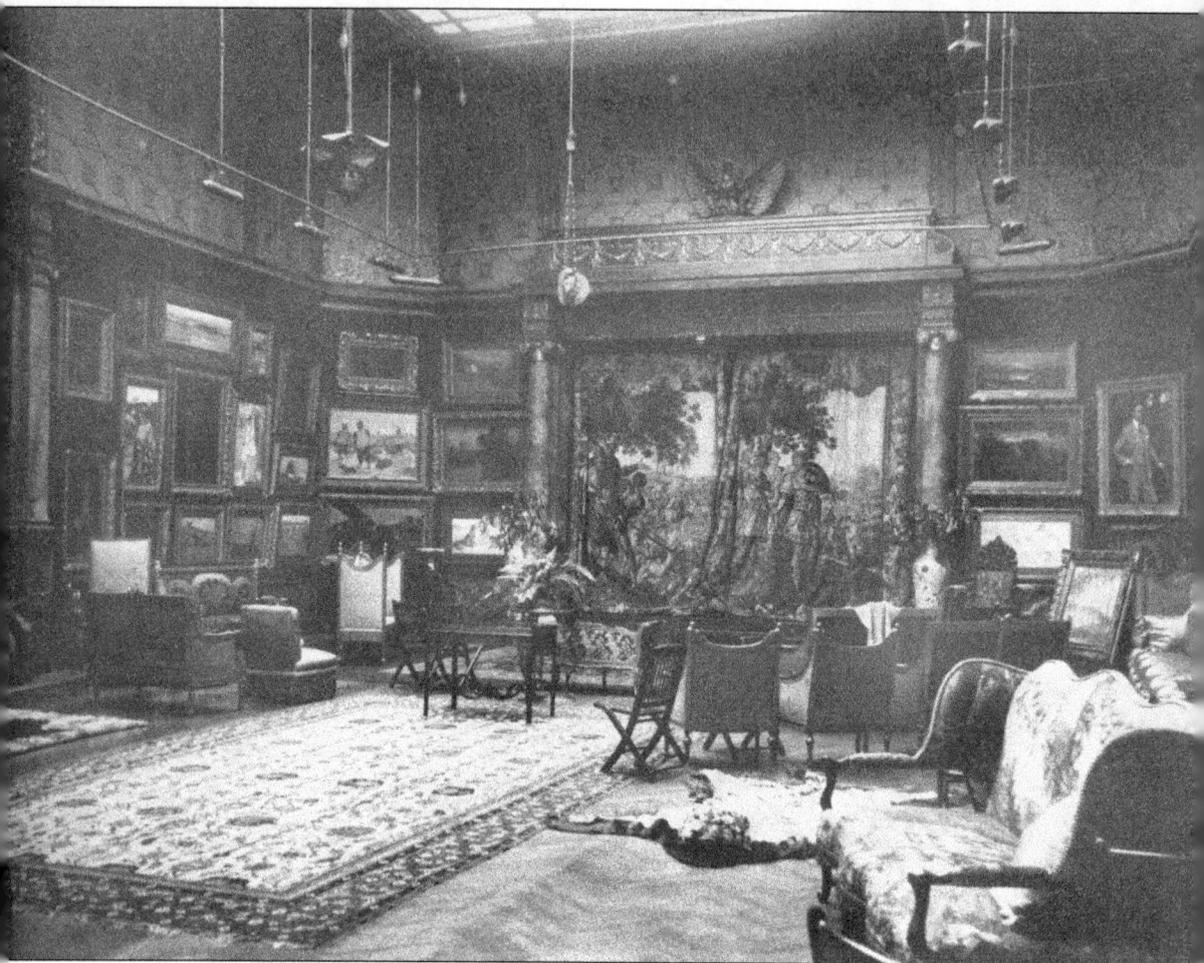

The Formal Gallery was considered the most beautiful room inside of the Palmer mansion. Bertha (Honoré) Palmer traveled the world to collect her paintings from artists such as Edgar Degas, Claude Monet, Pablo Picasso, and Pierre-Auguste Renoir. After her death in 1918, many of these paintings were willed to the Art Institute of Chicago, and the furniture was sold. Sadly, in 1950, the Palmer mansion was demolished to make room for two 22-story buildings containing over 700 apartments.

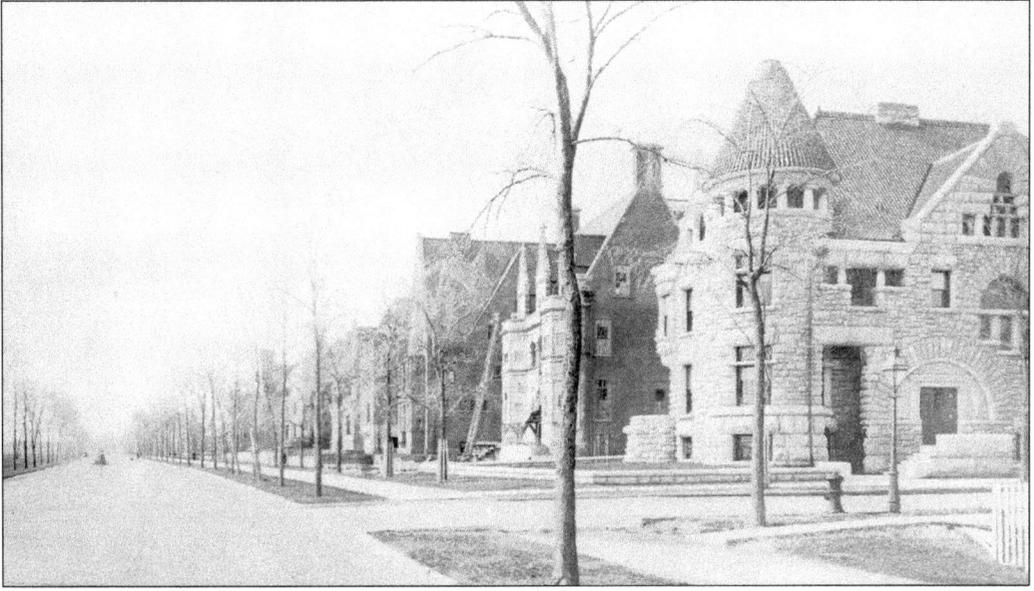

The 1890s photograph above shows Lake Shore Drive and Burton Place to the south. Note the second home located on the left is under construction. It was built for Alexander Caldwell McClurg (1832–1901). At the time the image was captured, it was the peak development and building period of the Gold Coast neighborhood. Pictured below, this Richardson Romanesque mansion was built for president of the Illinois Steel Company Orrin W. Potter (1837–1907). His home was located at the 1400 block of North Lake Shore Drive. Today, a cooperative apartment building sits on this site at 1448 North Lake Shore Drive.

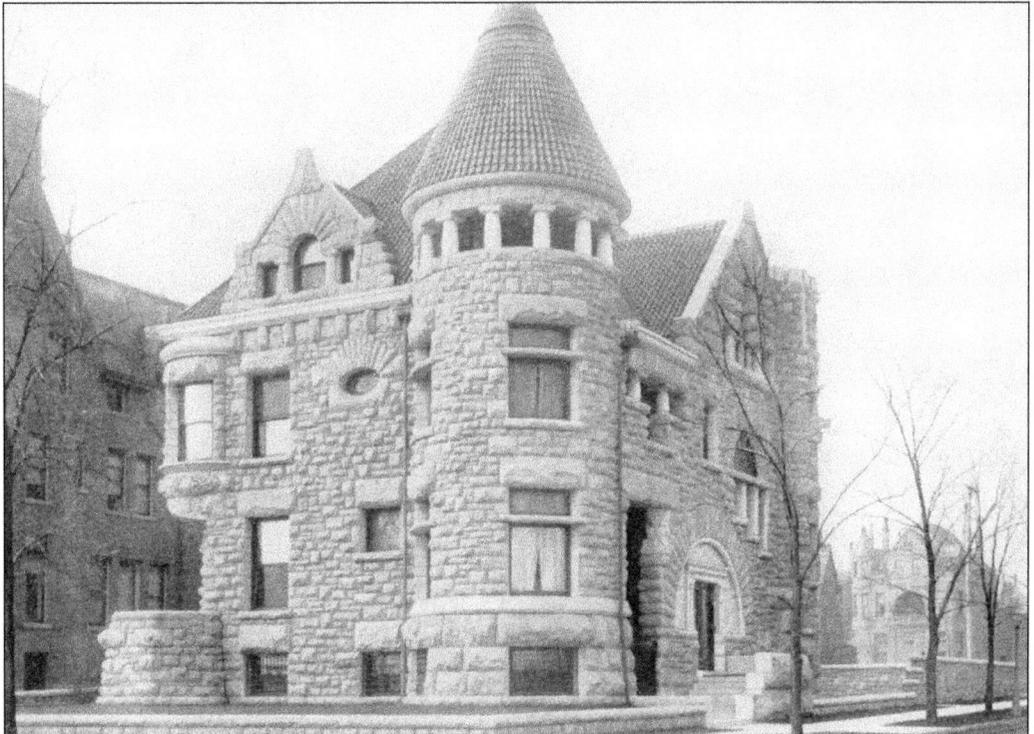

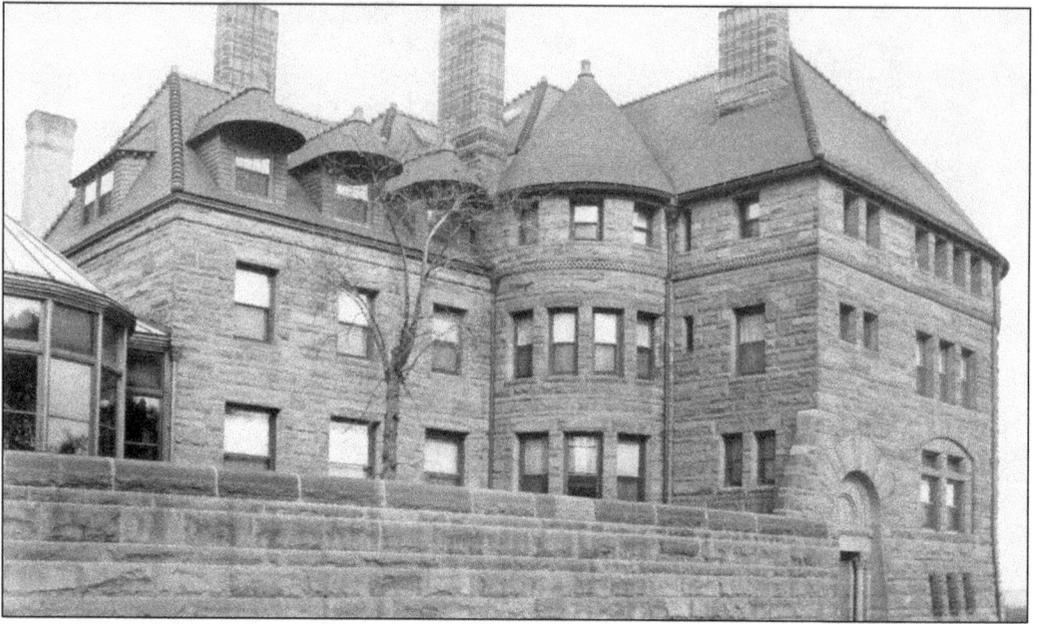

This granite mansion was designed by famous architect Henry Hobson Richardson in 1887. Once the home of Franklin MacVeah (1837–1934), it was located on the corner at 1400 North Lake Shore Drive and Schiller Street. MacVeah was the US secretary of the treasury, serving under Pres. William Howard Taft. In 1922, it was torn down and replaced by an apartment complex containing 23 floors and 440 units.

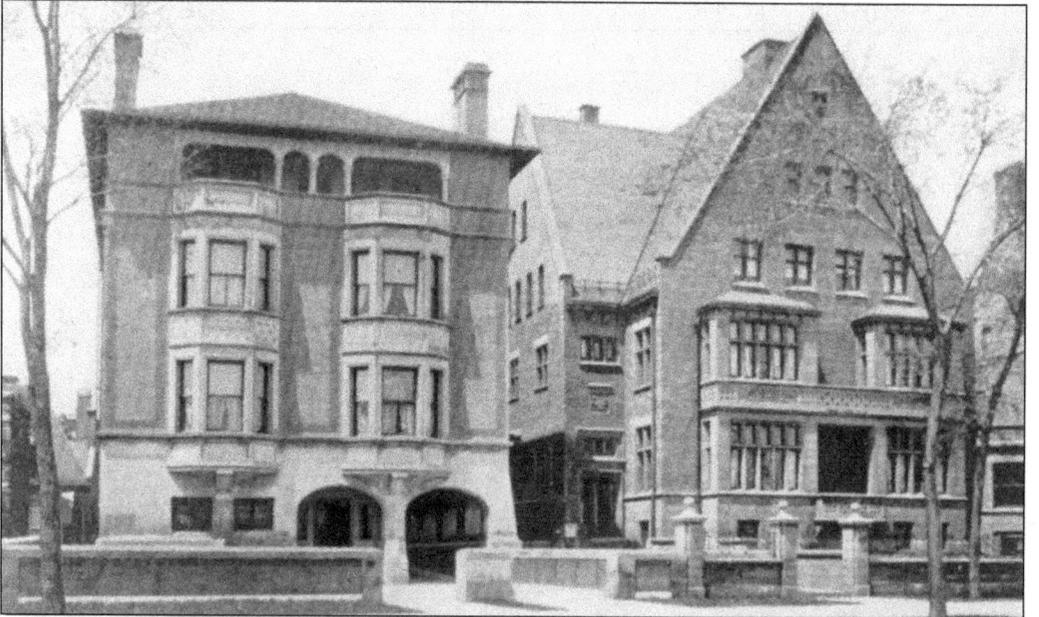

Here is a close-up of two of the mansions built on the 1400 block of North Lake Shore Drive. On the left was the home of Harry Gordon Selfridge (1858–1947), who made his fortune working as a partner at the Marshall Field Company. He eventually left his Lake Shore Drive mansion and moved to London, where he opened the renowned Selfridge Department Store. The home on the right belonged to newspaper publisher and editor Herman Henry Kohlsaat (1853–1924).

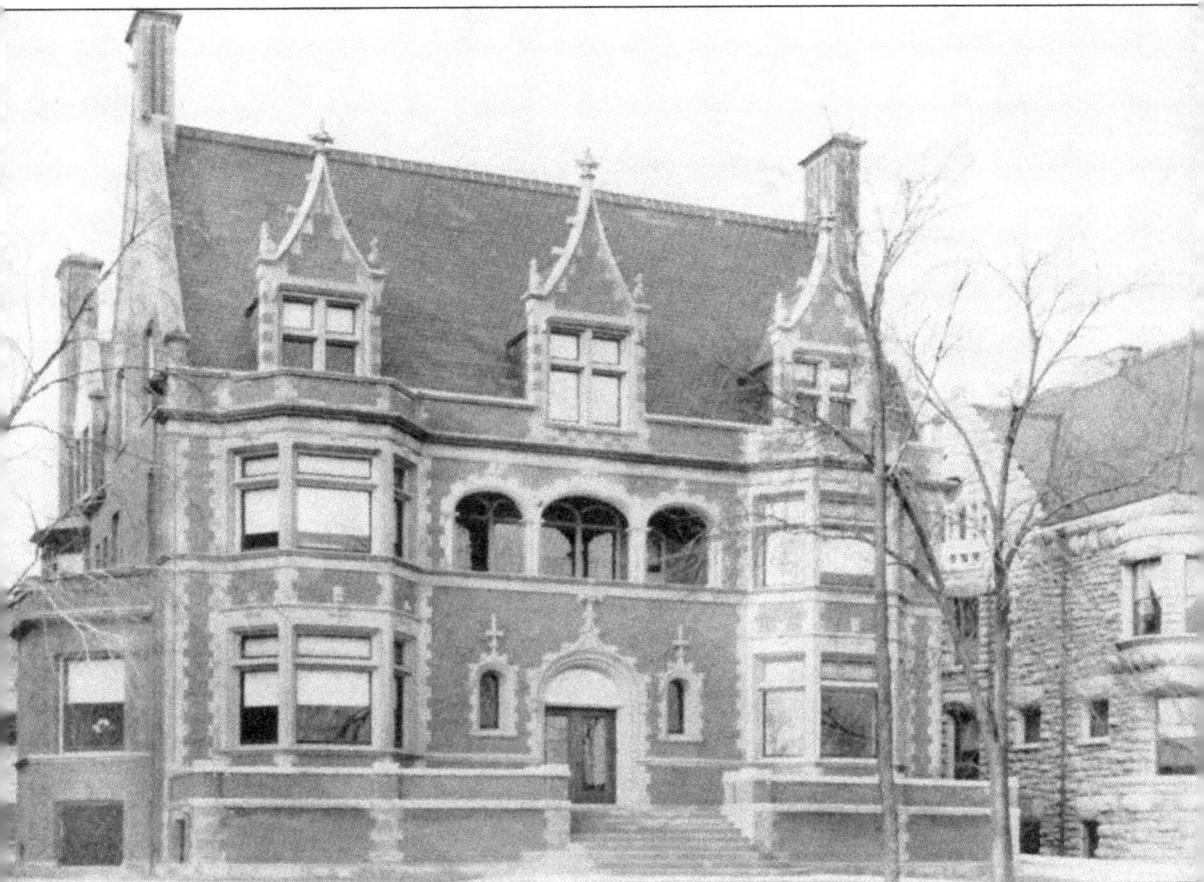

This home was constructed during the late 1800s for Gen. Alexander Caldwell McClurg (1832–1901). He was a hero in the Civil War, a successful bookseller, and a publisher. This lovely home was located at 103 North Lake Shore Drive, which would have been the 1400 block on Lake Shore Drive today. It was demolished to make room for more large apartment buildings.

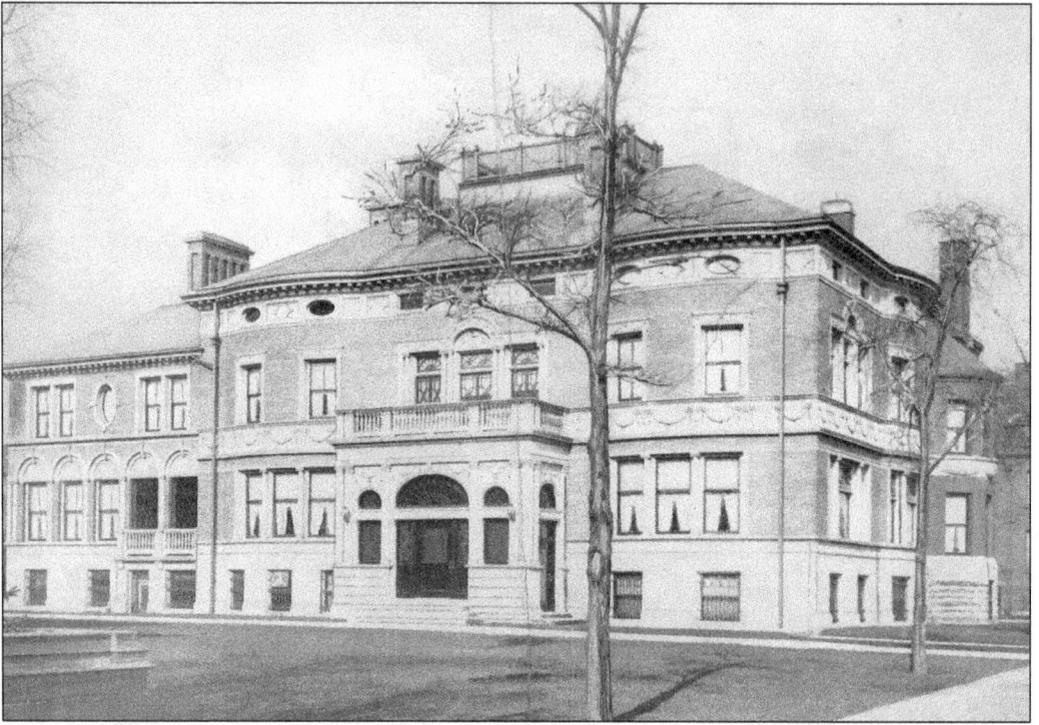

The architectural firm Burling & Whitehouse built this home in 1891 for successful lumberman Col. John Mason Loomis at 1220 N. Lake Shore Drive. In 1921, Loomis sold the property to the Illinois Life Insurance Company, which razed the building and erected lovely offices in its place. The company eventually became bankrupt, and the offices were torn down.

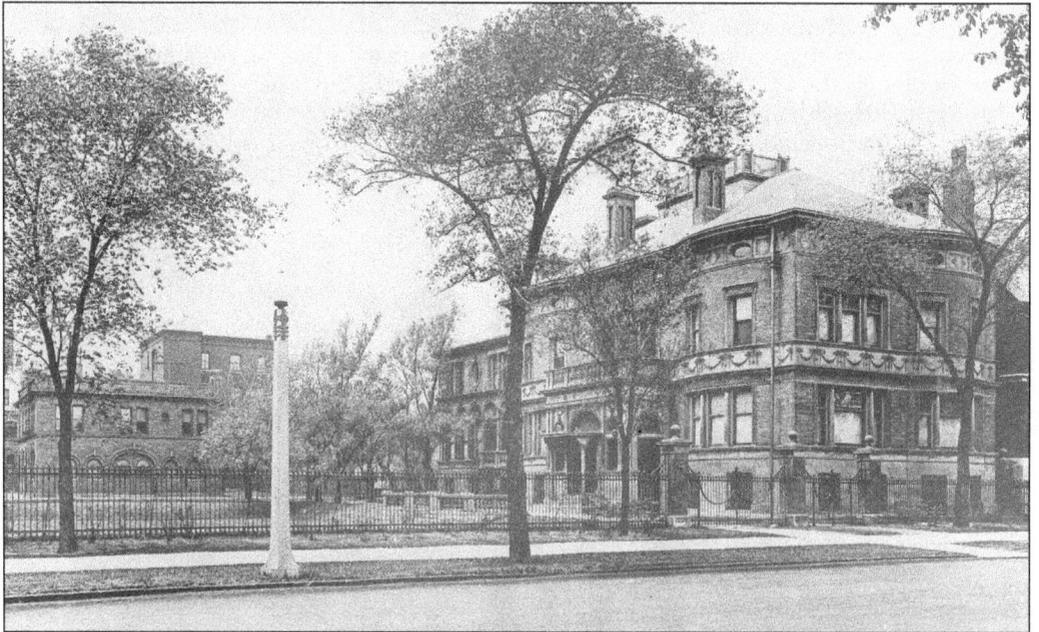

The spacious yard at 1220 North Lake Shore Drive was used for elaborate outdoor parties. Guests enjoyed beautiful views of Lake Michigan.

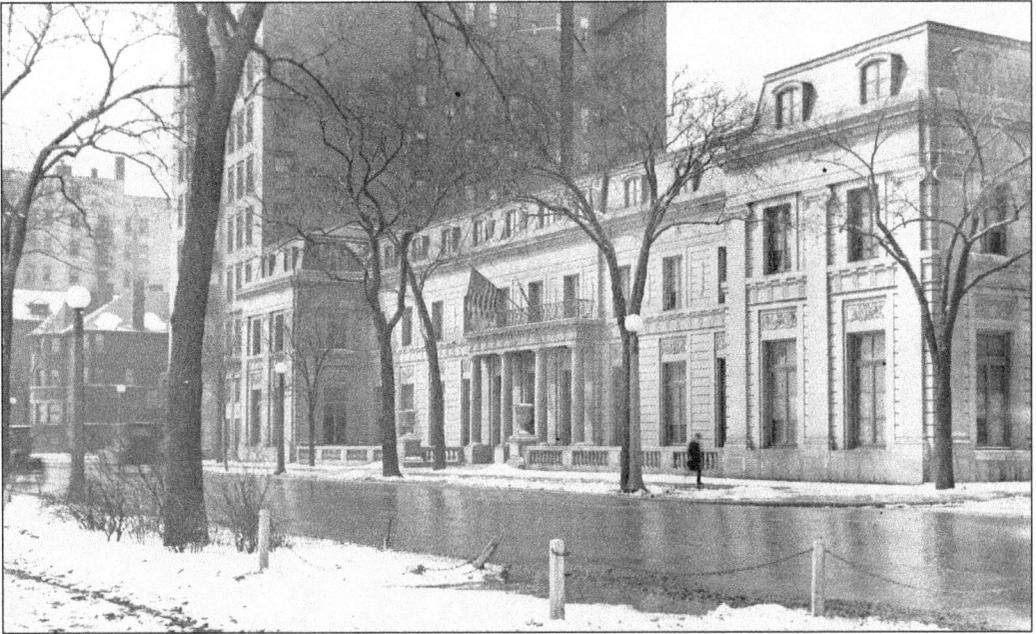

The architectural firm Holabird & Roche designed and constructed this building for the Illinois Life Insurance Company in 1922, located at 1208–1224 North Lake Shore Drive. The exterior was made of Indiana limestone supplied by the Central Oolitic Stone Company.

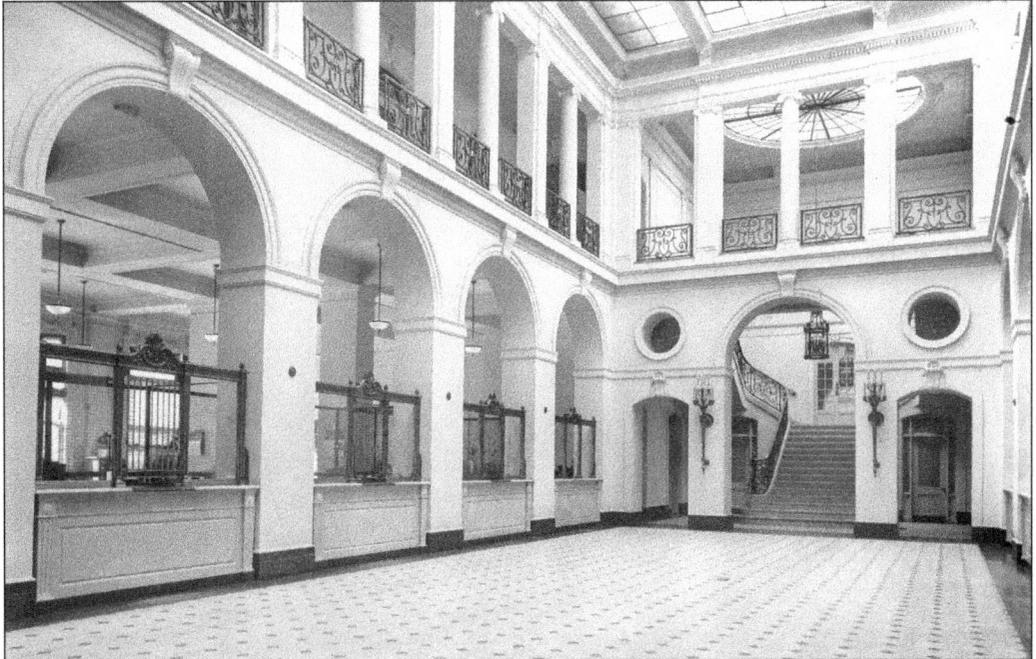

Here is a rare internal photograph of the Illinois Life Insurance Building. It won a gold medal, issued by the Lake Shore Trust & Savings Bank, for being the most distinctive building erected in the North Central District. Due to a financial downturn, this company filed for bankruptcy. The building was purchased by the government and used as the US Appellate Court for several years. It was razed and replaced by the 1212 North Lake Shore Drive apartment complex.

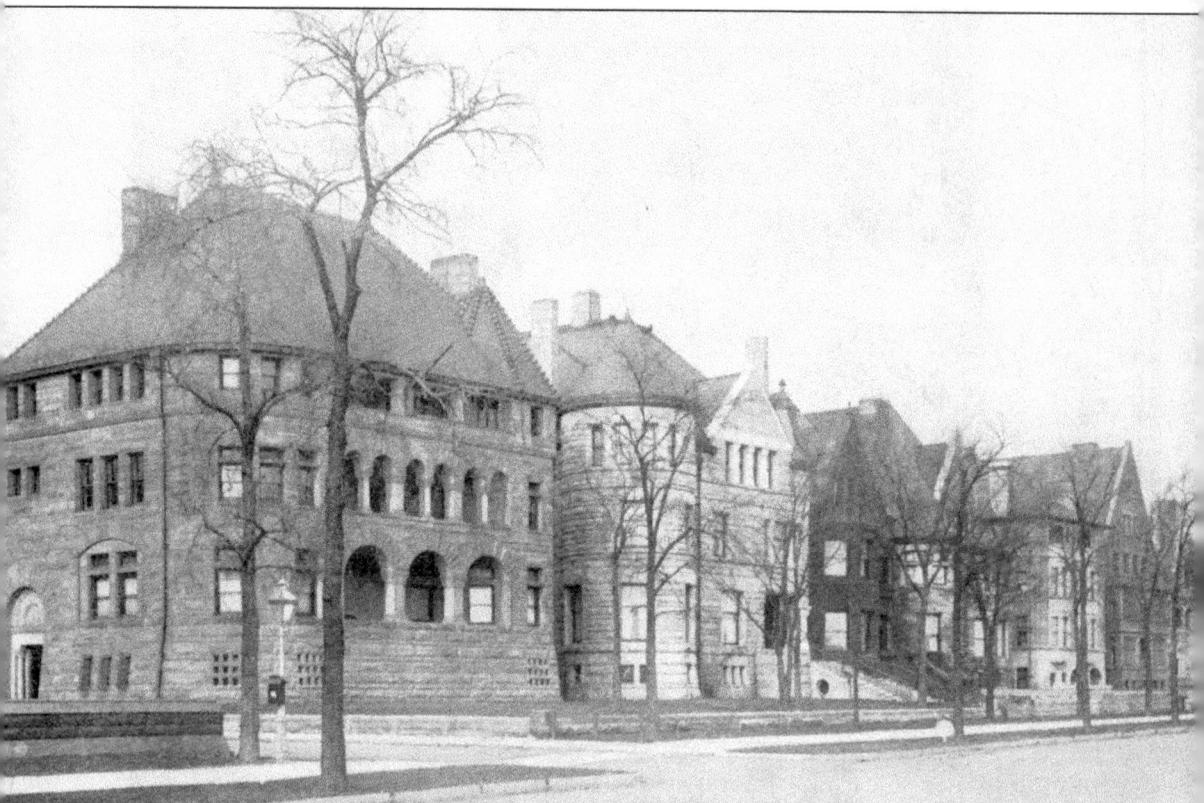

This impressive row of mansions once lined the 1400 block of North Lake Shore Drive between Schiller Street and Burton Place. Today, there are six high-rise buildings on this block containing hundreds of apartments.

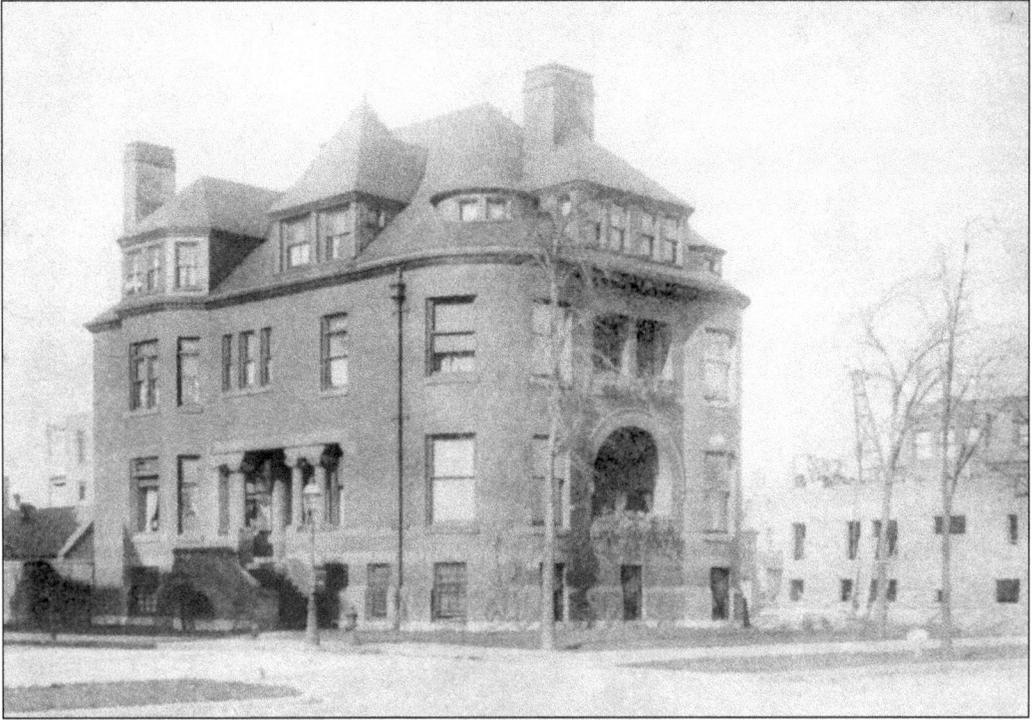

Located at 1234 North Lake Shore Drive, this was the home of Robert Todd Lincoln (1834–1926). The first son born to Pres. Abraham Lincoln and Mary Todd Lincoln, he was a successful lawyer and the secretary of war during the Civil War.

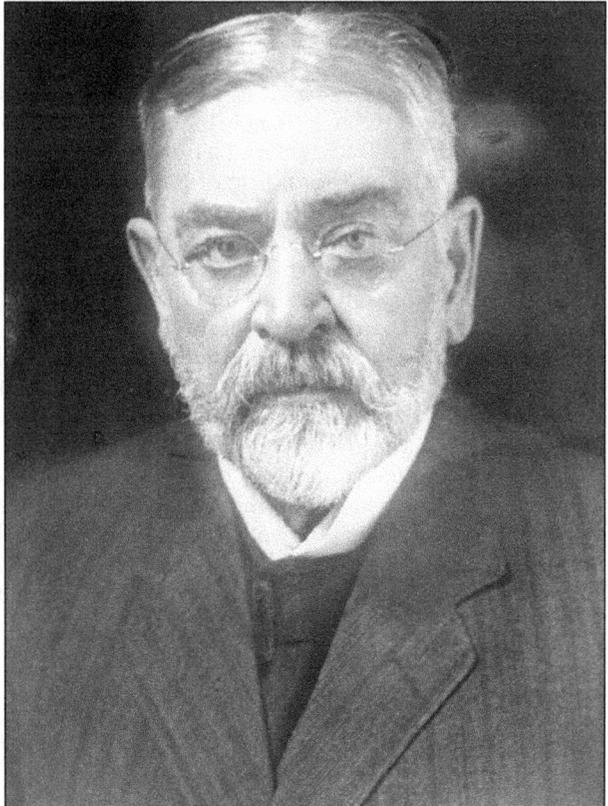

Pictured here is Robert Todd Lincoln in his later years.

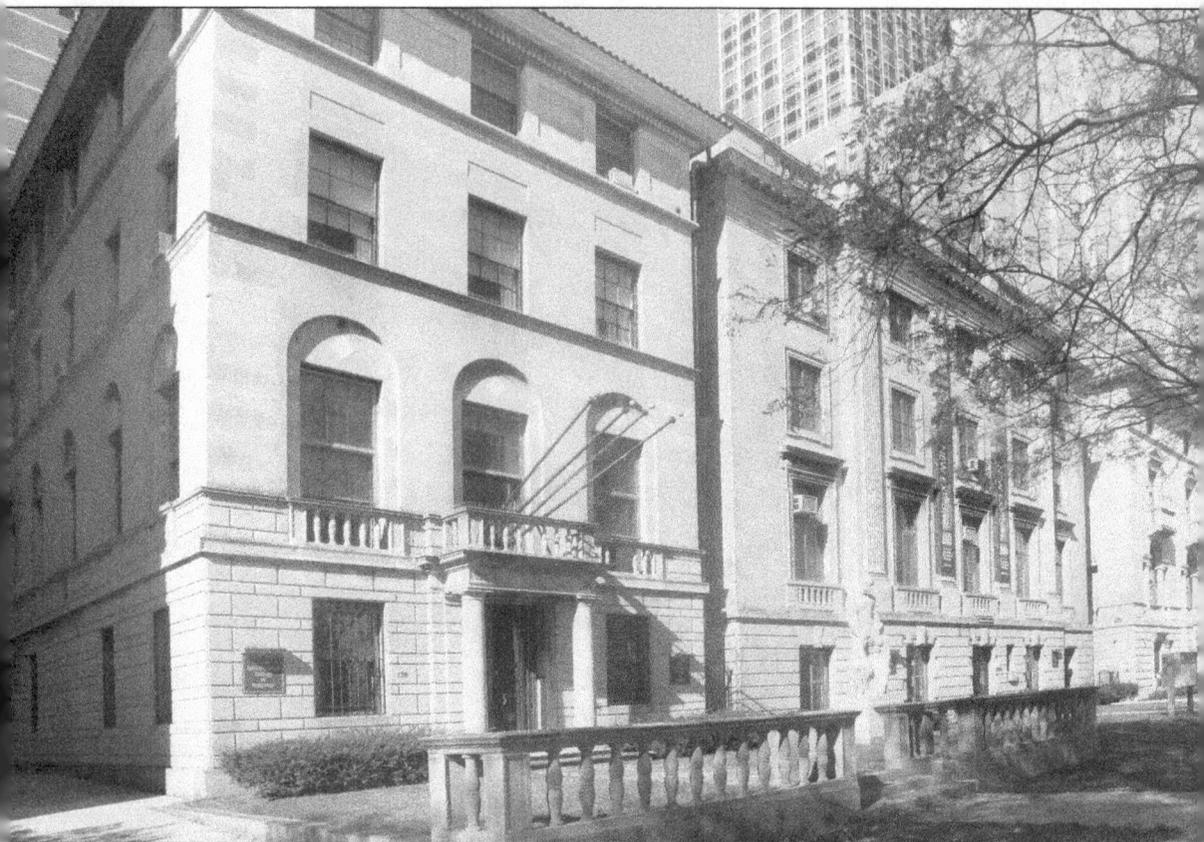

As of today, there are seven remaining mansions on North Lake Shore Drive. Three of them are located in the 1500 block. From left to right, 1516 North Lake Shore Drive was built in 1914 by the New York architectural firm of McKim, Mead & White for wealthy hardware merchant Edward Tyler Blair (1857–1939); 1524 North Lake Shore Drive was constructed in 1917 by architect Howard Van Doren Shaw for president of the Chicago Stock Exchange Fredrick Downer Countiss (1872–1926); and 1530 North Lake Shore Drive was built in 1916 by architect Benjamin H. Marshall for Illinois state senator and director of the Chicago Board of Trade Bernard Albert Eckhart (1852–1931). In 1950, two of the mansions (1516 and 1524 North Lake Shore Drive) were purchased by Dr. Max Thorek and the International College of Surgeons. After several years of renovation, they became home to the International Museum of Surgical Sciences in 1954. Then, in 1989, the Gold Coast Neighbors Association, along with the Commission of Chicago Landmarks, stepped in to save these mansions. They were in danger of being demolished and replaced by a 40-story condominium complex. The developers who proposed the condominium development were defeated. Today, the remaining seven mansions are now protected by the Illinois Register of Historic Places and the City of Chicago Landmarks. The other four mansions are located on the 1200 block on North Lake Shore Drive. The Bernard Albert Eckhart mansion at 1530 North Lake Shore Drive is owned and occupied by the consulate general of the Republic of Poland.

The Fredrick Downer Countiss mansion is the largest of the three, located in the 1500 block of Lake Shore Drive. The exterior design was influenced by the historical design of Le Petit Trianon, a chateau on the ground of Versailles built for Louis XVI and Marie Antoinette in 1770.

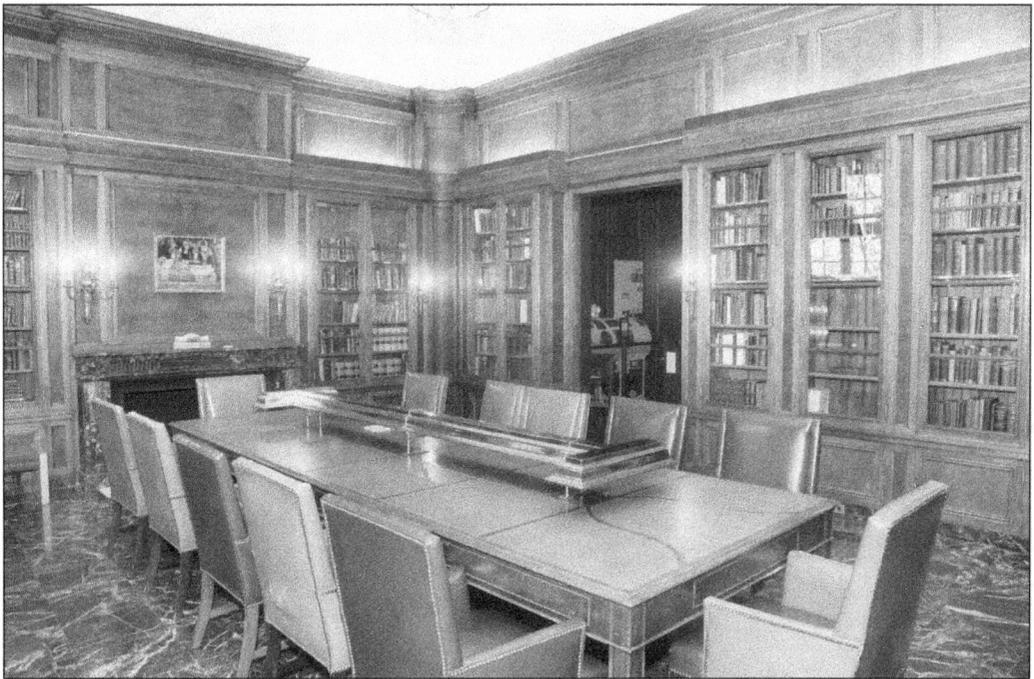

This is a photograph of the library inside of the Countiss mansion, which has remained intact. Note the beautiful wood paneling, Italian marble floors, and fireplace. This is one of the rooms the International College of Surgeons rents out for private parties and special events.

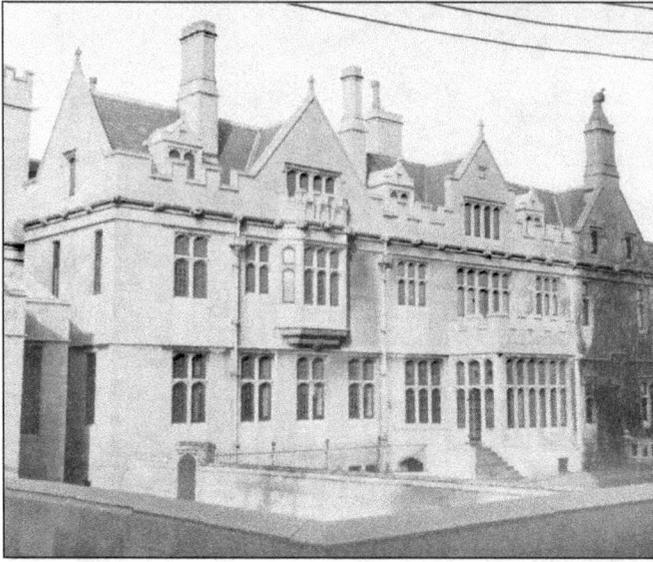

This impressive home was located at 1550 North Lake Shore Drive. It was built for Richard Teller Crane Jr. (1873–1931), a manufacturer of plumbing supplies and solid brass goods. The architectural firm Shepley, Rutan & Collidge designed and constructed this home in 1910. It is the same firm that designed the Art Institute of Chicago, which was erected in 1893 as the World Congress auxiliary building for the World's Columbian Exposition. Crane's home was razed in the 1950s, and a modern apartment building was constructed on this site.

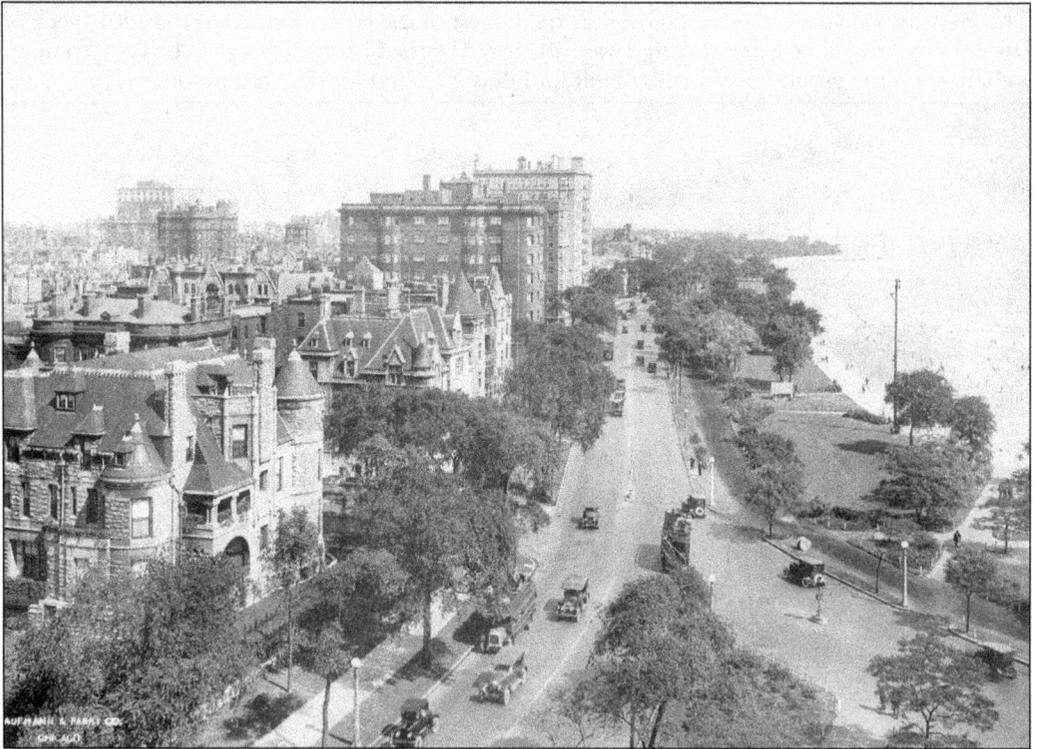

There was a time when beautiful mansions lined the street of Lake Shore Drive. This area was a tourist destination even back in the 1920s when this photograph was taken. Note the tour buses moving in both directions. Today, tourists flock to the Gold Coast to see the remaining mansions on North Lake Shore Drive.

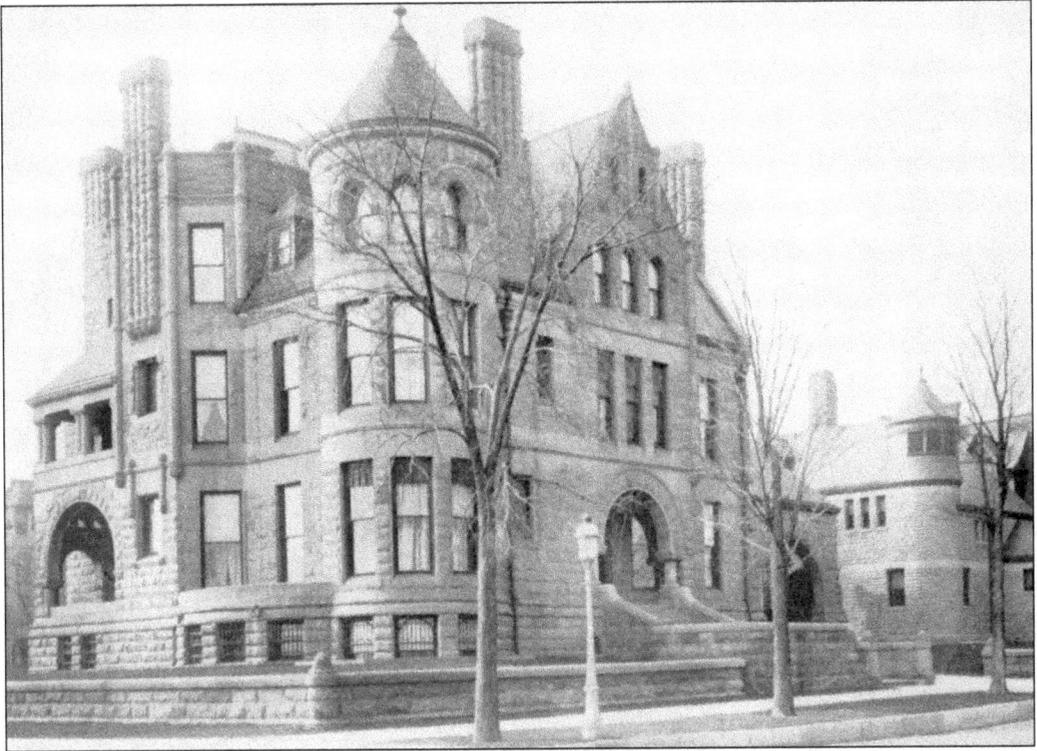

Once located at 1000 North Lake Shore Drive, this 41-room Bedford Limestone mansion was designed by architect Solon Spencer Beman in 1883. It was originally built for wealthy attorney and grain trader Nathaniel M. Jones and was later purchased by oil tycoon John D. Rockefeller (1838–1937) as a wedding gift for his daughter Edith Rockefeller McCormick (1872–1932) in 1897.

Thousands of prominent guests entered through this reception hall over the course of 28 years. Edith Rockefeller McCormick hosted hundreds of extravagant parties in this home. She was considered the queen of Chicago when it came to entertaining. Bertha Palmer was the official queen until her death in 1918. Sadly, due to the stock market crash of 1929 and a stormy relationship with her wealthy father, Edith lost a great deal of her personal fortune. She closed her home and moved to the Drake Hotel until her death on August 25, 1932. In 1953, her beloved Lake Shore Drive mansion was demolished.

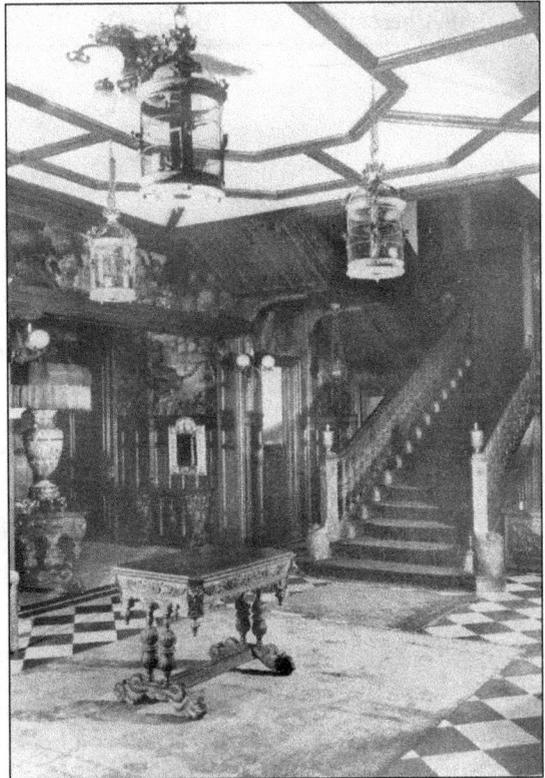

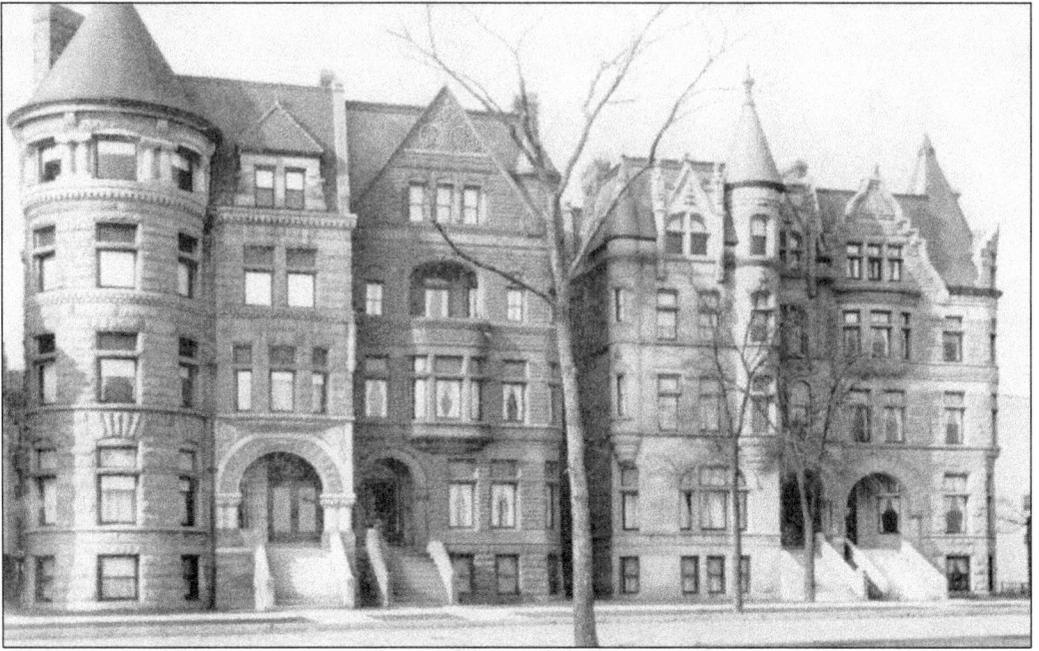

These magnificent mansions were located just north of Edith Rockefeller McCormick's mansion. Pictured from left to right are the homes of wealthy attorney Charles Evens Pope (1847–1917) at 1040 Lake Shore Drive, railroad supply executive Alfred Henry Mulliken (1853–1931) at 1042 Lake Shore Drive, and president of the A.B. Dick & Company (a major American manufacturer of office supplies) Albert Black Dick (1856–1934) at 1046 and 1050 Lake Shore Drive on the far right.

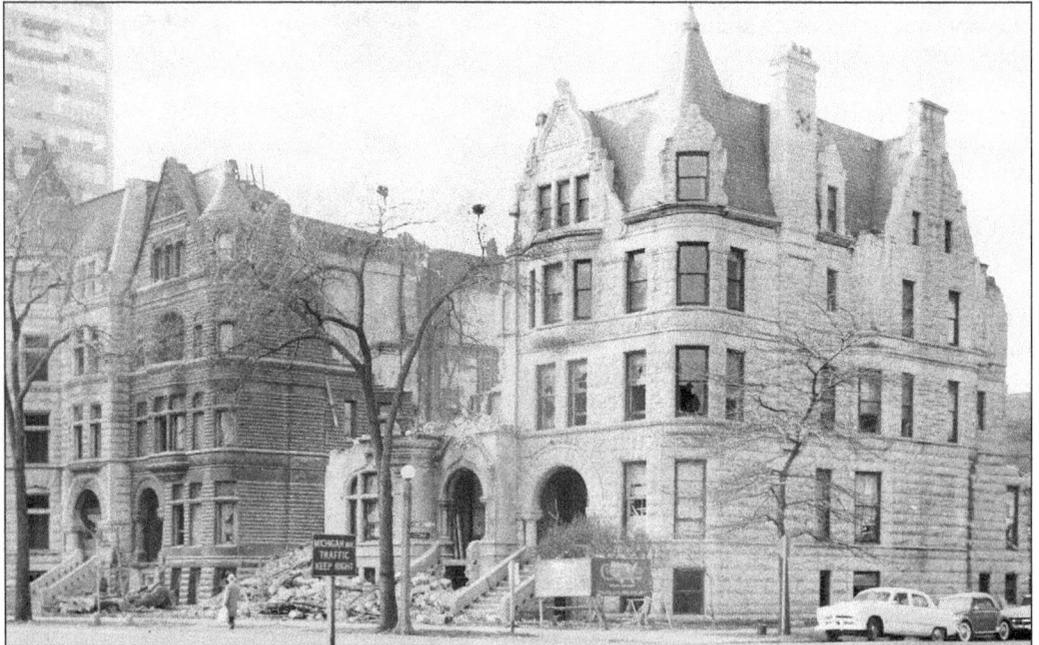

This rare photograph shows 1040 to 1050 North Lake Shore Drive mansions being demolished in the early 1960s. The Carlyle, an elegant condominium, was built on this site in 1964. It contains 40 floors and a large staff to serve its residents.

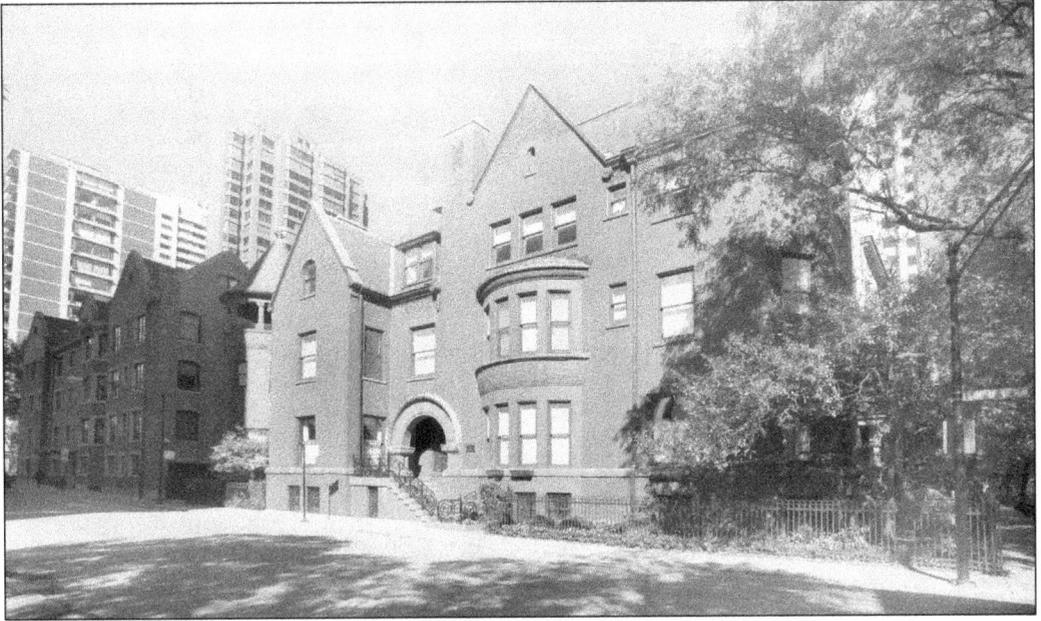

Some of the most unique homes in the Gold Coast were erected on Astor Street during the later part of the 19th century. Pictured above, one of these homes is located at 1400 North Astor Street. It was designed and constructed by architects Henry Ives Cobb and Charles Sumner Frost. Cobb and Frost built Potter Palmer's mansion, which was located just around the corner, a few years earlier. The home was built in 1887 for Perry H. Smith Jr. (1854–1893), whose father, Perry Smith Sr., made a fortune in the railroad and real estate business. Although this home has gone through extensive renovations, the exterior and a great deal of its interior remain intact. There are 15 rooms with over 10,000 square feet of living space. Below is 1435 North Astor Street.

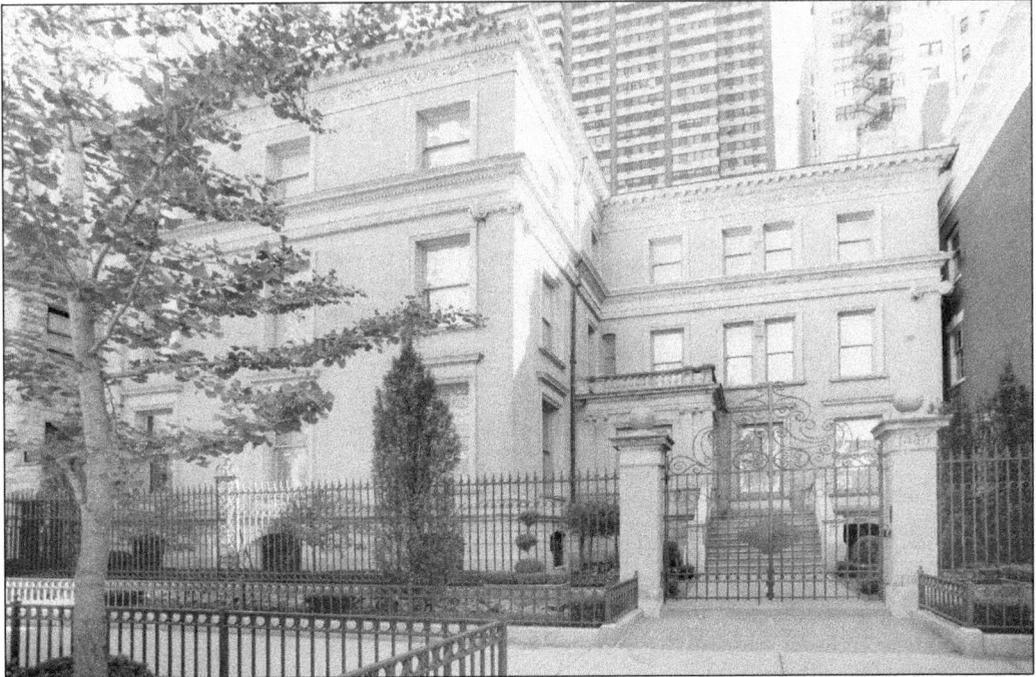

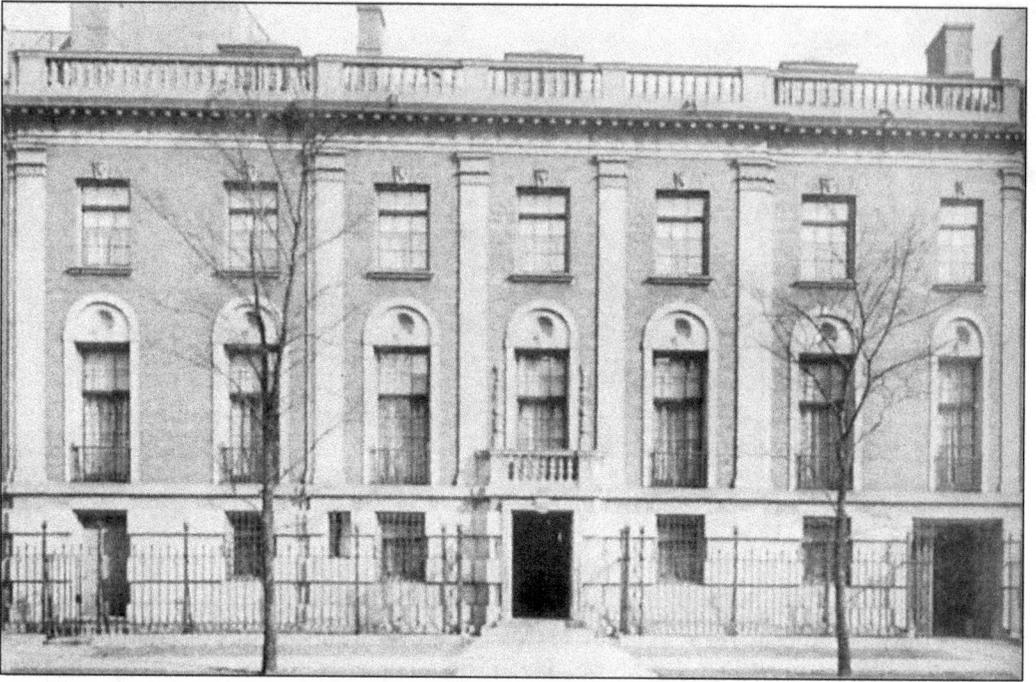

This Federal home at 1355 North Astor Street was built in 1914 by architect Howard Van Doren Shaw for lumber magnate William Owen Goodman (1848–1936). It was more formal compared to Goodman's pervious home on Greenwood Avenue, which was located on the south side of the city. Chicago's famous Goodman Theatre was named for him because of his generous donations and support of the arts.

Even today, tourists peek though the beautiful iron fence to catch a glance of the Goodman mansion's grounds, including the lovely courtyard.

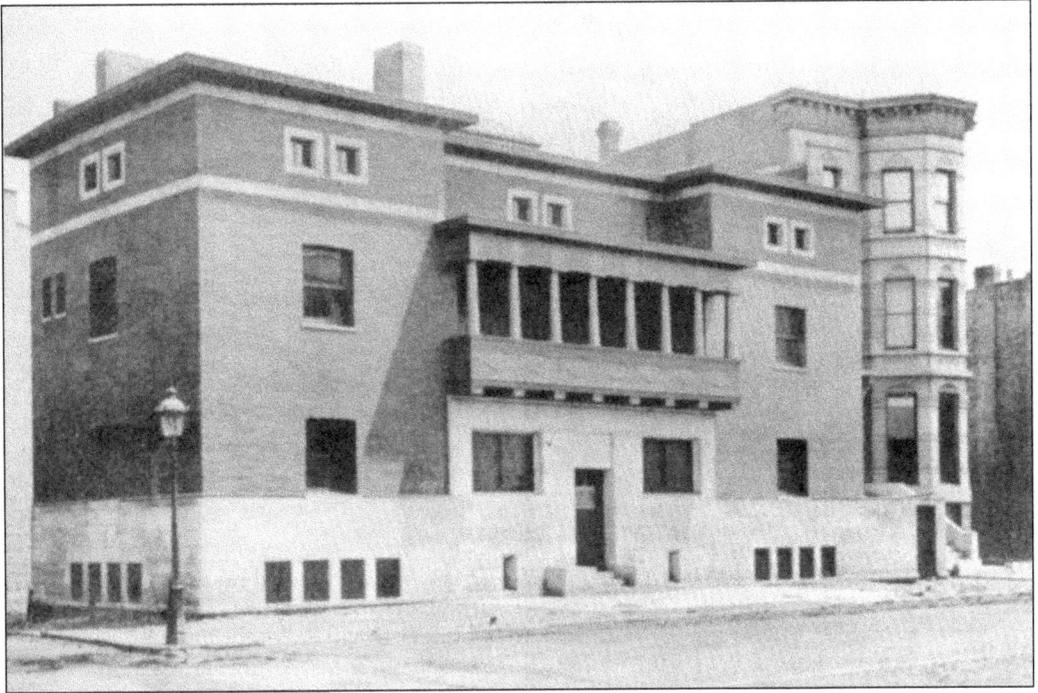

Located at 1365 North Astor Street next to the Goodman mansion, the Charnley house was built by the architectural firm of Adler & Sullivan. This masterpiece home is the result of two major American architects working together in 1892. At that time, Frank Lloyd Wright was a junior draftsman and designer in Louis Sullivan's office. This home was built for lumberman James Charnley (1844–1905). In 1995, it was purchased by philanthropist Seymour Persky for the Society of Architectural Historians.

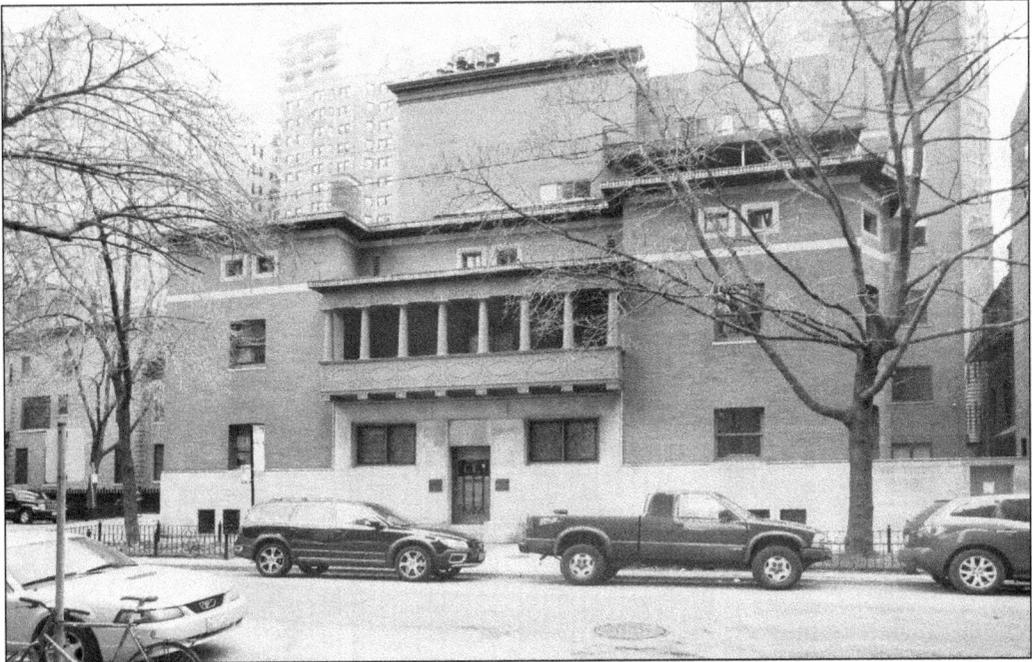

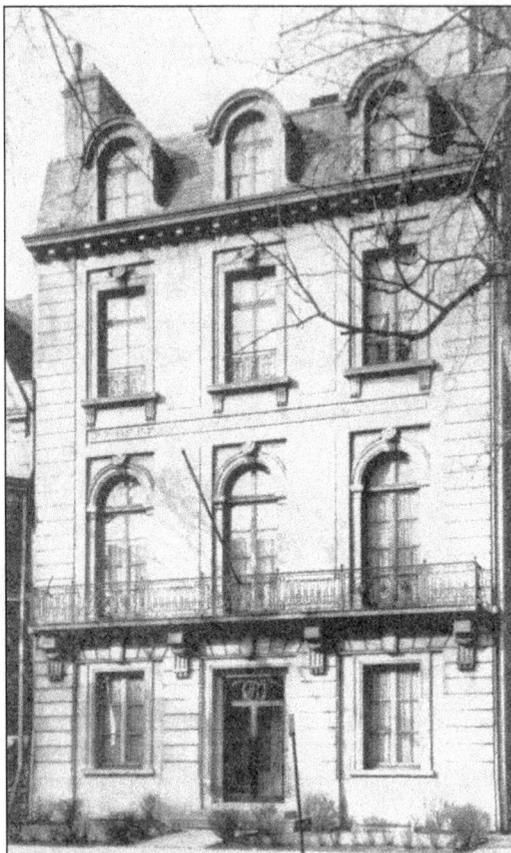

This Classical Revival home is located at 1406 North Astor Street. It was built by architect David Adler for iron and steel manufacturer Joseph Turner Ryerson Jr. in 1922. In 1931, a fourth floor and mansard roof was added under the direction of Adler. Today, this 16,000-square-foot home remains a single-family residence. Above the home's main entrance, there is decorative ironwork containing the initials of Joseph Ryerson Jr.

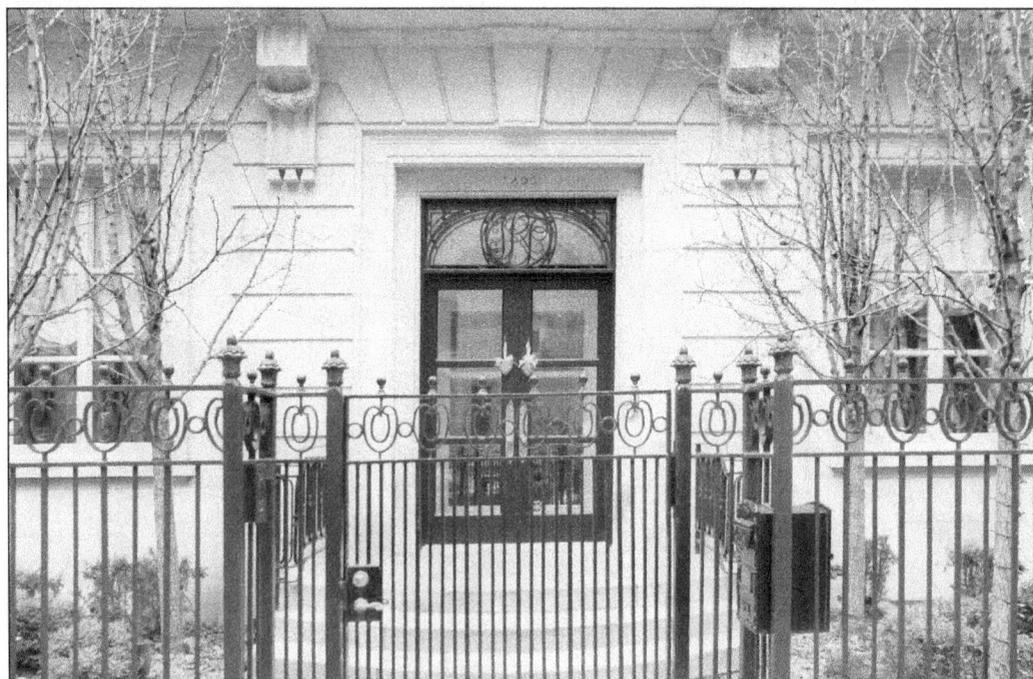

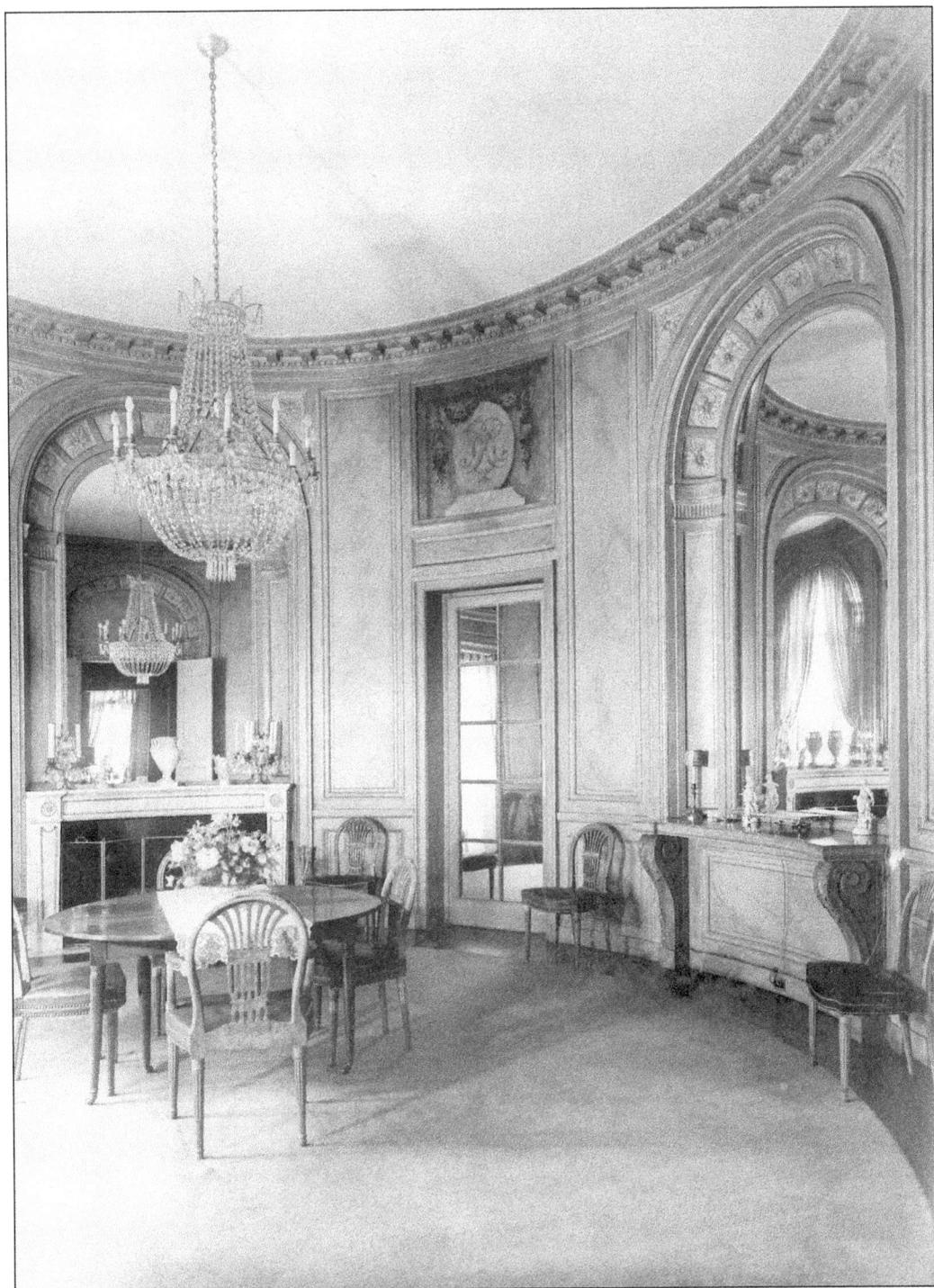

Architect David Adler designed this circular Classical Revival dining room of the Ryerson mansion.

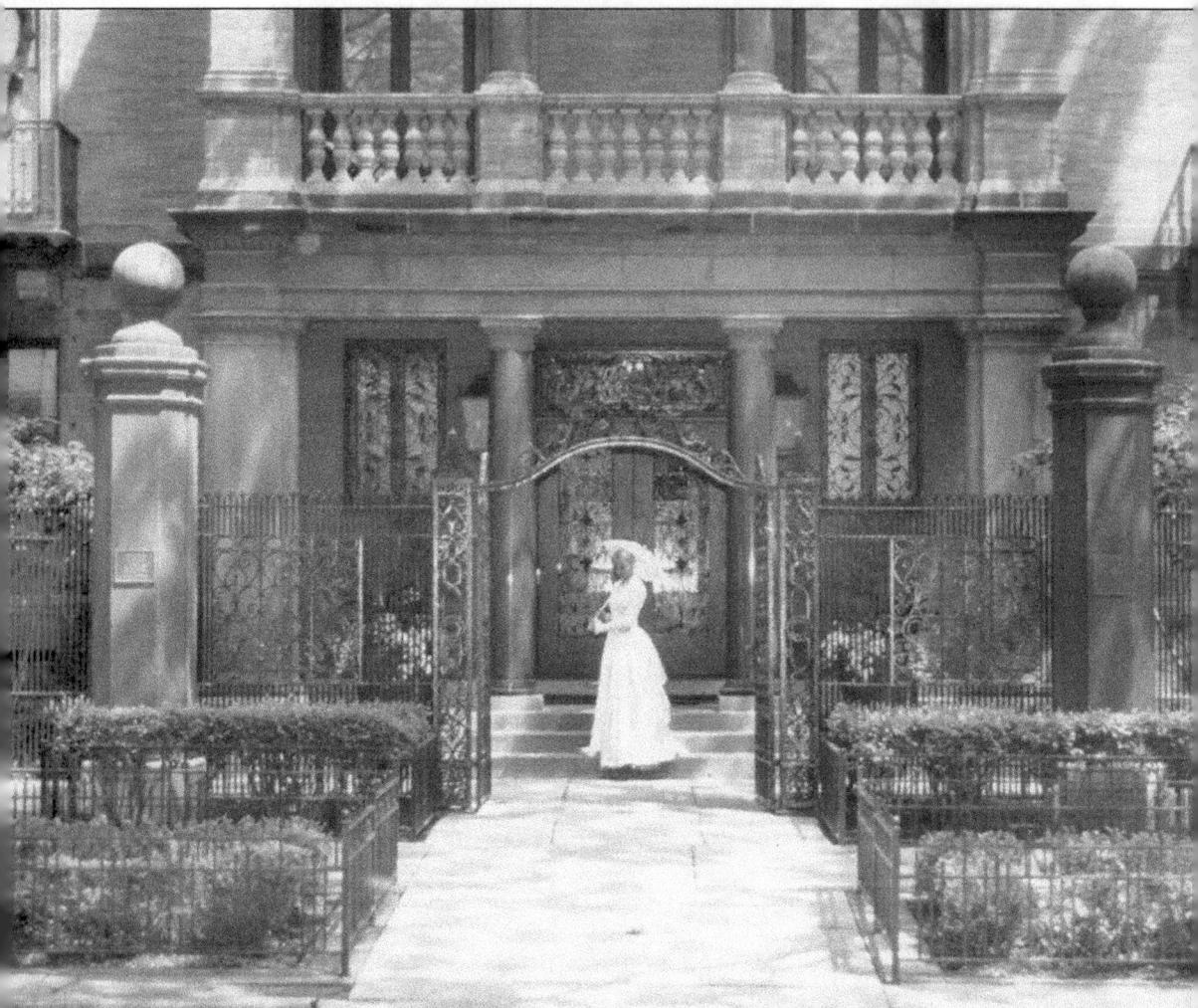

The Patterson-McCormick mansion, located at 1500 North Astor Street, was also the home of the Bateman School. It was designed and built by New York architect Stanford White for *Chicago Tribune* publisher Joseph Medill (1823–1889), who gave it to his daughter Elinor Josephine Medill Cissy Patterson (1881–1948) as a wedding gift on April 14, 1904. The model in this photograph, taken by Steve Skoropad, is Bekah Webb.

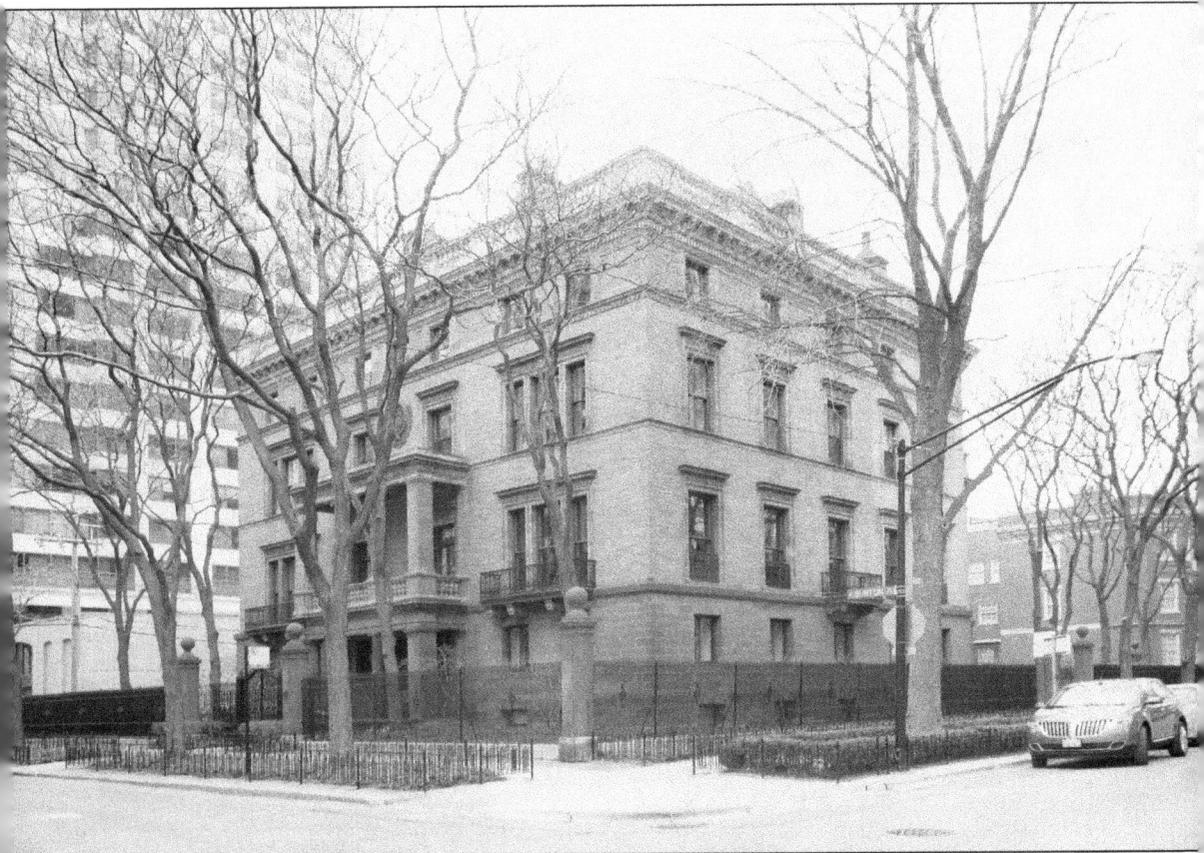

In 1914, Cyrus Hall McCormick II (1859–1936) bought the Patterson-McCormick mansion. In 1927, he hired architect David Adler to put an addition on the rear part of the house, as seen on page 39.

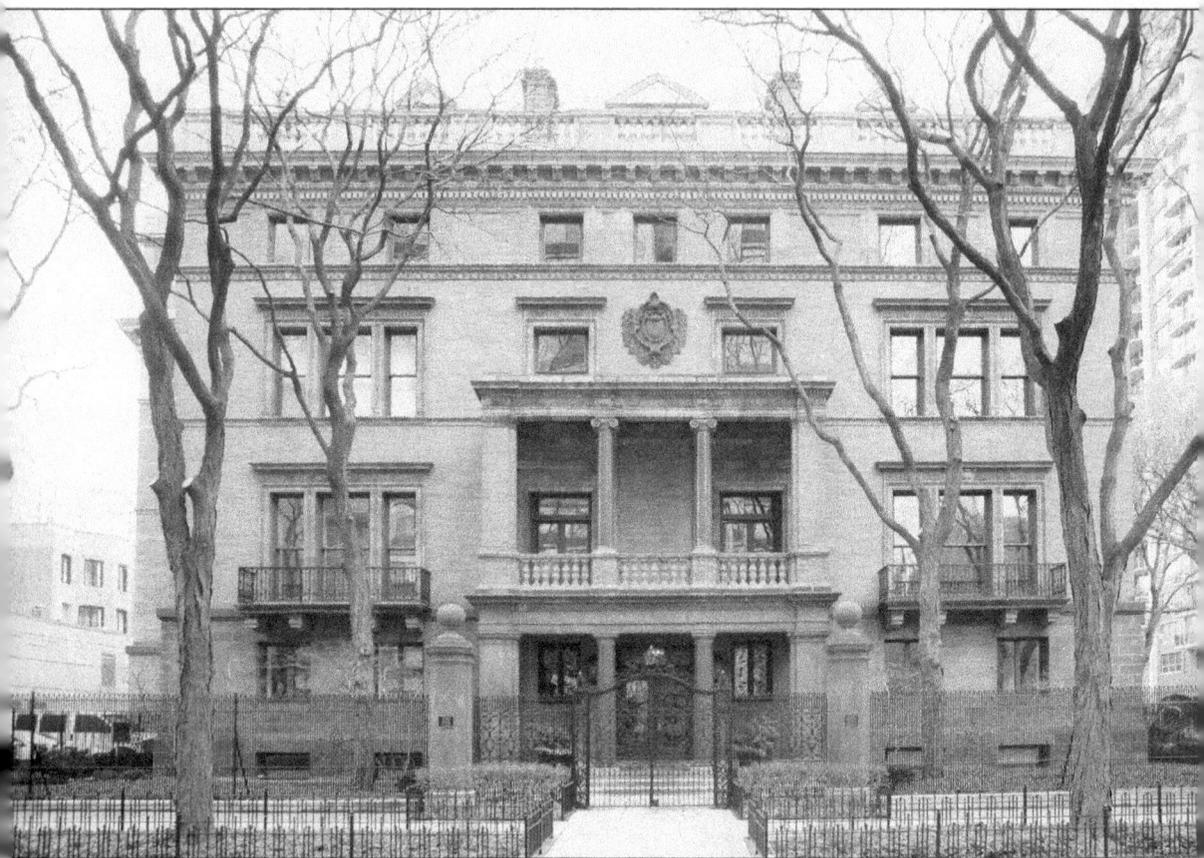

Although the fence that surrounds this home is not original, the pillars located on each side of the front of the home are.

PATTERSON—McCORMICK
MANSION

ORIGINALLY BUILT IN 1891
FOR ELINOR "CISSY"
PATTERSON BY ARCHITECT
STANFORD WHITE AND
LATER ENLARGED AND
OCCUPIED BY
CYRUS H. McCORMICK.

THIS LANDMARK PROPERTY
IS NOW INDIVIDUAL
CONDOMINIUM RESIDENCES.

From 1950 to 1976, the Patterson-McCormick mansion, one of the most expensive homes in Chicago, became the home of the Bateman School. Chauffeurs drove many of the children who attended this school. The school closed in 1978. That year, the building was purchased by a developer and converted to luxury condos.

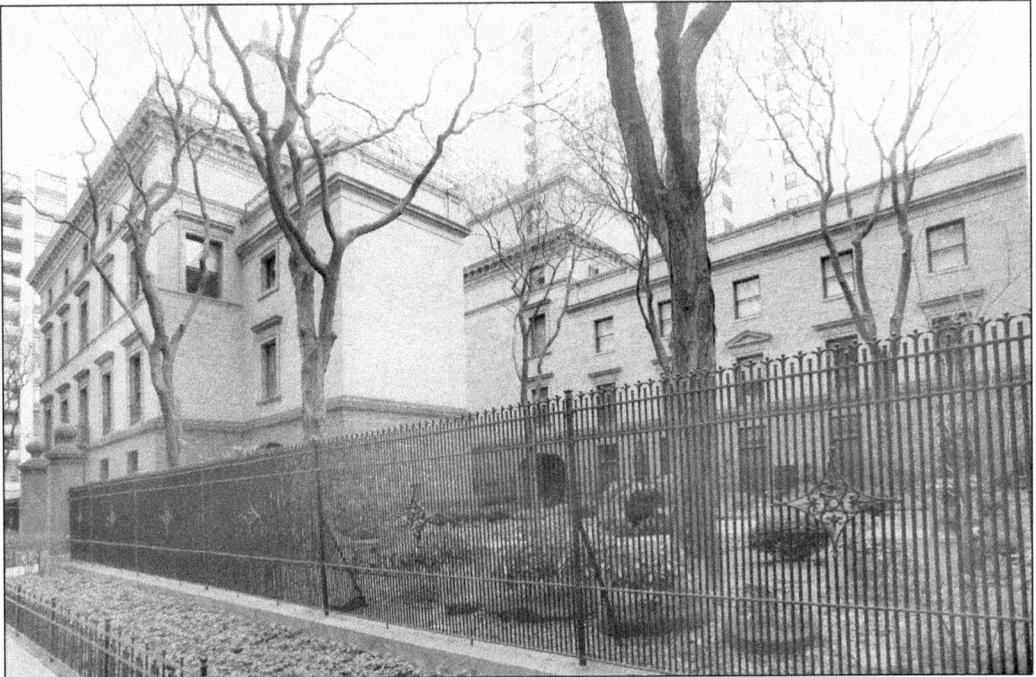

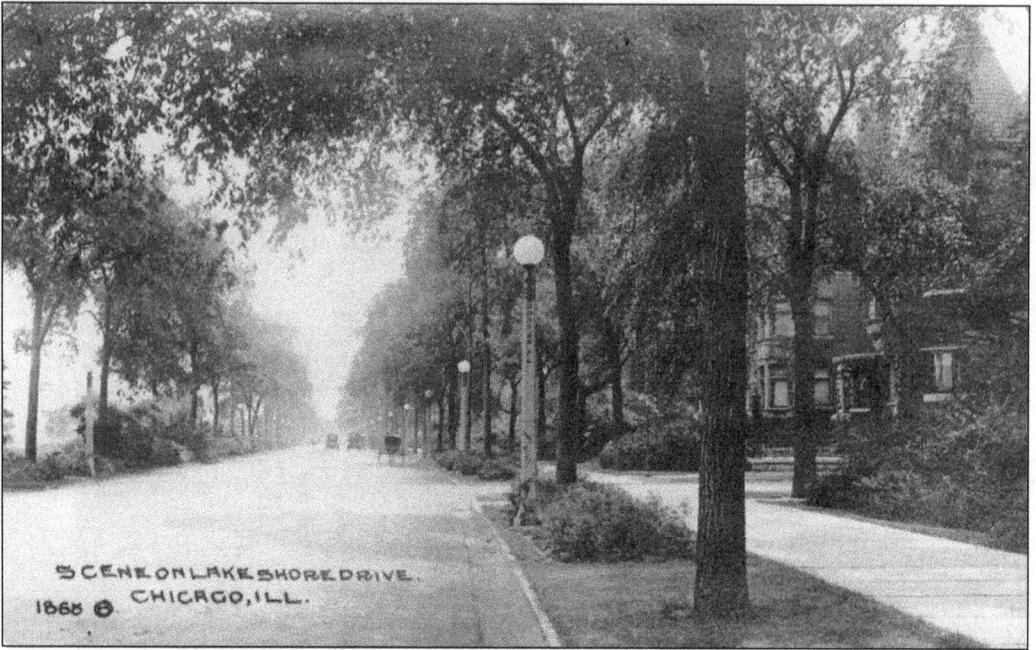

Before tall condo and cooperative apartments were built on Lake Shore Drive, this street was lined with trees and some of the most beautiful mansions in America. This photograph was taken in the summer of 1914 at Lake Shore Drive and Burton Place.

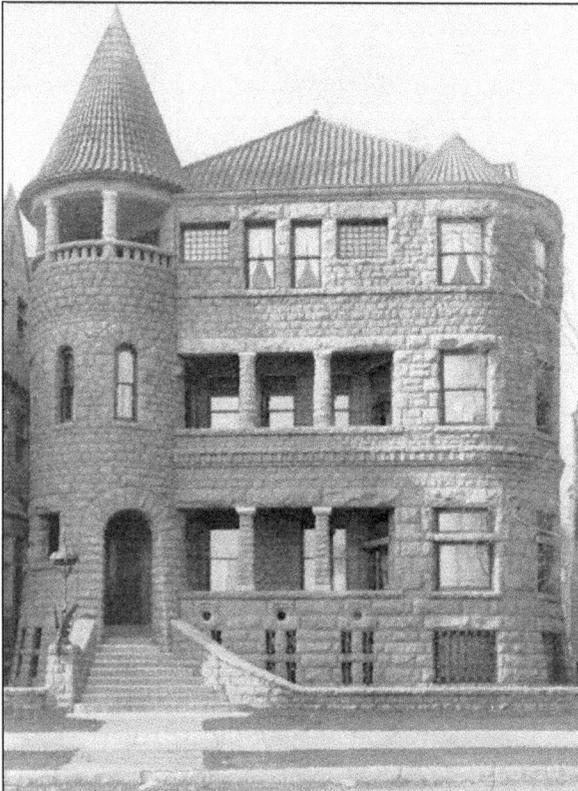

This four-story mansion located at 1250 North Lake Shore Drive was designed by architect Frank B. Abbott in 1890 for real estate tycoon Charles Constantine Heisen (1854–1945).

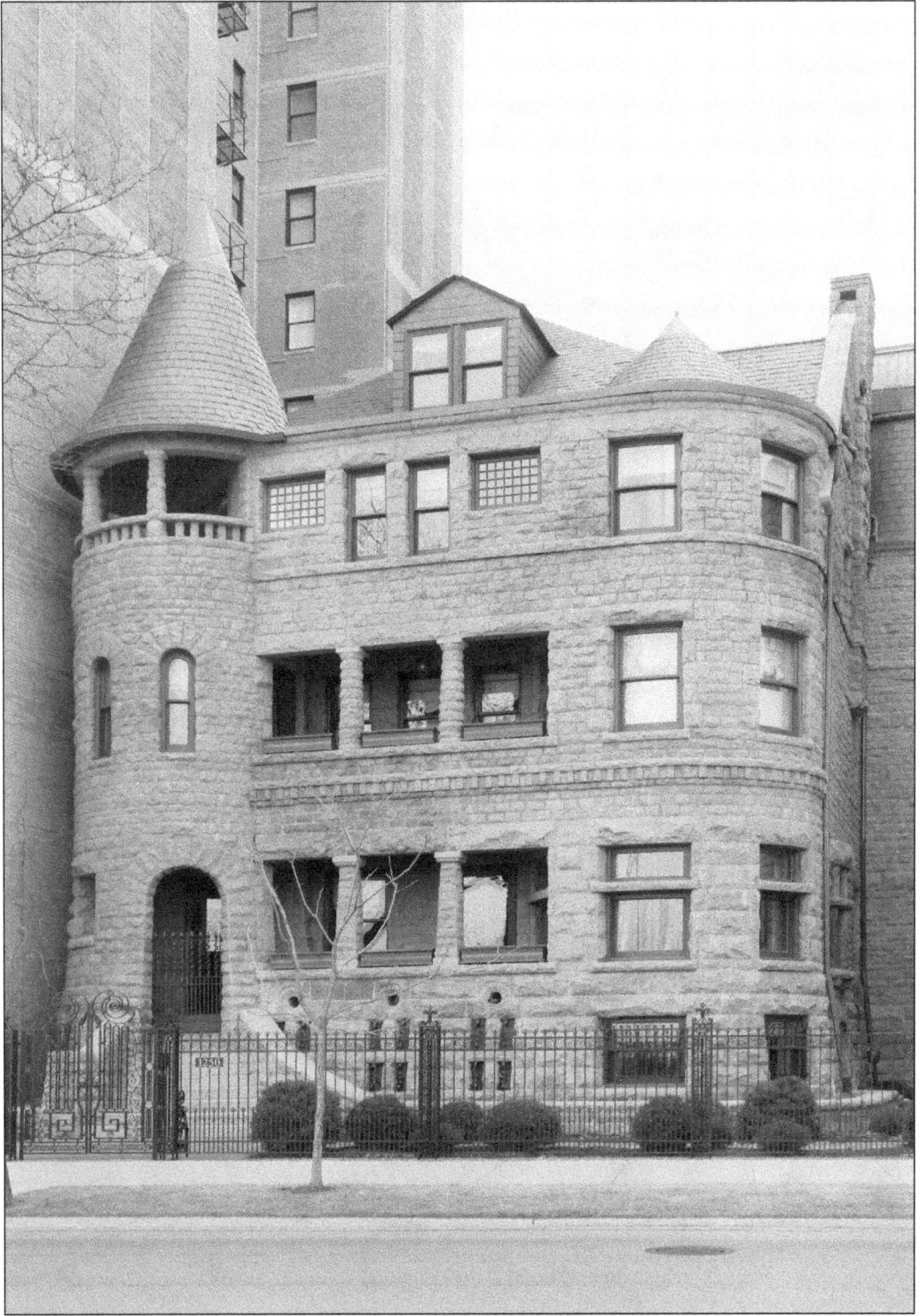

The Heisen mansion has over 15,000 square feet of living space and 23 rooms. It is one of the Gold Coast's largest homes today.

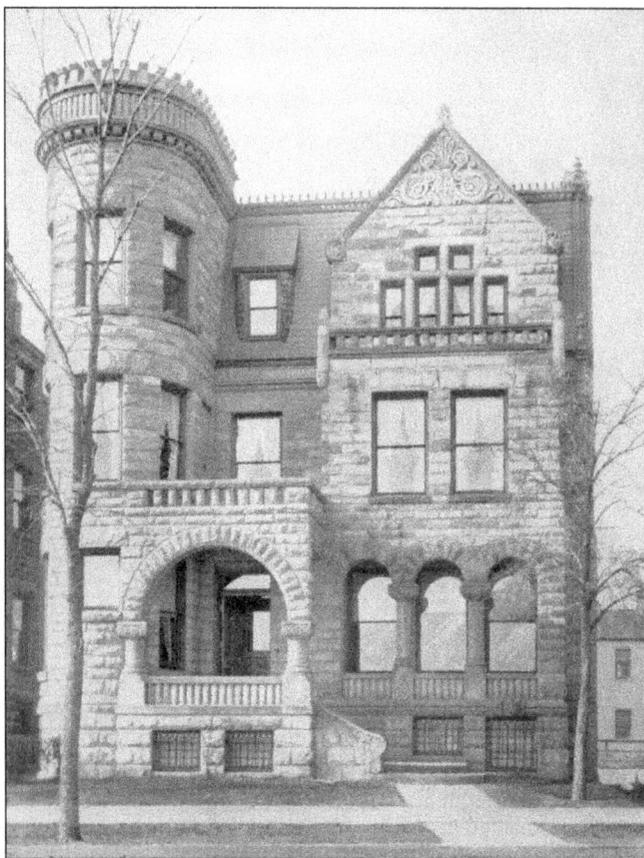

Located at 1254 North Lake Shore Drive, this home was designed by architect Lawrence Gustav Hallberg in 1889 for attorney and railroad executive Mason Brayman Starring (1859–1934). Both the Starring mansion and Heisen mansion at 1250 North Lake Shore Drive are Richardson Romanesque designs.

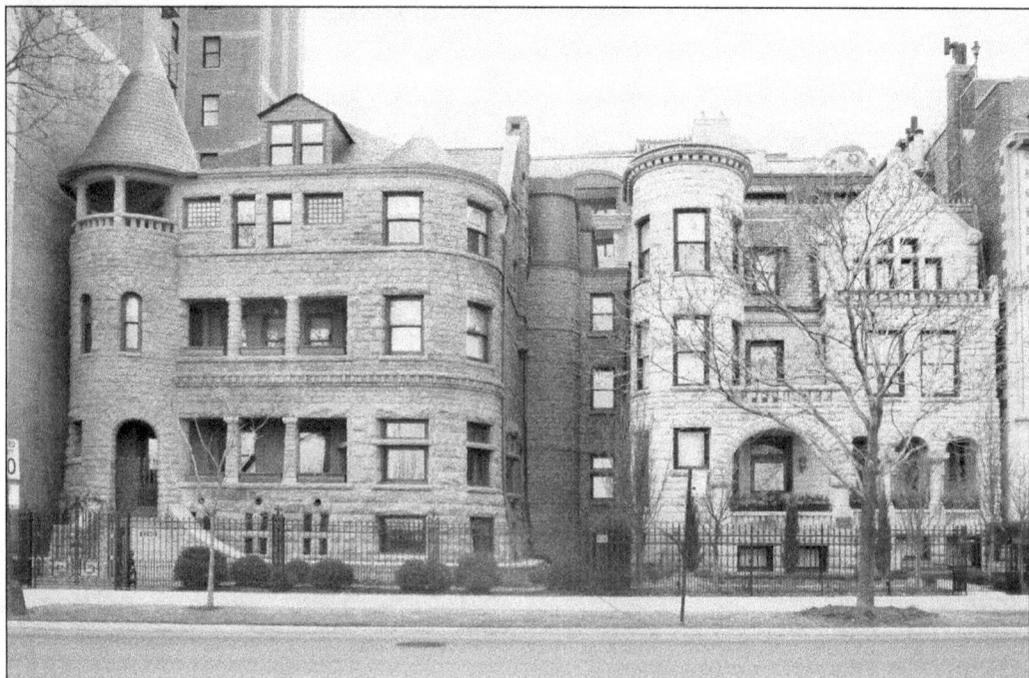

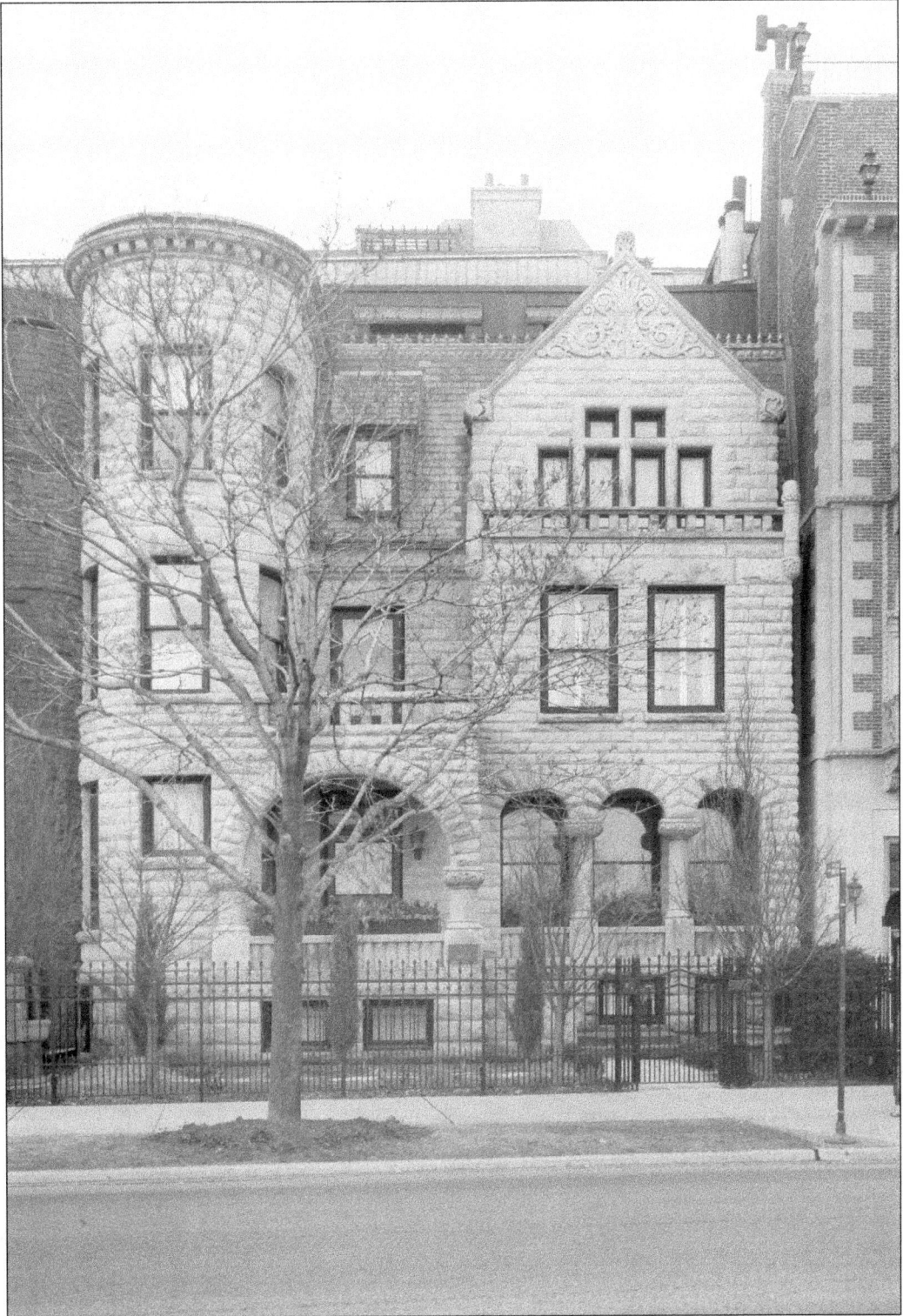

In the 1990s, Starring's home was renovated and divided into four apartments.

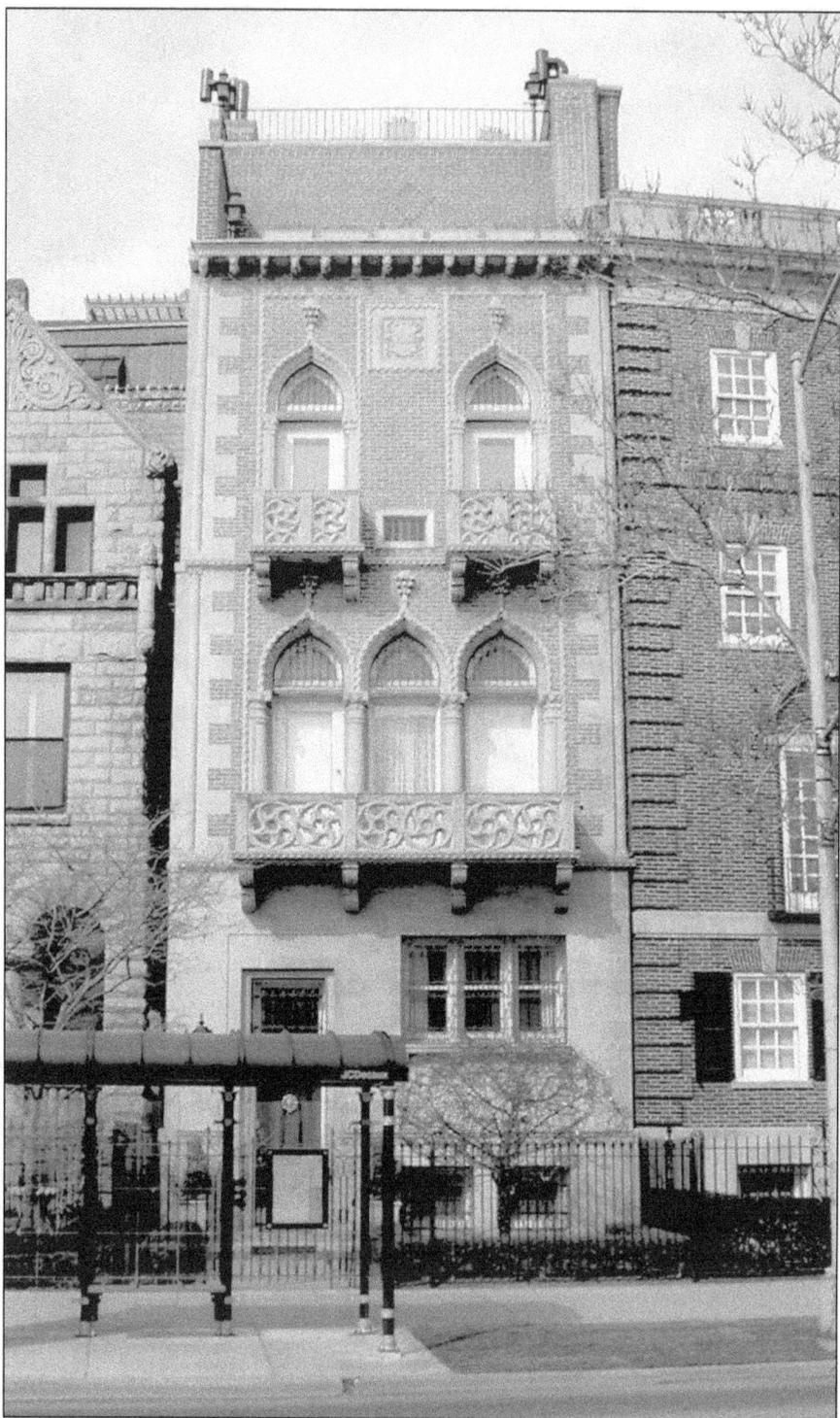

In 1892, the architectural firm Holabird & Roche designed this Venetian Gothic home located at 1258 North Lake Shore Drive for real estate executive Arthur Taylor Aldis (1861–1934). This four-story, 4,000-square-foot home contains five bedrooms, several fireplaces, and palazzo-inspired details.

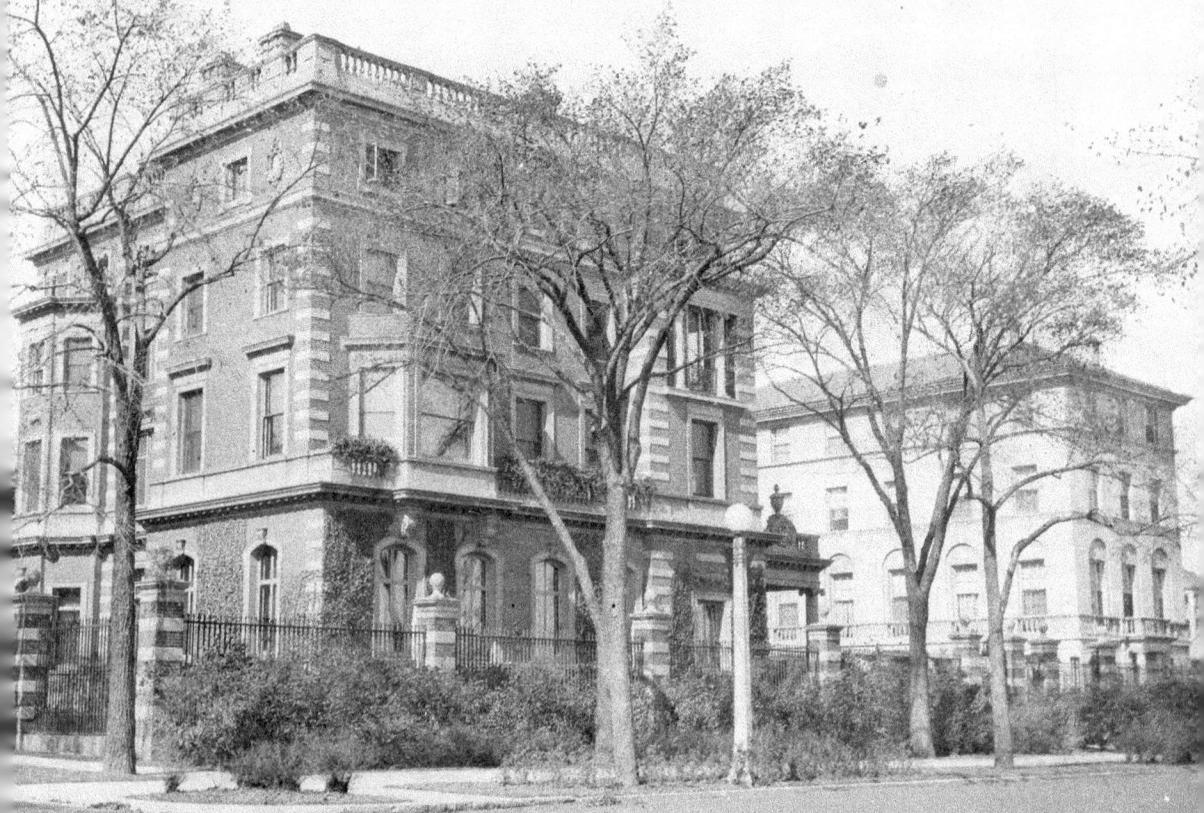

This beautiful mansion belonged to Victor F. Lawson (1850–1925), the editor and publisher of the *Chicago Daily News*. Located at 1500 North Lake Shore Drive and Burton Place, it was rumored to have cost over $1 million to build. It was demolished to make room for the cooperative apartment at 1500 North Lake Shore Drive in 1929; however, several interior parts of Lawson's mansion were inserted in some of the apartments.

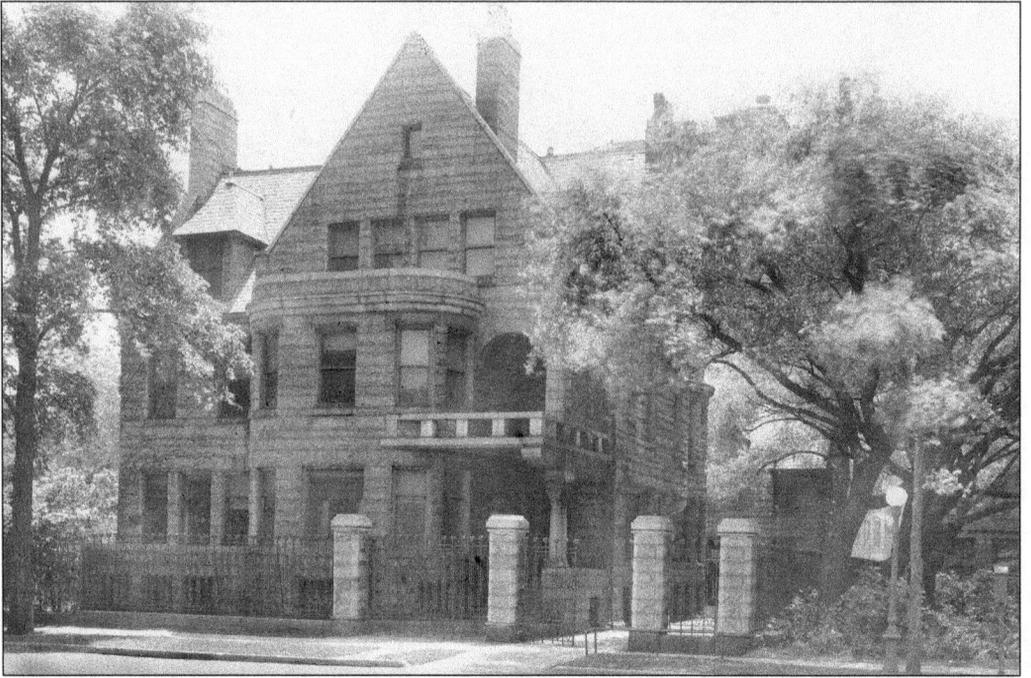

Built in 1892 by the architectural firm Treat & Flotz at 61 East Goethe Street, this was the stone residence of William J. Goudy (1864–1894). His son W.J. Goudy Jr. owned the home across the street at 1300 North Astor Street, situated between 1260 and 1301 North Astor Street cooperative apartments. It was demolished in 1962 to make way for the construction of Astor Towers, which now has the same address: 1300 North Astor Street.

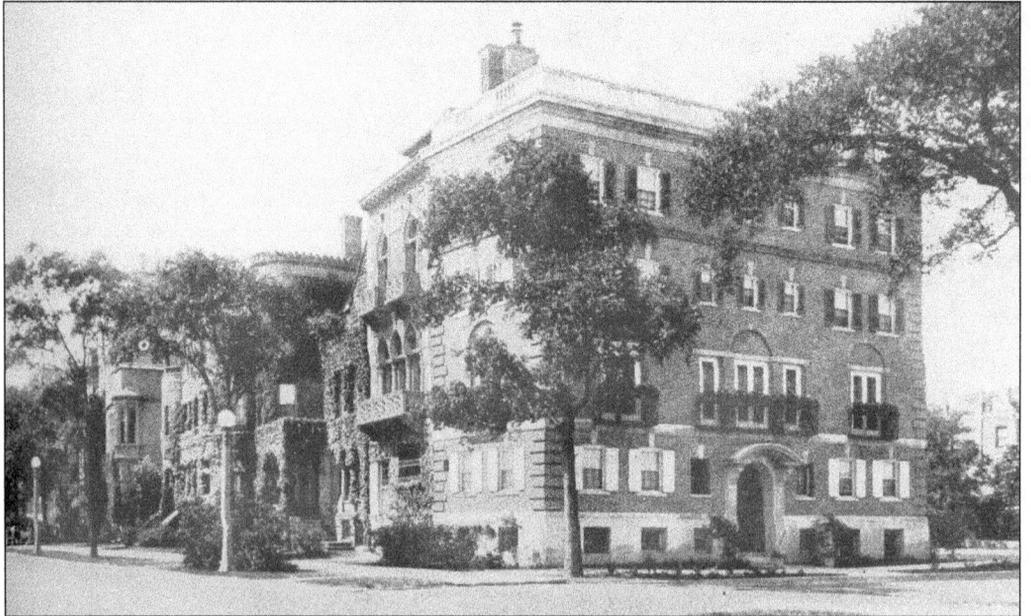

This Classical Revival home, built in 1911 for Lawrence D. Rockwell, is located at 1260 North Lake Shore Drive. It is one of the seven remaining mansions on this street. Although it has a Lake Shore Drive address, the entrance is located on Goethe Street.

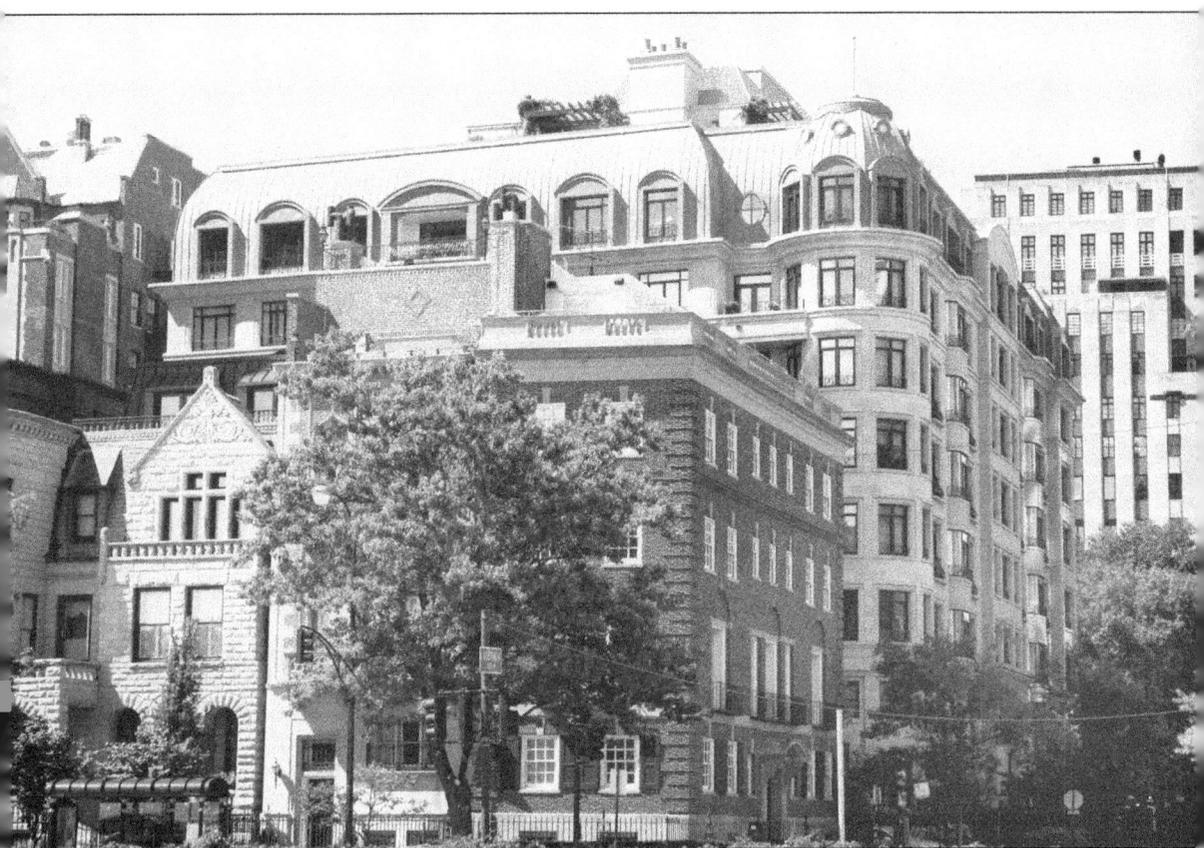

This photograph, taken in 2011, shows the perfect mixture of architecture found in the Gold Coast: late-19th-century buildings surrounded by 20th- and 21st-century buildings.

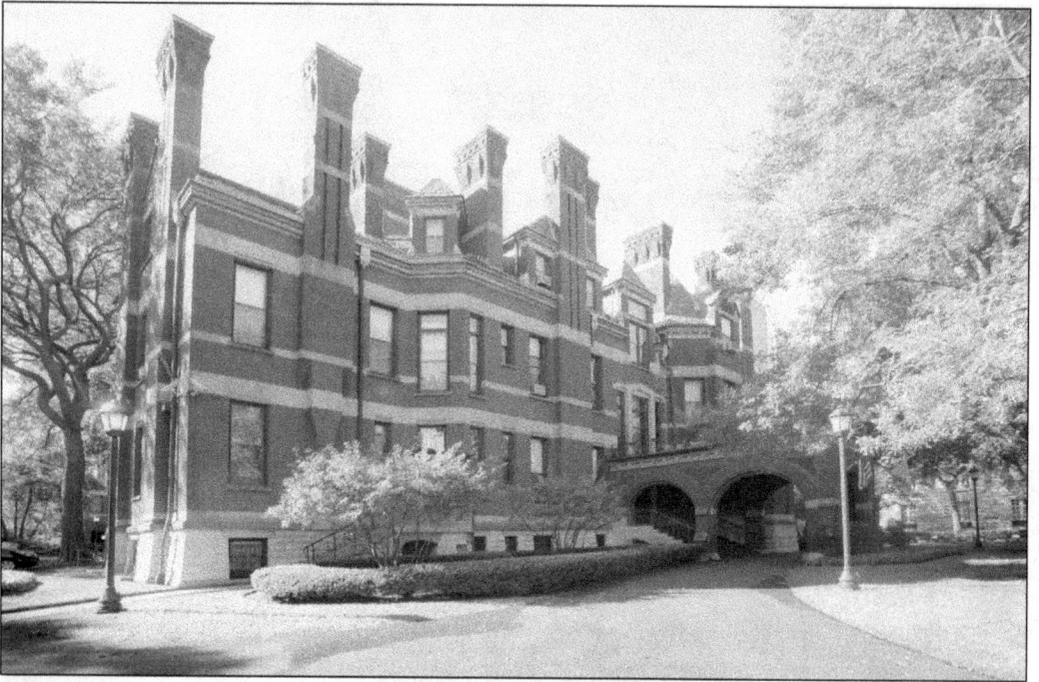

This Queen Anne mansion is the residence of Cardinal Francis George, who has lived here since 1997. It was designed by Alfred F. Pashley and Maj. James H. Willet in 1885. It takes up an entire city block; there are 19 chimneys. Some of the world's greatest leaders have visited this home, including Pres. Franklin D. Roosevelt and several popes.

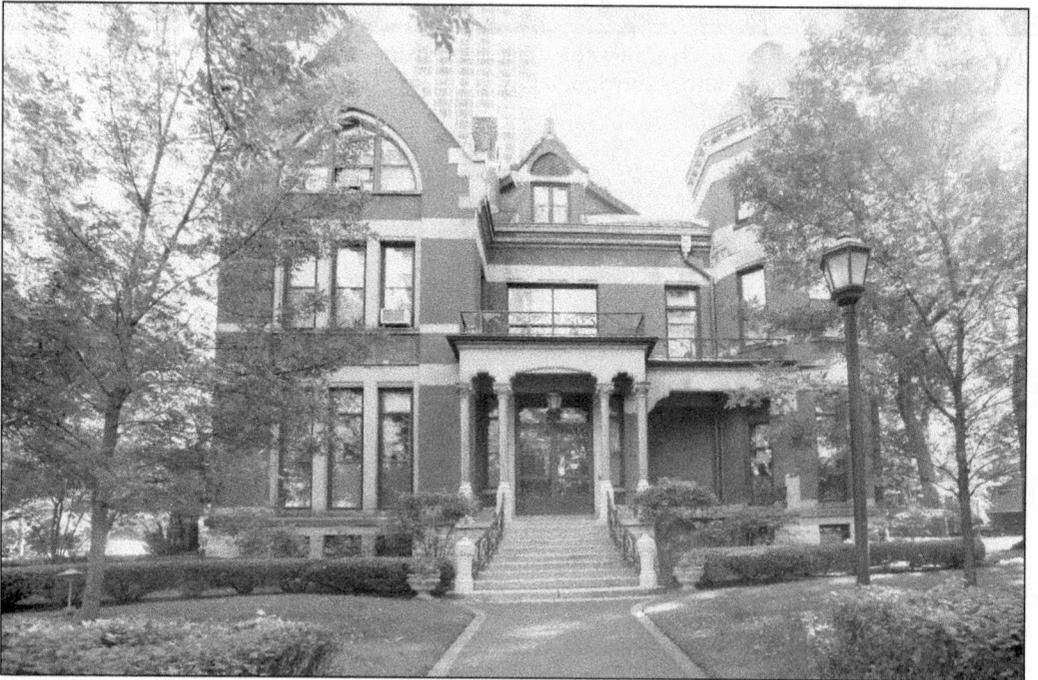

This is the main entrance of the home, which is situated at 1555 North State Parkway on the southeast corner of State Parkway and North Avenue. It is one of the oldest homes in the Gold Coast.

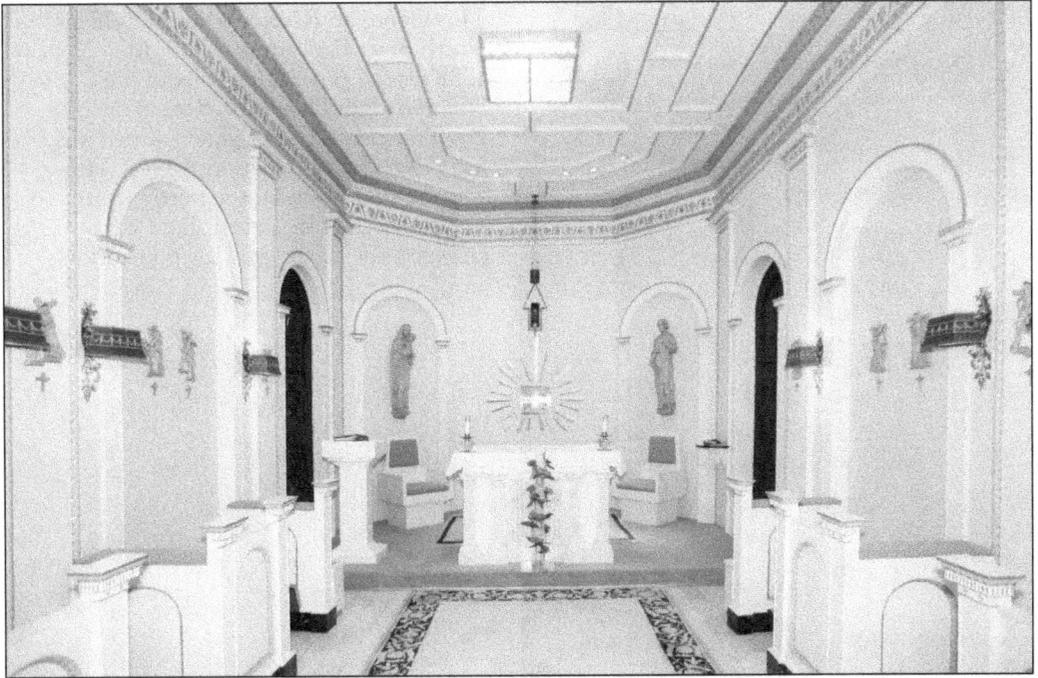

Among the numerous sitting rooms, this small chapel is also located inside of the cardinal's mansion.

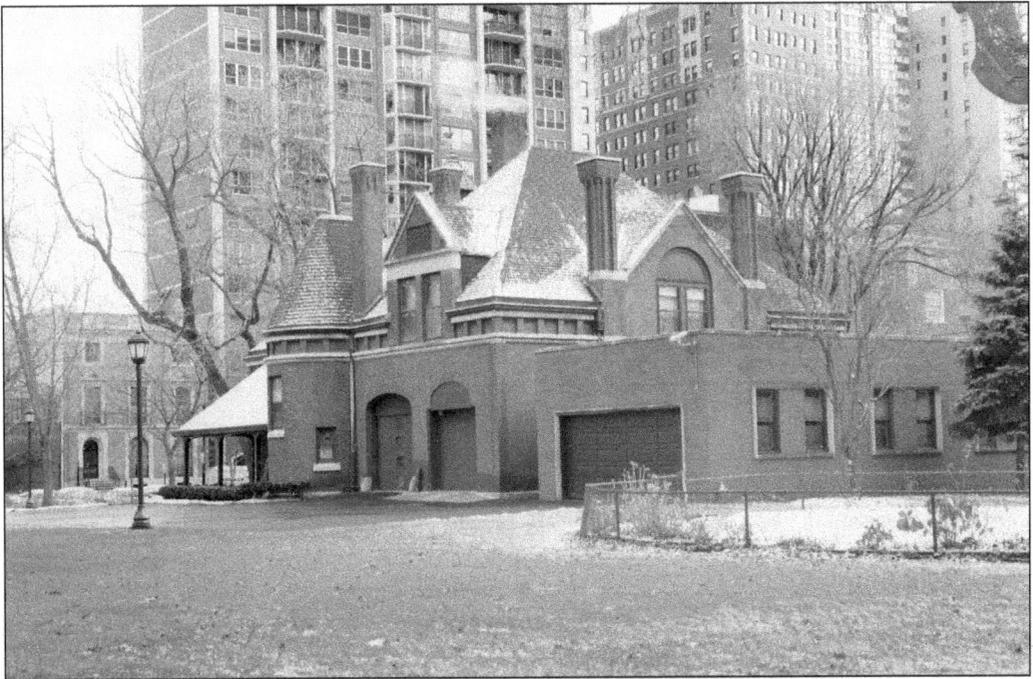

This two-story Queen Anne carriage house, located behind the Cardinal's Residence, was also designed by architects Alfred F. Pashley and Maj. James H. Willet.

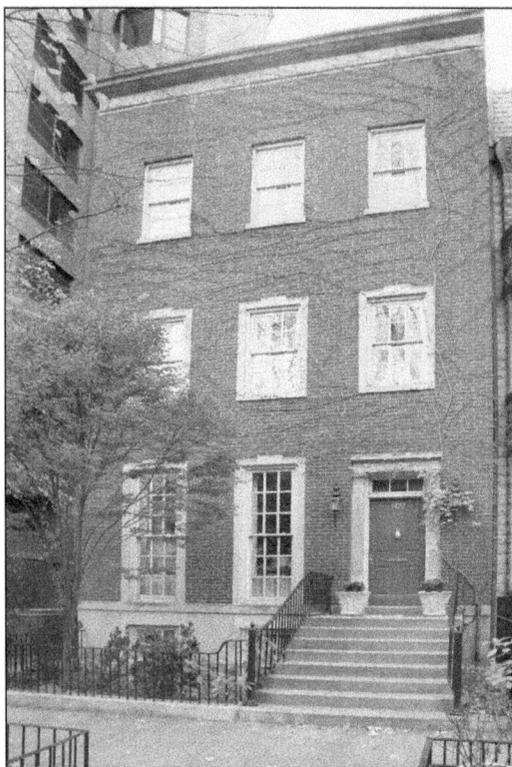

This Georgian Revival home at 1422 North State Parkway was built in 1885 for the general manager of the Fireman's Fund Insurance Company of San Francisco. The original address was 535 North State Street until 1909. This was the year when all the north–south street addresses in Chicagoland were changed due to the growing population.

Current homeowners Peggy and Richard Schulze purchased this home in 1988 and renovated it. When the garage was under construction, a concrete box containing human bones over 100 years old was unearthed. This discovery confirmed that a large part of the Gold Coast was once a cemetery.

This home was built for Frank W. Stanley, president of H.P. Stanley Company. This Romanesque structure once stood on the southeast corner of State Street and Burton Place. Stanley's home was torn down to make room for a luxury high-rise condominium complex.

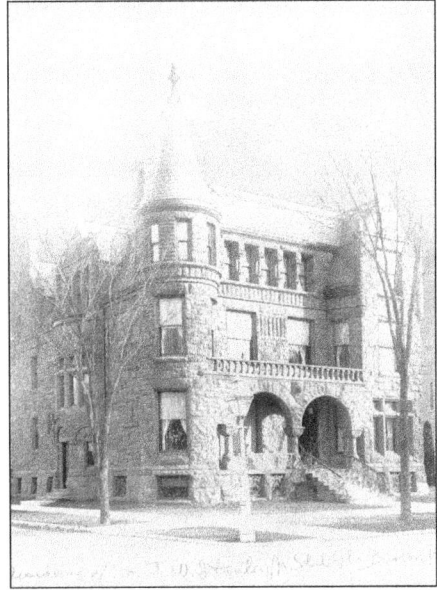

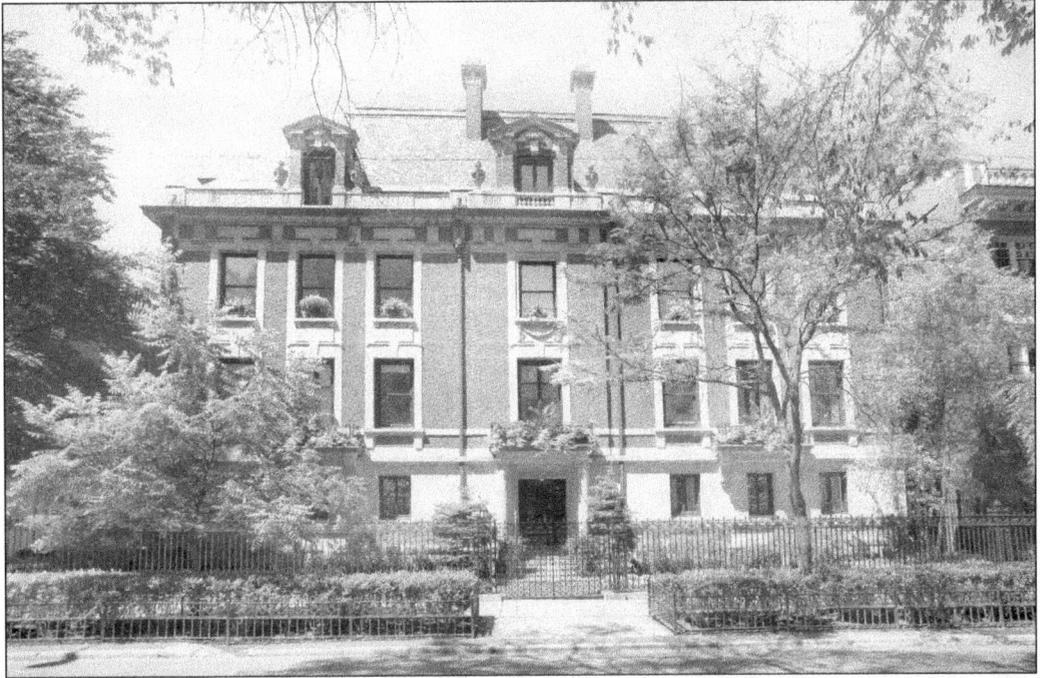

Located at 1340 N. State Parkway, this once 70-room, single-family home was built in 1899 by architect James Gamble Rogers (1867–1947) for wealthy Chicago physician George Snow Isham (1859–1926). Second only to the archbishop's residence, this French Renaissance mansion is one of the most popular homes in Chicago. In 1959, it was purchased by Playboy Enterprises founder Hugh Hefner. He turned it into the popular Playboy Mansion. Outside on the front door, a brass plate hung on the door with the Latin phase, "*Is Non Oscillas, Noli Tintinnare,*" meaning, "If you don't swing, don't ring." In 1974, Hefner decided to spend all of his time at his other Playboy Mansion in California. He donated the Chicago mansion to the School of the Art Institute of Chicago. In 1993, the property was sold to a developer and converted into seven condos.

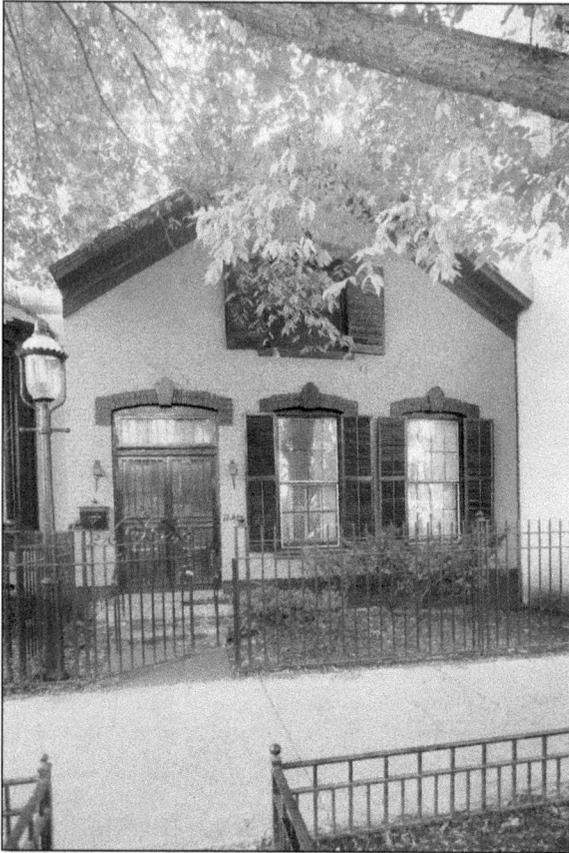

It is rumored this modest home at 1241 North State Parkway was built before the Chicago Fire of 1871. It is a single-family residence containing one bedroom and about 1,000 square feet of living space.

This property at 120 East Bellevue Place is a Georgian Revival mansion containing 23 rooms. It was designed by the architectural firm McKim, Mead & White and built for trustee of the Art Institute of Chicago Bryan Lathrop (1844–1916) in 1892. In 1922, it became the home of a women's literary club, the Fortnightly of Chicago. Bertha Palmer was an active member of this club.

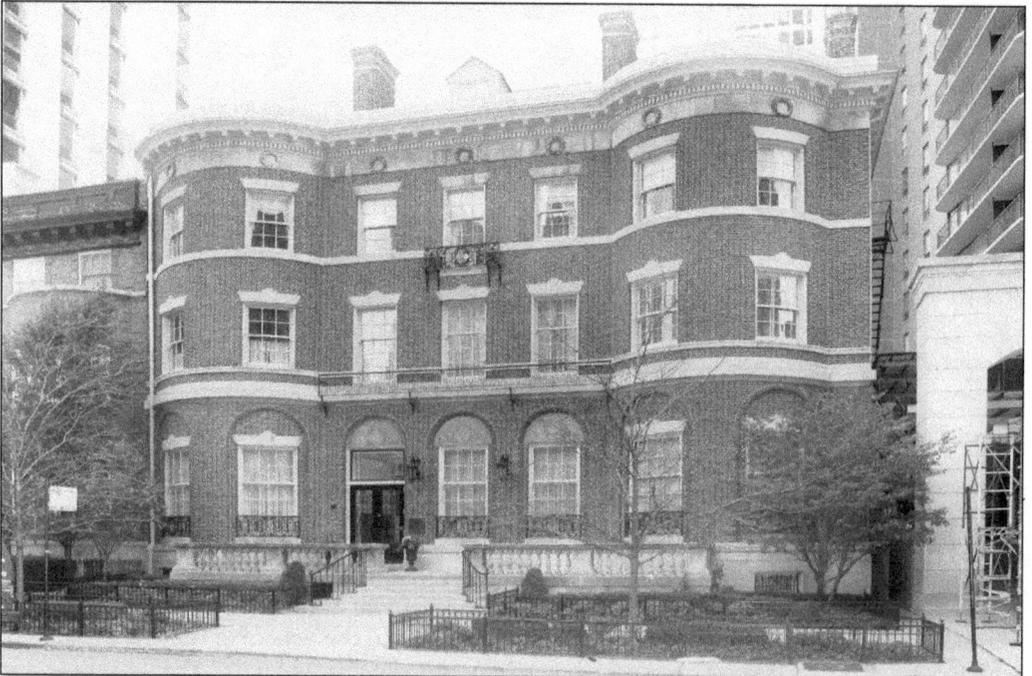

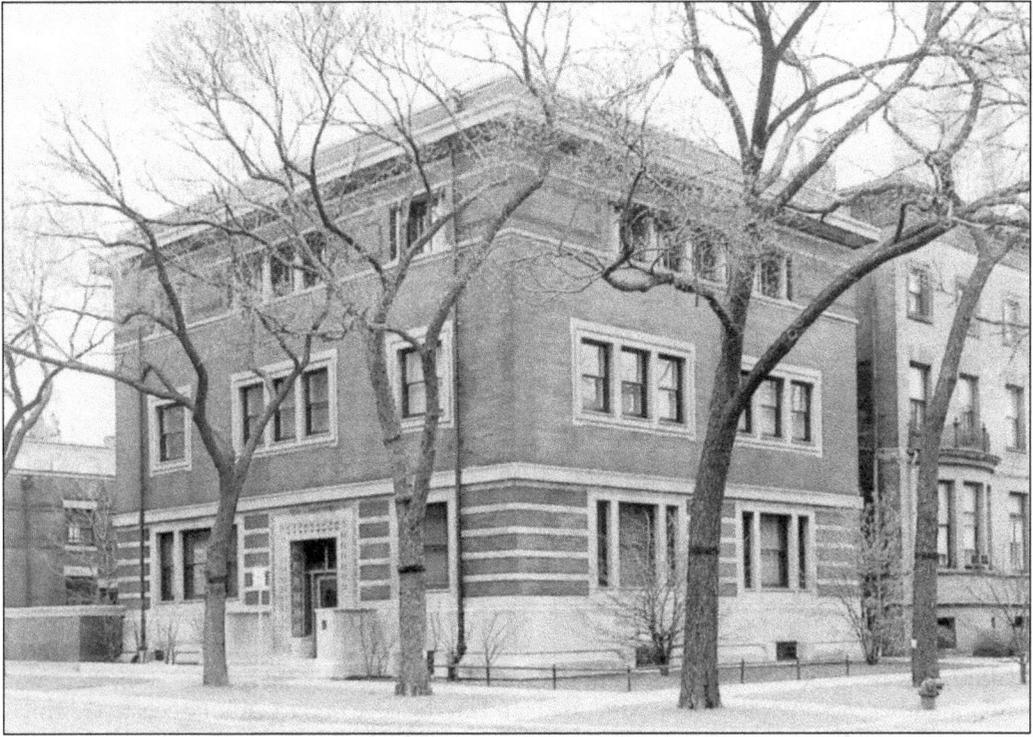

This home, an excellent example of Prairie School architecture, was designed and built by Richard Ernest Schmidt and Hugh Mackie Gordon Garden in 1902 for successful liquor wholesaler Albert Fridoline Madlener (1868–1947). In 1964, after a complete restoration, it became the home of the Graham Foundation for Advanced Studies in Fine Arts. In 1973, it was listed as a Chicago landmark; it is also listed in the National Register of Historic Places.

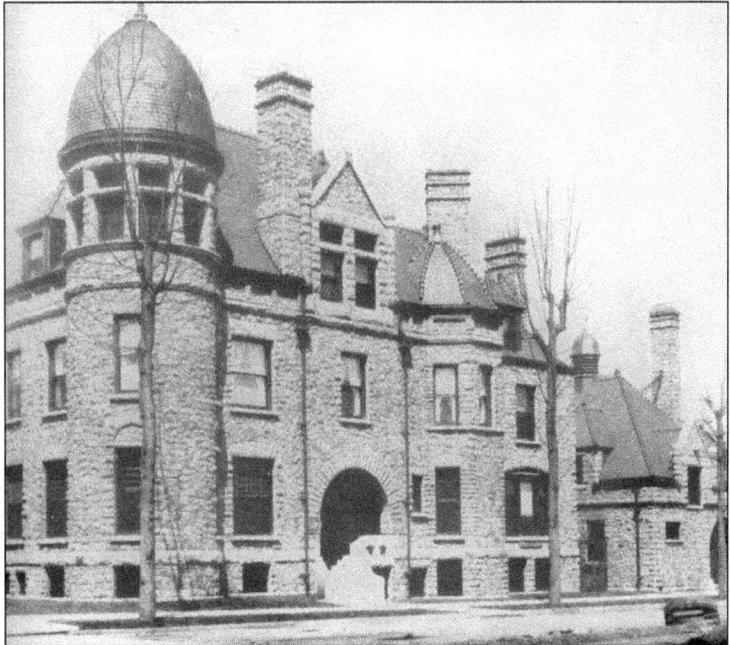

One of the most impressive homes built in the Gold Coast was that of Edward Everett Ayer (1841–1927), one of the founders of the Field Museum of Natural History. This lost treasure was constructed by prominent architects Daniel H. Burnham and John Wellborn Root in 1885. It was demolished in 1965.

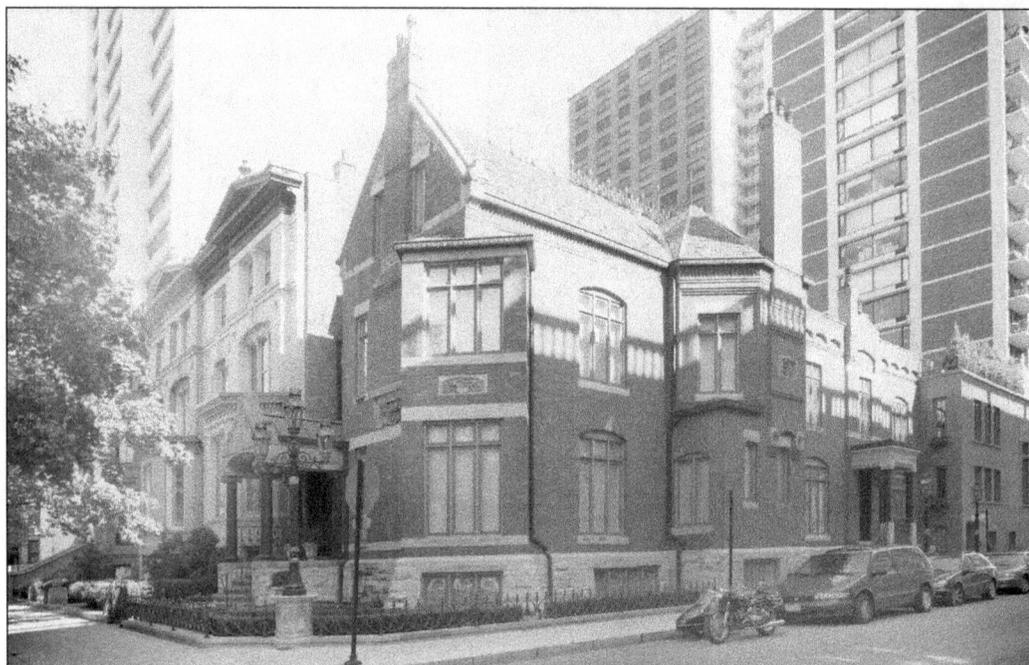

In 1887, this home at 1401 North Dearborn Street was designed by architect Asa Lyon. It was built for Luther McConnell after he purchased land on the edge of the Catholic cemetery, which took up much of the Gold Coast. He made his fortune working for the Marshall Field Company as the chief cashier.

This section of the home was constructed for Luther McConnell's daughter and her husband. When the home was purchased by the current owner, Richard Driehaus, he redesigned the space into an Art Deco–style room.

These two homes, located at 25 and 27 East Scott Street, are the homes of cosmetic entrepreneur Marilyn Miglin, built around 1878 by a German architect. The styles of the homes were modeled after row houses in London.

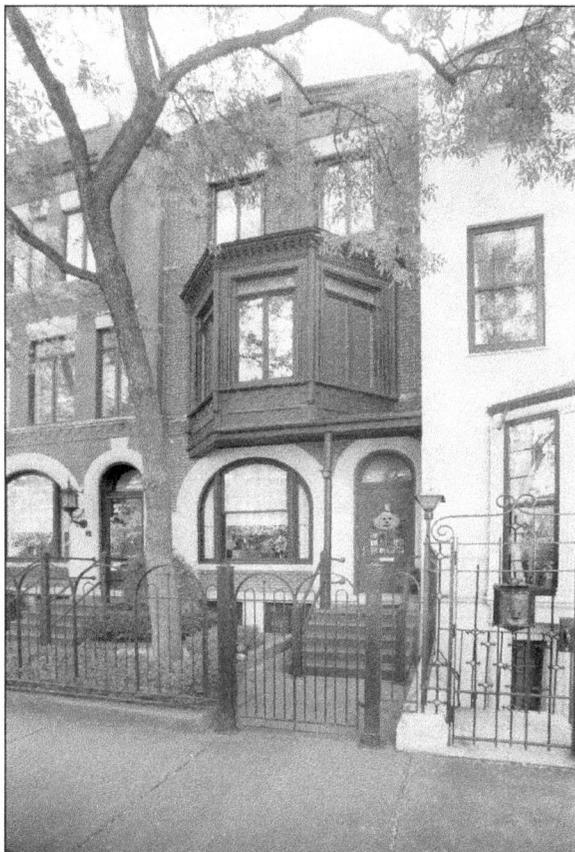

This is a rare photograph of Marilyn Miglin's living room inside of her 134-year-old townhome.

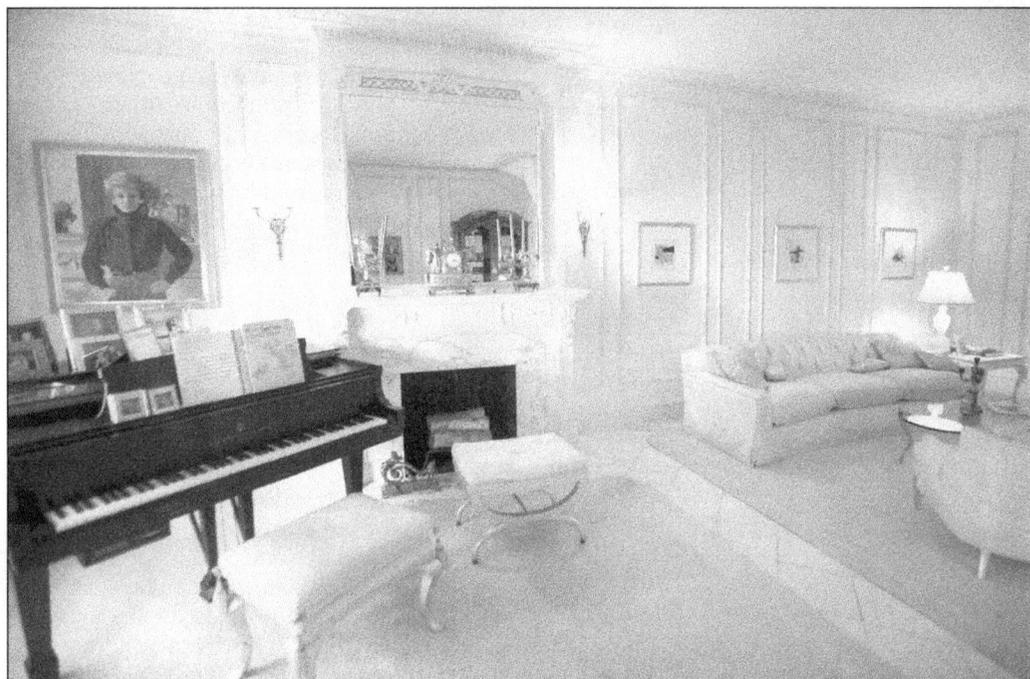

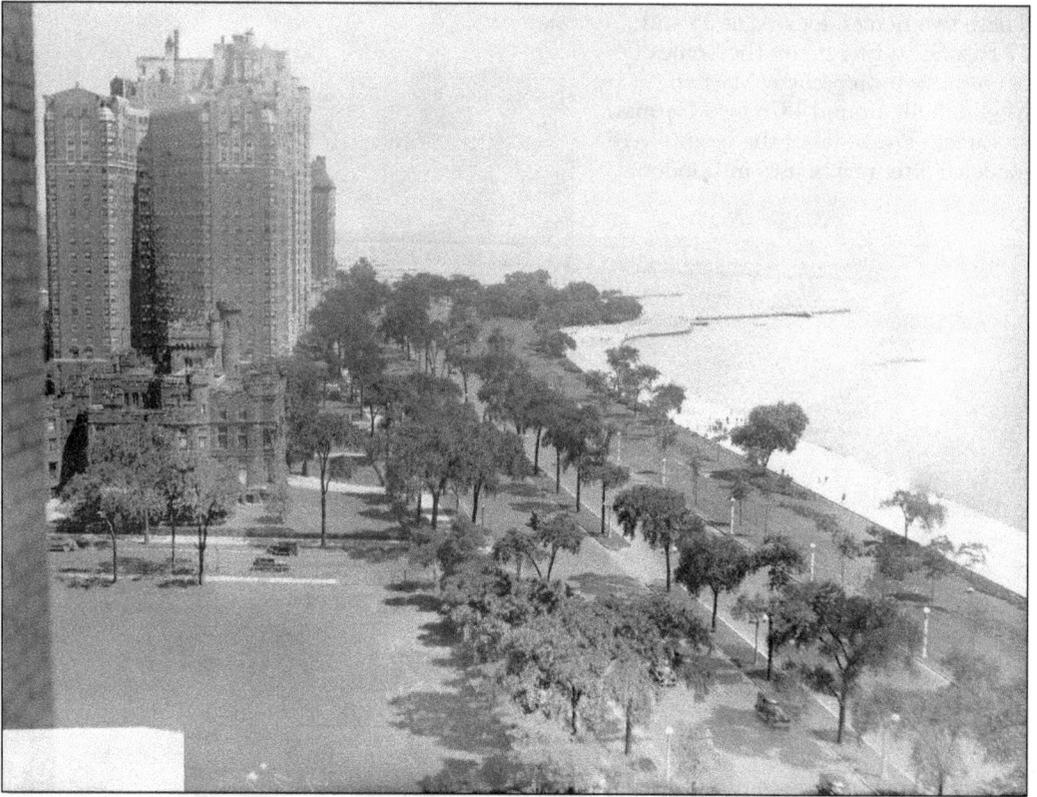

This is Potter Palmer's mansion facing north on Lake Shore Drive around the 1930s. Located on the next block, the 1400 North Lake Shore Drive massive apartment building now occupies the site of the Franklin MacVeah mansion. There are several other high-rise buildings north of the 1400 Lake Shore Drive apartments, and several of them replaced mansions along this street.

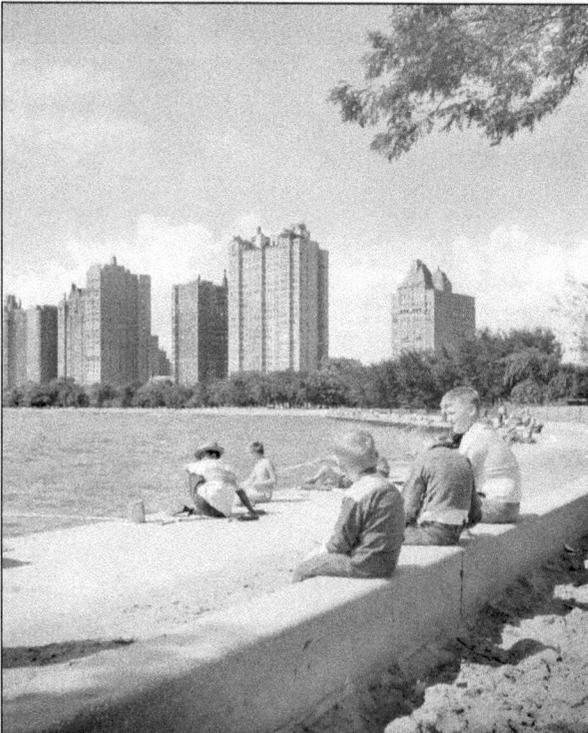

This 1950s photograph shows a completely different Gold Coast landscape as compared to what it looked like during the late 19th century. From left to right, starting at 1400 to 1540 North Lake Shore Drive, large apartment buildings were constructed close together.

Two

Making Room for More Neighbors
Cooperative Buildings, Condominiums, and Rental Apartments

During the early part of the 20th century, many of Gold Coast's grand mansions and elegant townhomes were torn down and replaced by high-rise apartment buildings. The neighborhood's signature streets, such as Lake Shore Drive, Astor Street, and State Parkway, changed their look forever.

One of the architects responsible for this transformation was Benjamin H. Marshall (1874–1944). Chicago's elite called him "the man whom builds mansions in the sky." In 1904, Marshall formed a partnership with architect Charles E. Fox (1879–1926), which lasted for 20 years. During this time together, they built some of Chicago's most luxurious properties, including hotels, banks, clubhouses, mansions, and apartment buildings.

One of the firm's prized pieces of work was the series of buildings located on East Lake Shore Drive. The Marshall & Fox architectural firm erected five of the eight properties: the Drake Hotel, which has an East Walton Address, Drake Tower at 179 East, the Breakers at 199 East, 209 East Lake Shore Drive Apartments, and Lake Shore Apartments at 999 North Lake Shore Drive. Today, on passing East Lake Shore Drive, people say, "This is the wall that Marshall built."

One of the firm's first apartment buildings was located at 1100 North Lake Shore Drive, which was constructed in 1905. Marshall & Fox understood what the wealthy wanted. All of the firm's apartment buildings included grand amenities, such as spacious floor plans that were usually designed as one apartment per floor, which was spacious like a mansion. Many of them contained large, formal rooms for entertaining, numerous bedrooms (some had more bathrooms than bedrooms), ample closets, and servants' quarters. And, one of the firm's signature marks, the floor plans were always written in French.

Marshall & Fox's apartment buildings were usually rented out first and then converted to cooperative apartments. Chicago's wealthy residents occupied these dwellings. Most came from the South Side elite neighborhoods such as Kenwood and Prairie Avenues.

This was the dawn of a new era, when it no longer made financial sense for the wealthy to purchase and try to maintain a 40-room city home. This new era brought about tighter immigration laws, as most servants were immigrants from Europe during this time. The US government passed the income tax law. By the 1920s, when these laws went into full effect, even the wealthy cut back. Many of them sold their large homes and moved into luxury apartment buildings.

57

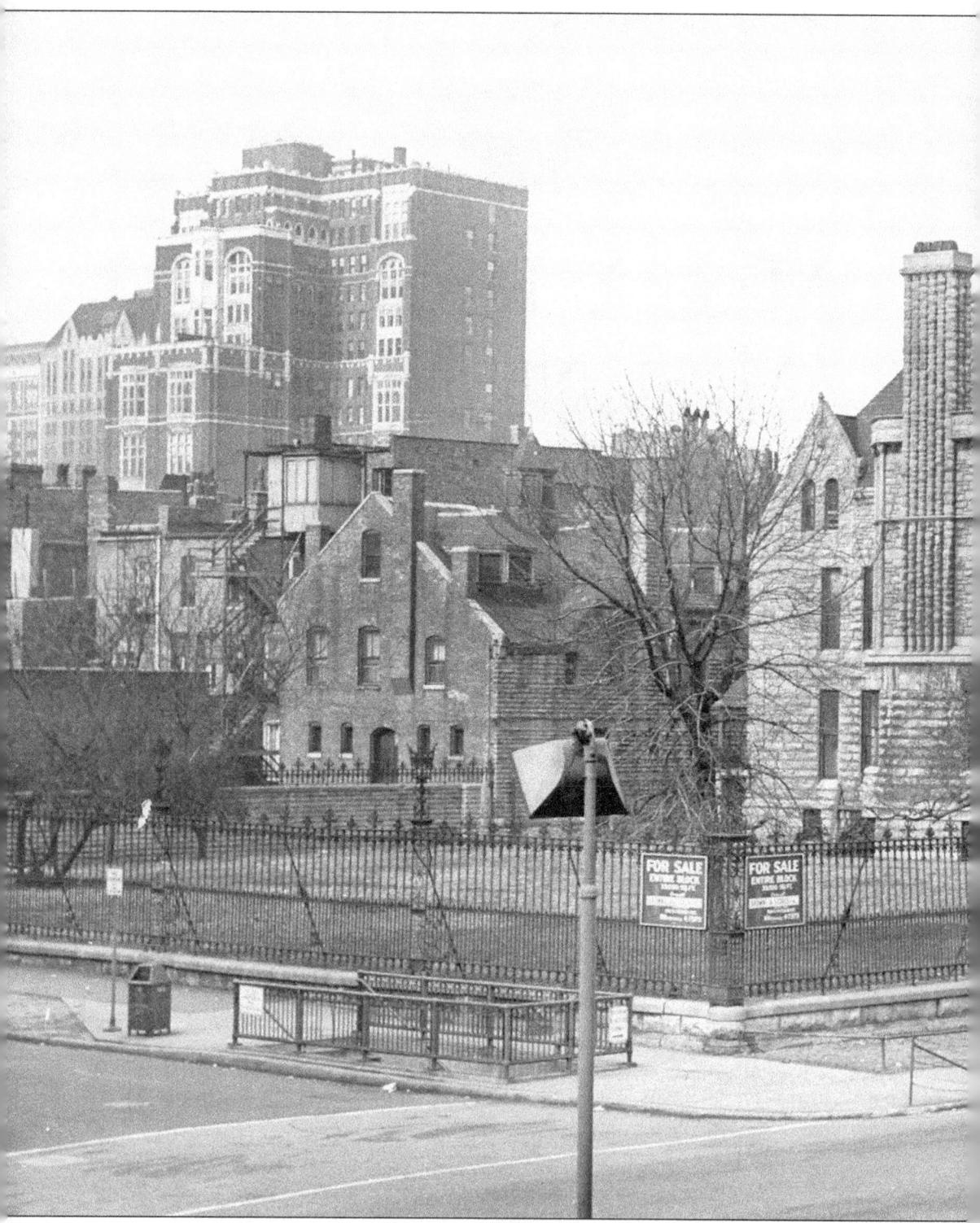

This photograph was taken in 1953 just days before the late Edith Rockefeller McCormick's mansion was to be demolished. The land was sold to a developer. Eventually, two high-rise apartments

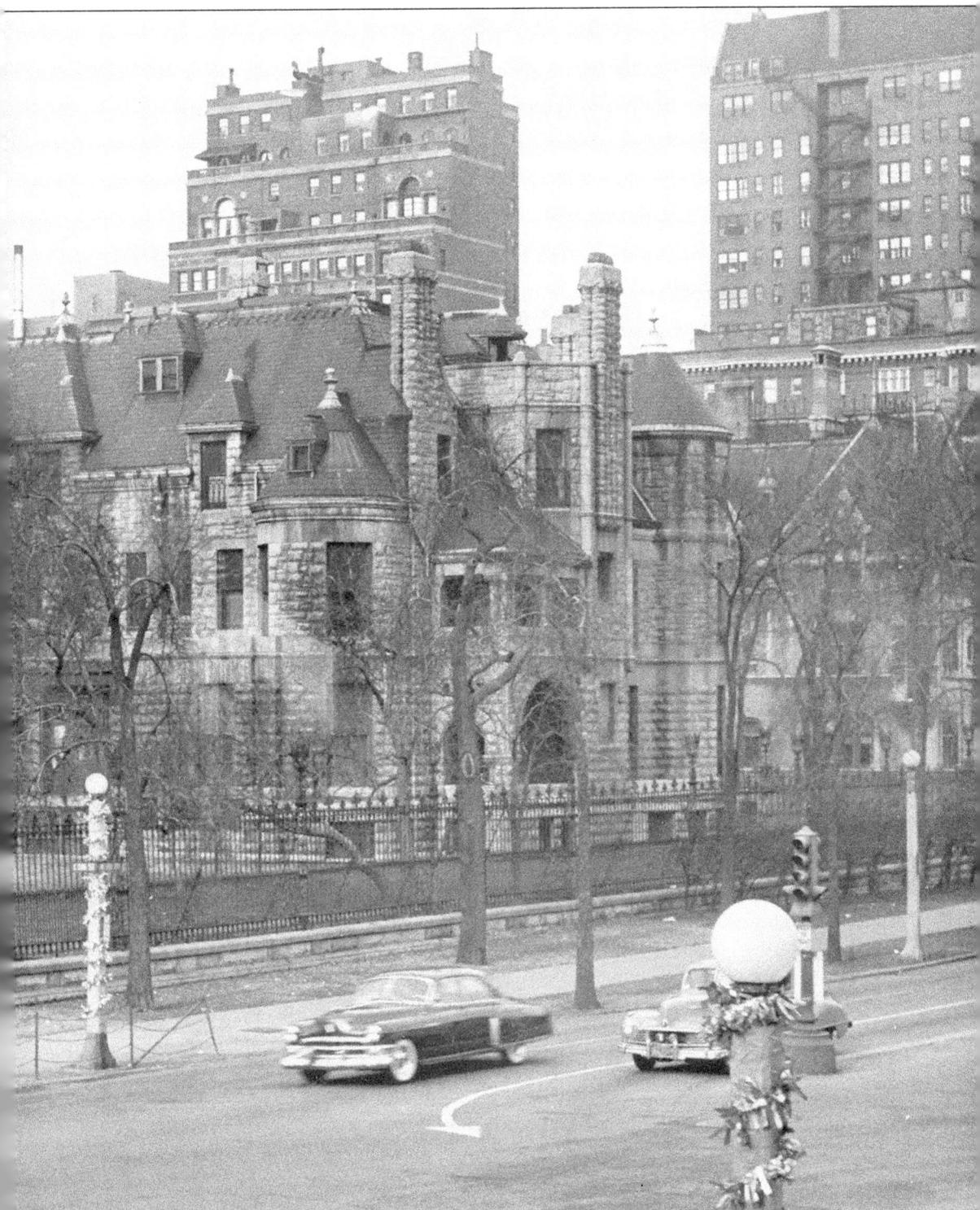

were built on this site. Note the "For Sale, Entire Block" sign on the fence.

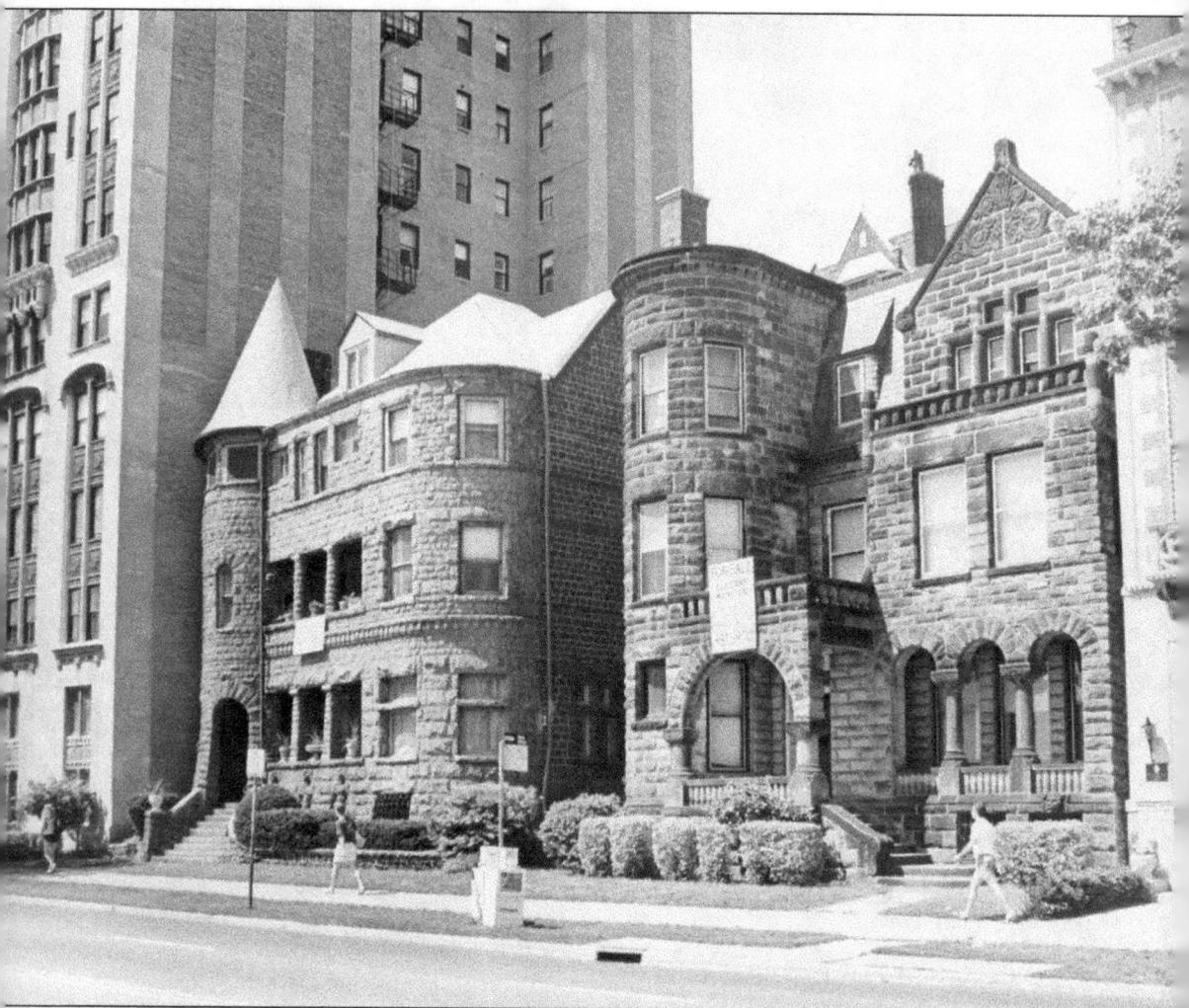

During the 1970s, the few remaining mansions located on Lake Shore Drive were at risk of being sold, torn down, and replaced by high-rise apartment buildings. Luckily, these two mansions with the posted "for sale" signs survived the wrecking ball and remain intact today. They are the former homes of Charles Constantine Heisen, located at 1250 North Lake Shore Drive, and Mason Brayman Starring, situated at 1254 North Lake Shore Drive.

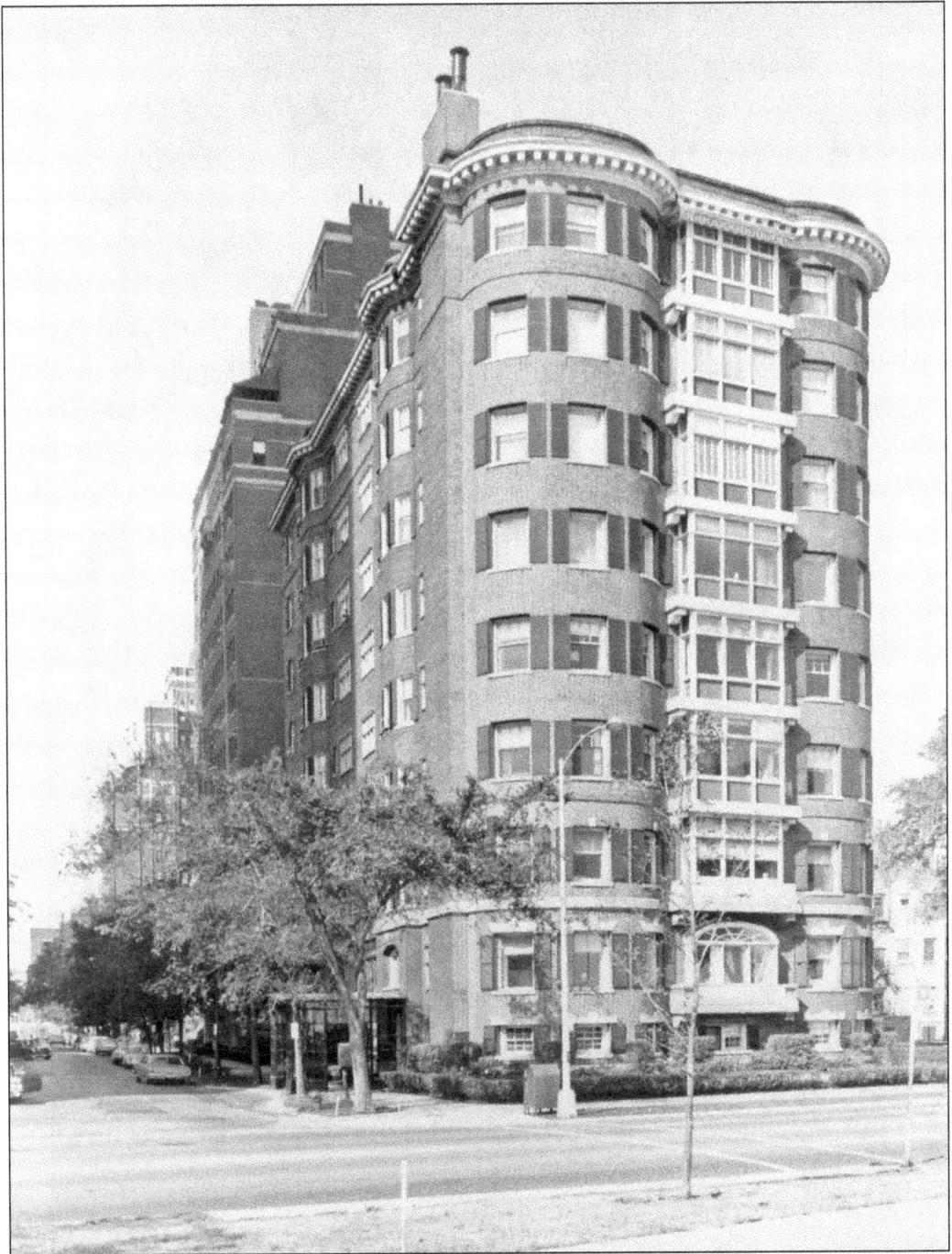

Considered one of Chicago's finest luxury apartment buildings, the Marshall Apartments, built in 1905 by the architectural firm Marshall & Fox, were located at 1100 North Lake Shore Drive. Each floor contained one apartment, a huge reception hall, four spacious bedrooms, five bathrooms, a solarium, gigantic living room, and separate dining room. Although it was converted to a cooperative apartment building, sadly, it was torn down. Now, a 40-story condominium occupies the property.

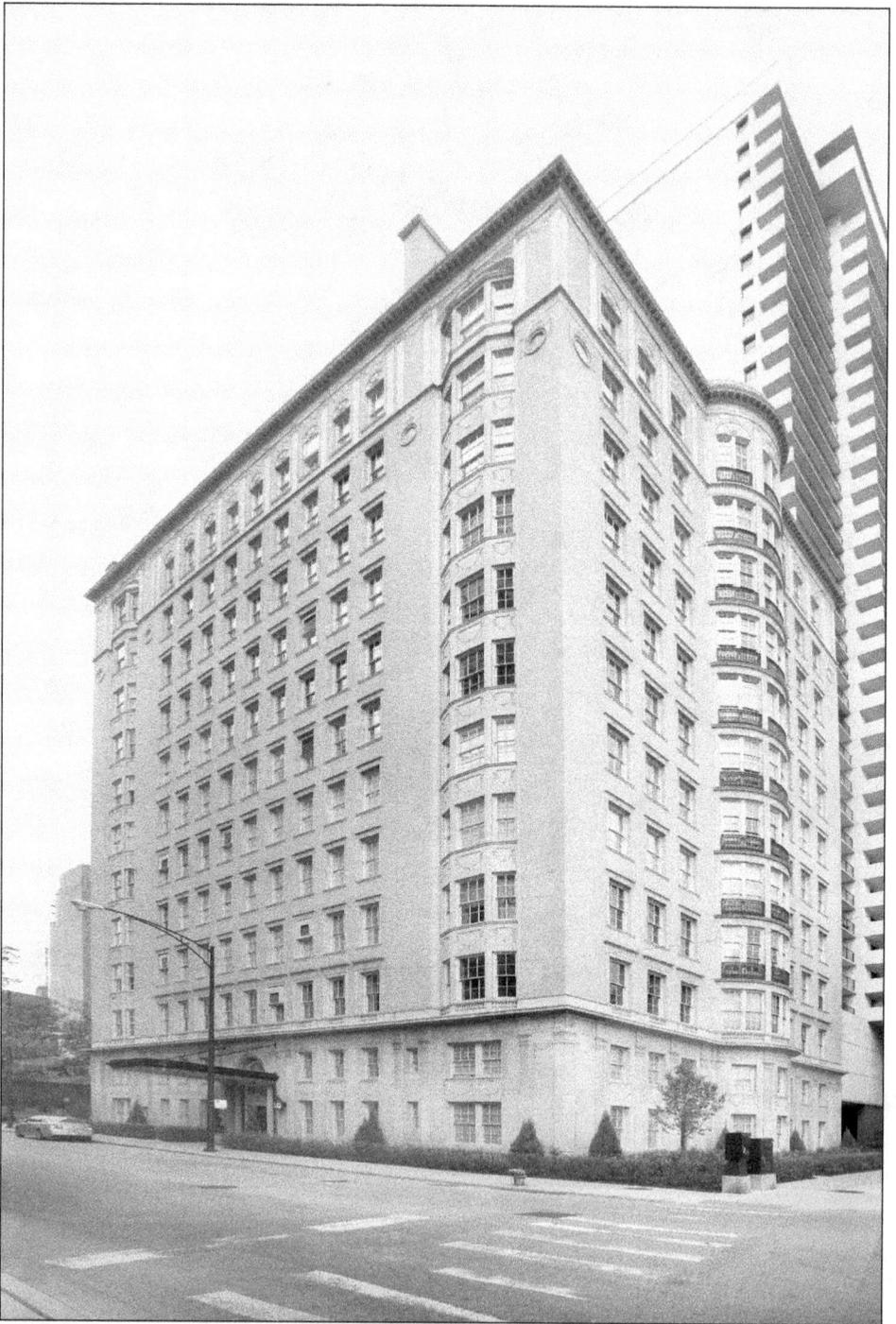

This 12-story building, located at 1200 North Lake Shore Drive, is another excellent example of the Marshall & Fox firm's luxury apartment houses. It is called 1200 Lake Shore Drive, which was designed to accommodate just 10 families. The first two floors were servants' quarters, and the top floors were designed for playrooms and additional staff. Within each apartment, there were also four to five servants' rooms.

The main entrance door of 1200 Lake Shore Drive is located on Division Street. Like most luxury apartment buildings on Lake Shore Drive, the main entrance was situated on a side street. Over the years, this once one-apartment-per-floor structure has been divided into smaller units.

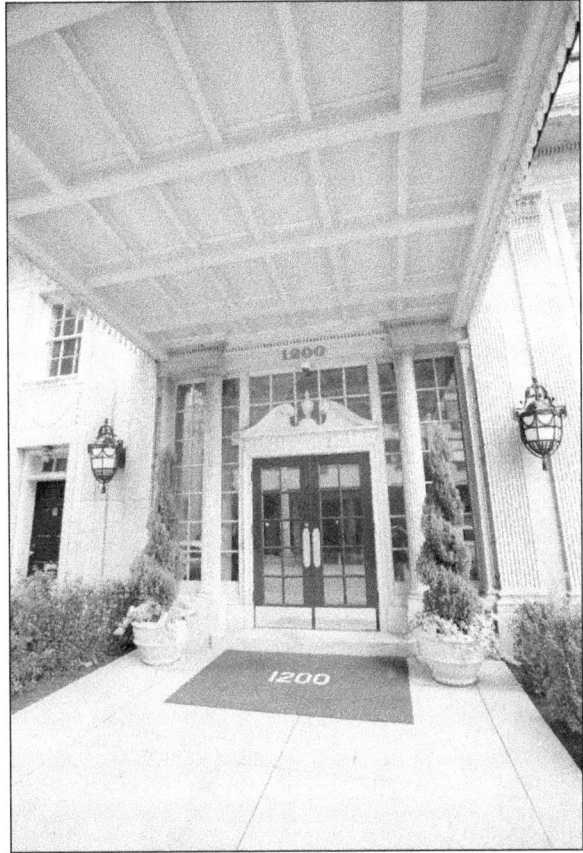

Here is the receiving room of 1200 Lake Shore Drive. Recently, the exterior and interior common rooms underwent an extensive renovation. Many of the architectural details look as elegant as they were over 100 years ago. Although the apartments have been divided over the years, this structure remains one of Chicago's most elegant cooperative buildings.

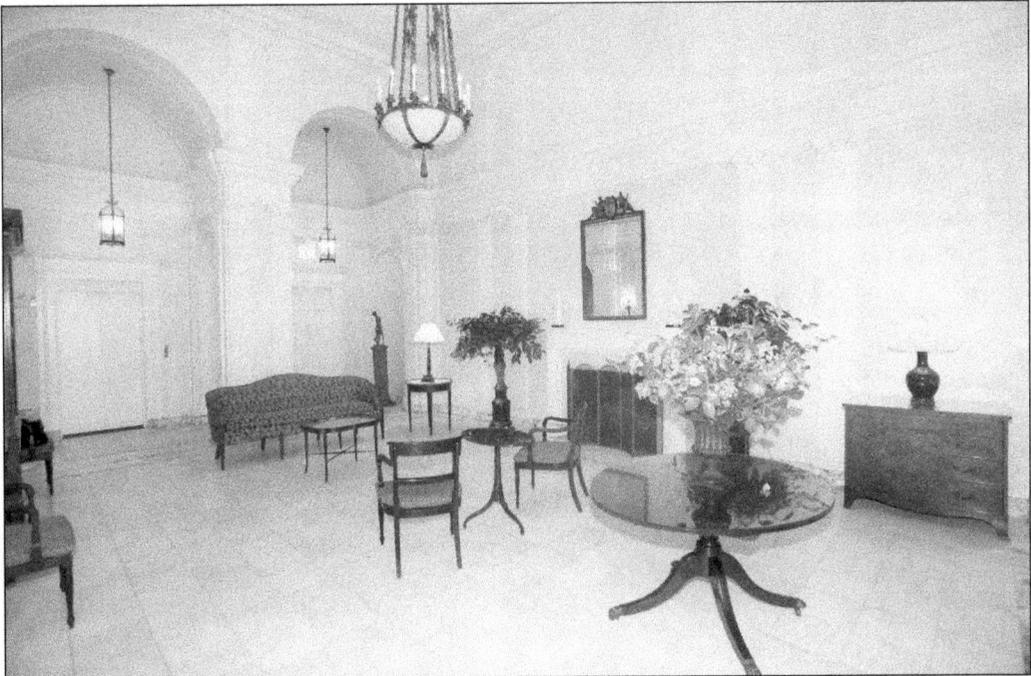

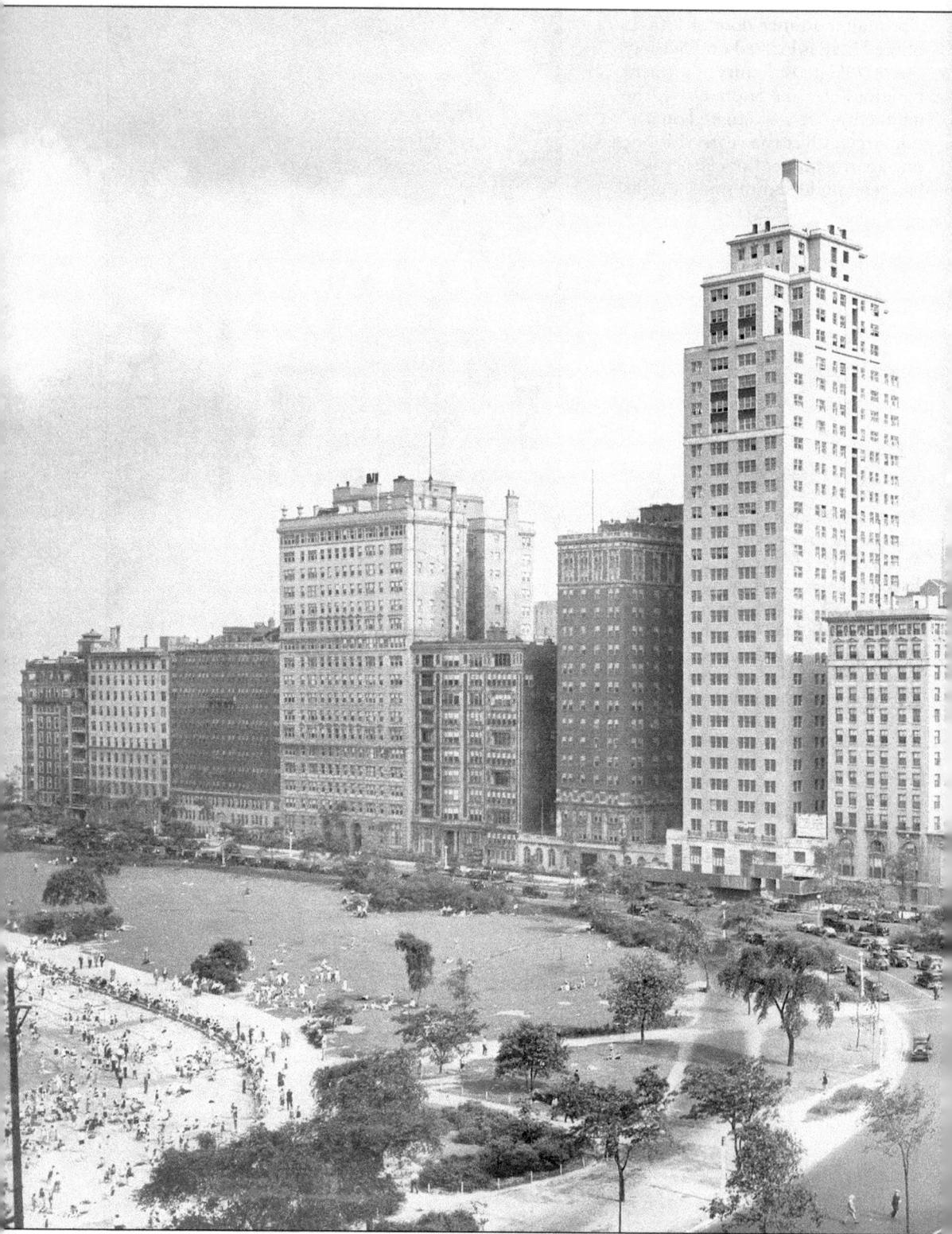

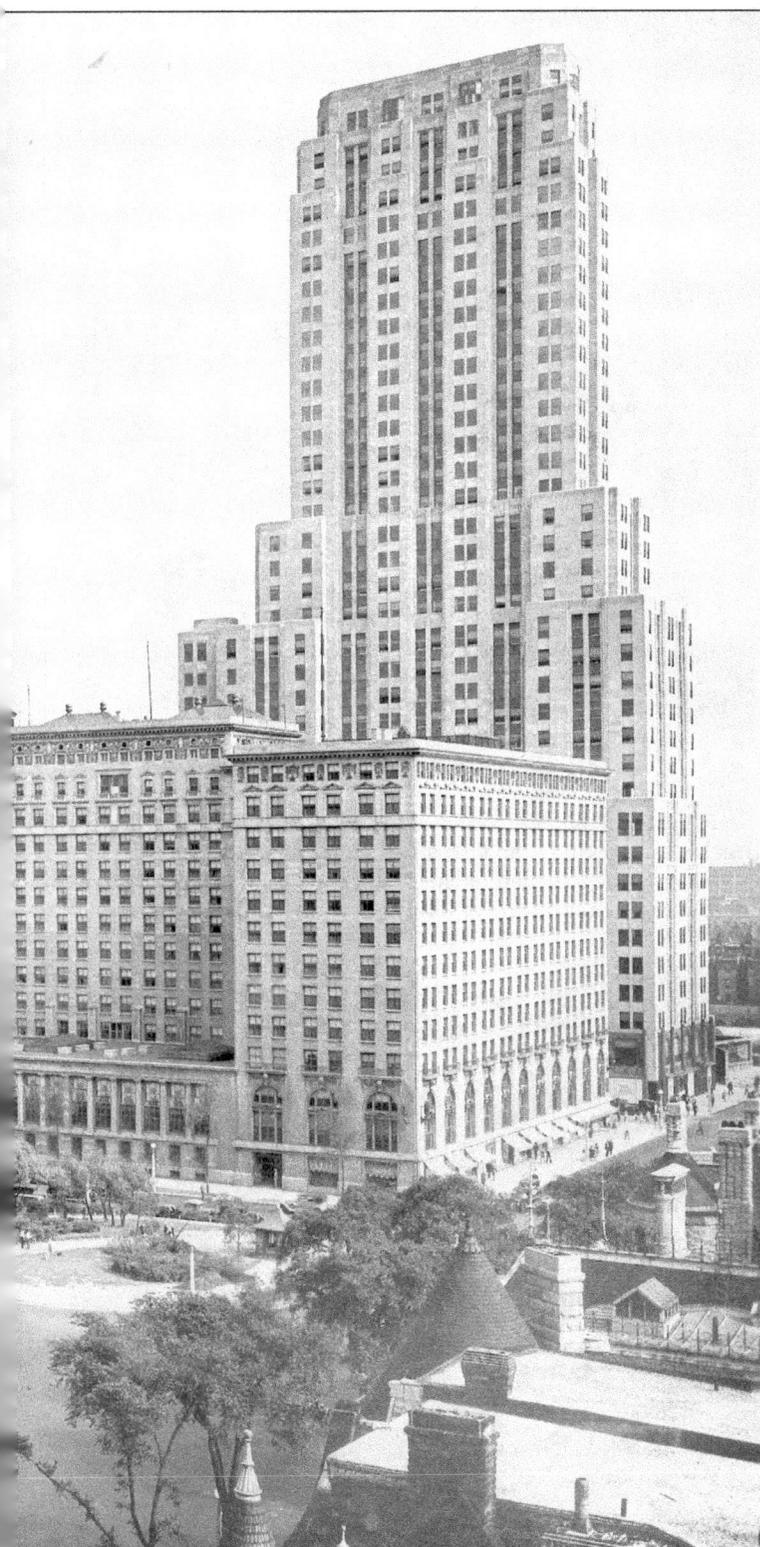

This is East Lake Shore Drive, known as "the wall that Benjamin Marshall built." This 1920s photograph shows that Oak Street Beach was just as popular nearly 100 years ago as it is today.

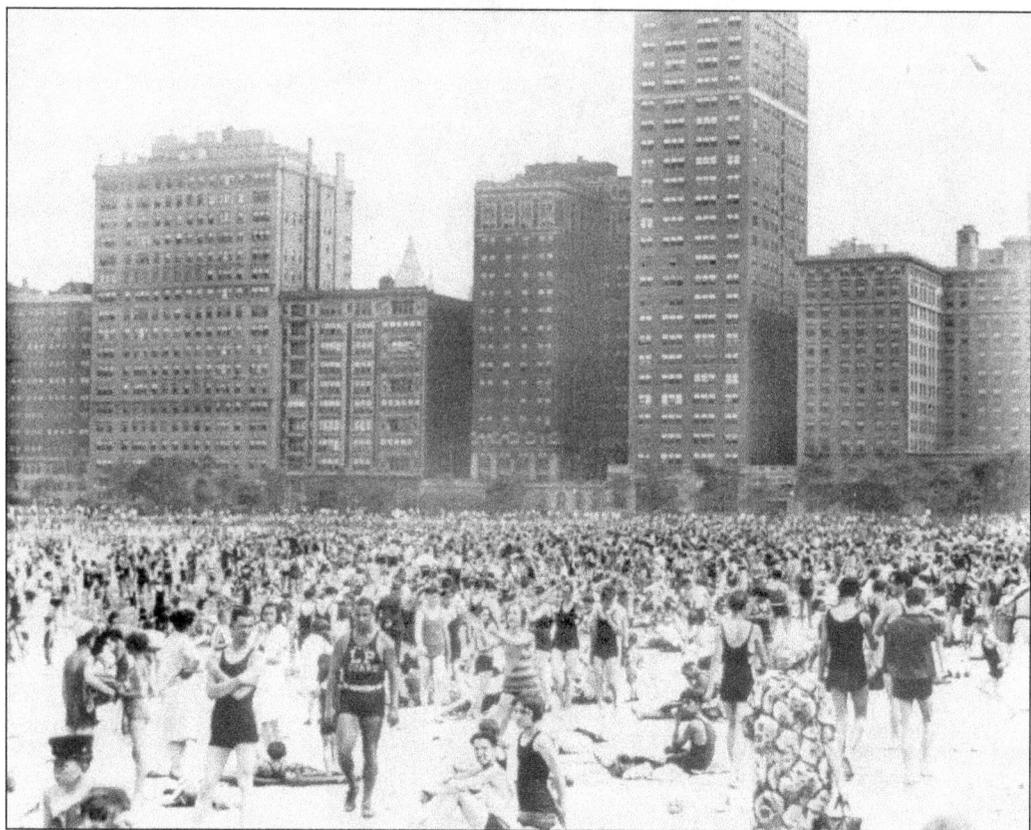

Here are two busy Oak Street Beach scenes taking from virtually the same angle, yet decades apart. The photograph above was taken during the first half of the 20th century, and the one below is from the 1960s. Today, Oak Street Beach remains one of Chicago's most popular beaches.

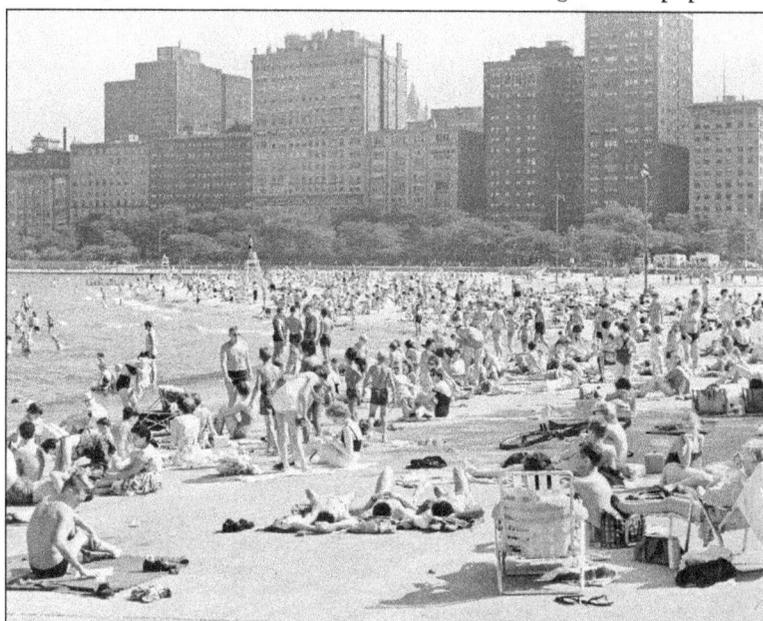

Drake Tower, located at 179 East Lake Shore Drive, was built by Marshall & Fox between 1928 and 1931. Residents of Drake Tower had access to all the services and amenities offered by a hotel; in this case, the services and amenities matched that of neighboring Drake Hotel, also constructed by Marshall & Fox. Even today, this concept is practiced by luxury hotels and condominiums, including two of Chicago's own, the Ritz-Carlton and Four Seasons Hotels.

The Drake Tower was originally designed to accommodate one apartment per floor. Today, it contains 66 apartments with as many as three 4-room units per floor.

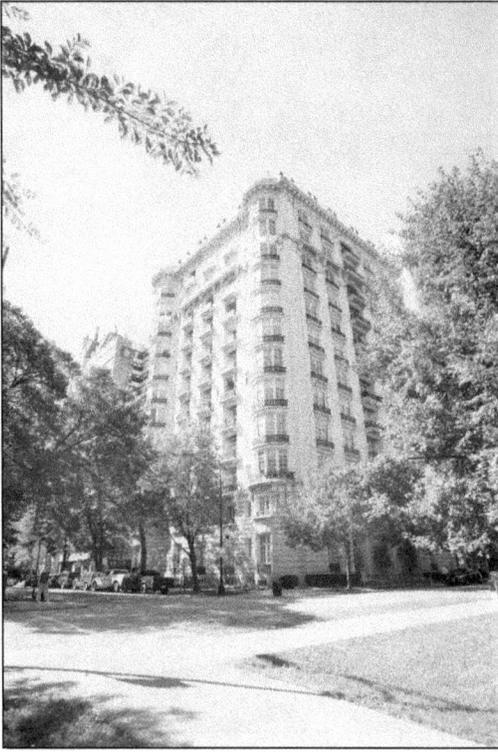

This apartment complex at 1550 North State Parkway was also designed by Marshall & Fox. Although it is over 100 years old, this French-inspired, terra-cotta building is considered one of the most beautiful in the Gold Coast. Originally, it was designed as one apartment per floor, containing more than a whopping 8,000 square feet and at least 20 rooms. From its construction in 1913 to today, some of Chicago's most prominent residents have lived here. Several of Marshall & Fox's designs, including 1550 North State Parkway apartments, were broken up into smaller units. This building remains a cooperative today.

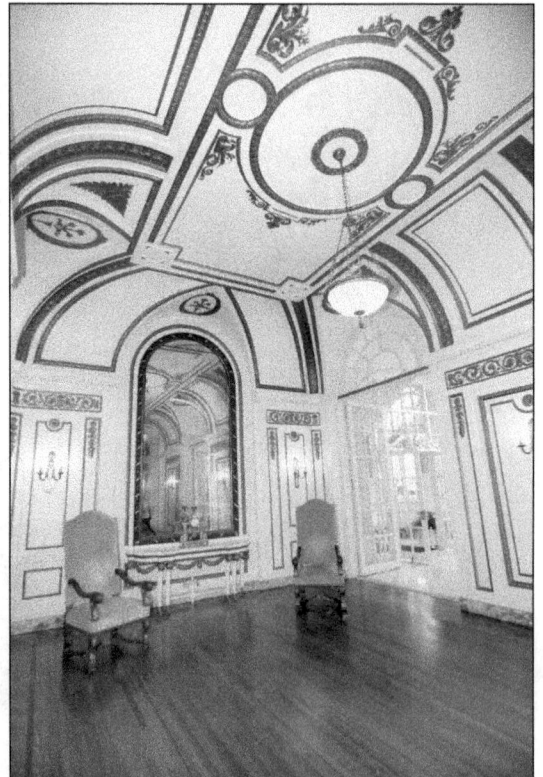

Pictured here is one of the public rooms inside of 1550 North State Parkway. The walls and ceiling show gilt work and French mirrors and doors.

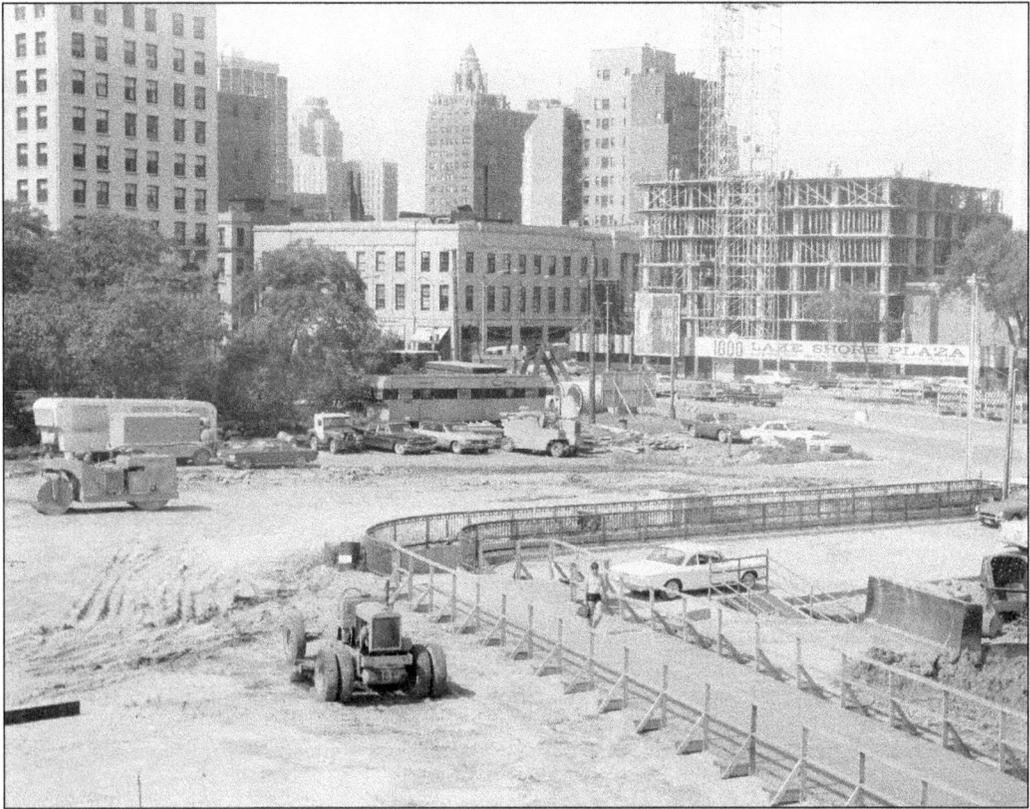

This 1960s photograph shows the construction site of the 1000 North Lake Shore Plaza apartment buildings. This was the site occupied by Edith Rockefeller McCormick's mansions. Also seen is the construction entrance of Lake Shore Drive Expressway at Oak Street and Lake Shore Drive.

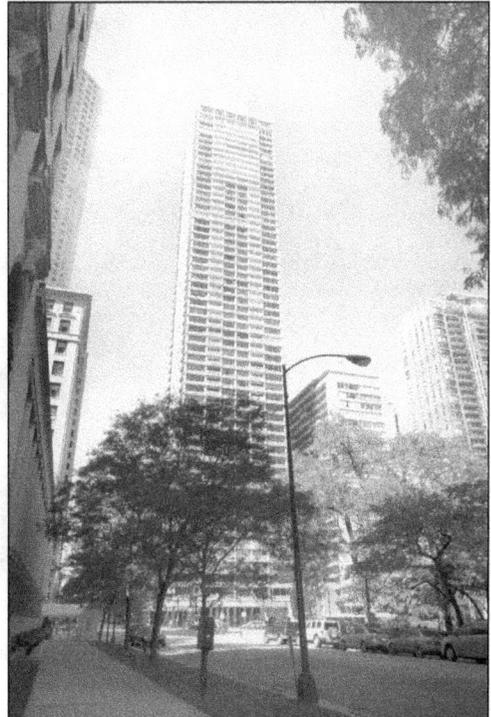

Here are both buildings, which share similar address names. The taller one on the left is called 1000 Lake Shore Plaza, erected in 1964, and the shorter one on the right is called 1000 Lake Shore Drive, built in 1953. Both buildings are condominiums.

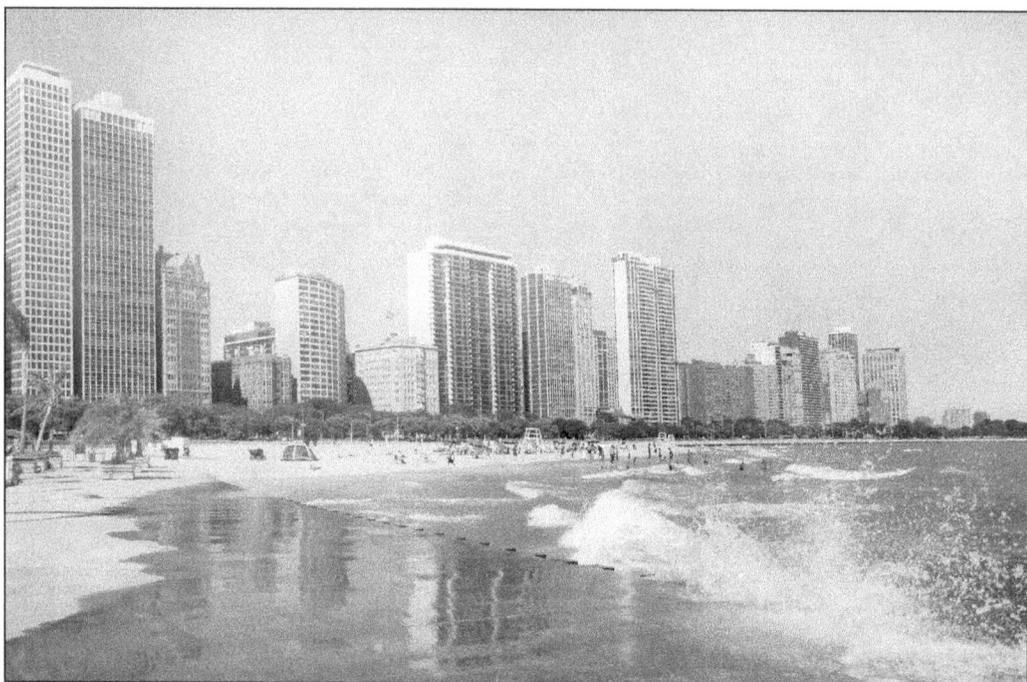

Here is Oak Street Beach and North Lake Shore Drive. This photograph was taken in the summer of 2011.

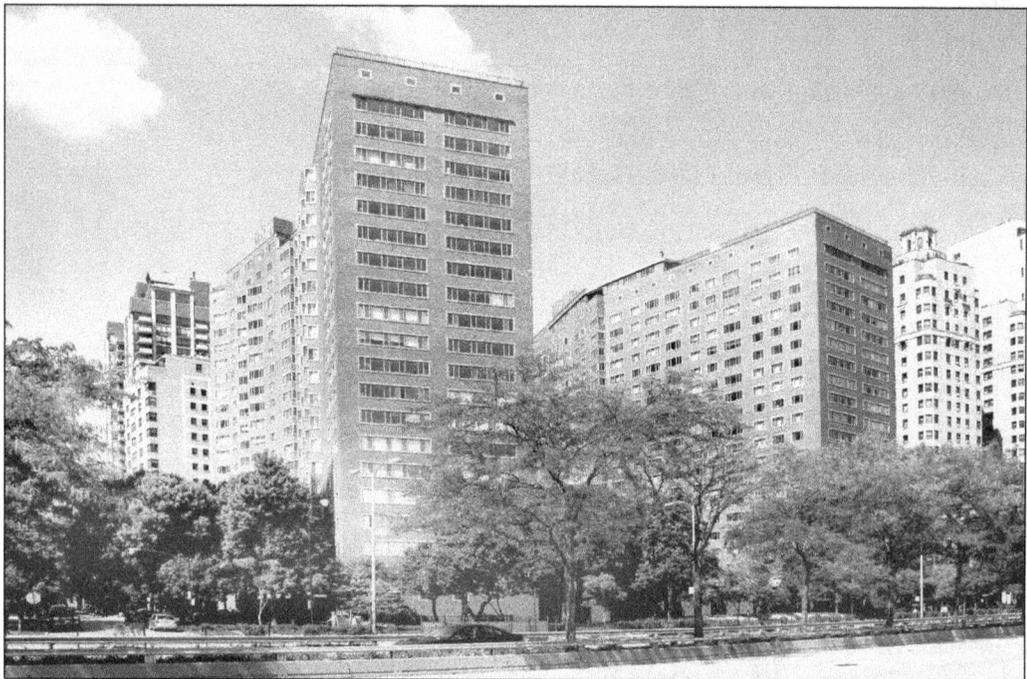

This high-rise apartment complex is located at 1350–1360 North Lake Shore Drive. It was built on the site of Potter Palmer's mansion in 1951. Draper and Kramer, Realtor hired architect Richard Marsh Bennett to design these 22-story towers, which contain 740 rental apartments. Bennett also designed two well-known malls, Old Orchard Shopping Center and Oakbrook Center.

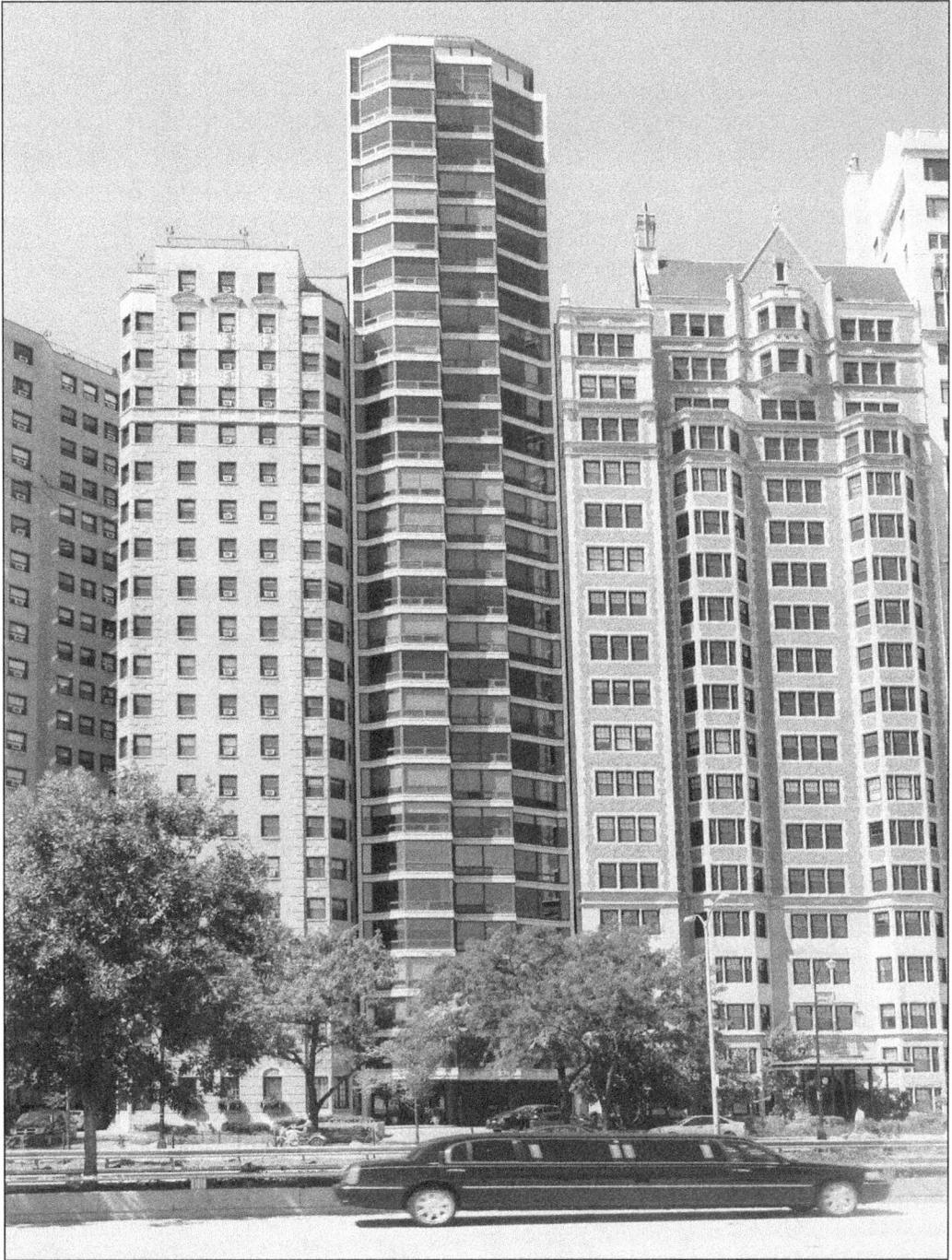

This 28-story building at 1418 North Lake Shore Drive was designed by architect Solomon Cordwell Buenz in 1980. It sits between two vintage buildings: 1400 North Lake Shore Drive condominiums on the left and the 1420 North Lake Shore Drive apartments on the right. Building 1418 is only 44 feet wide, which makes it the narrowest on Lake Shore Drive. Each condominium takes up an entire floor, about 3,000 square feet, and the living rooms have unrestricted floor-to-ceiling lakefront views.

This photograph, taken in the 1940s, shows an excellent view of the 1400 North Lake Shore Drive apartments, built in 1926 as a unique, hotel-style apartment complex. After it failed as a cooperative apartment building, it was an affordable rental for many years. In 2004, it was converted into a condominium complex containing about 380 units ranging from studios to three bedrooms.

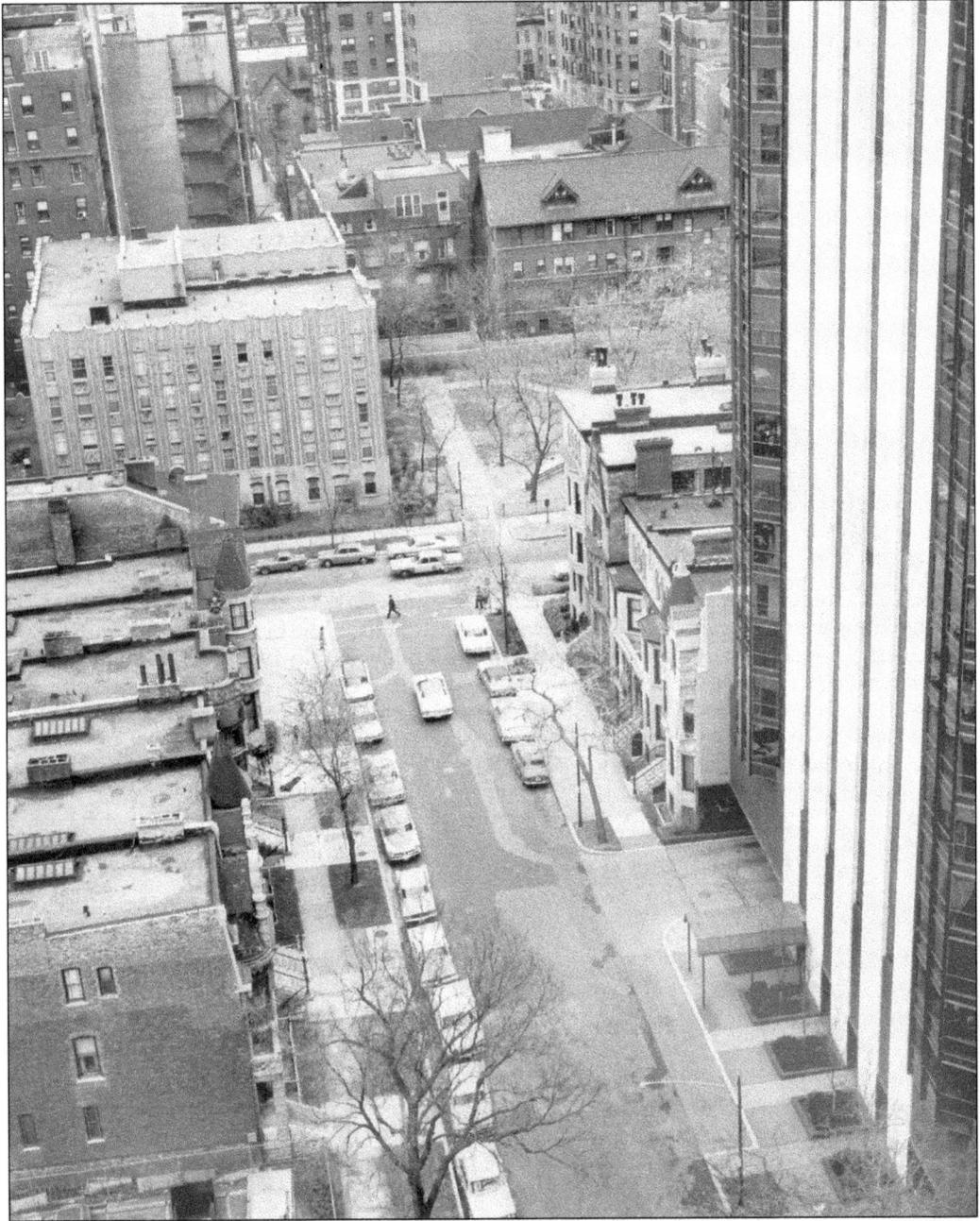

This is one of two residential buildings that once stood on the site of 65 East Goethe Street. Both were demolished in 1999 to make way for one of Gold Coast's newest luxury apartment buildings.

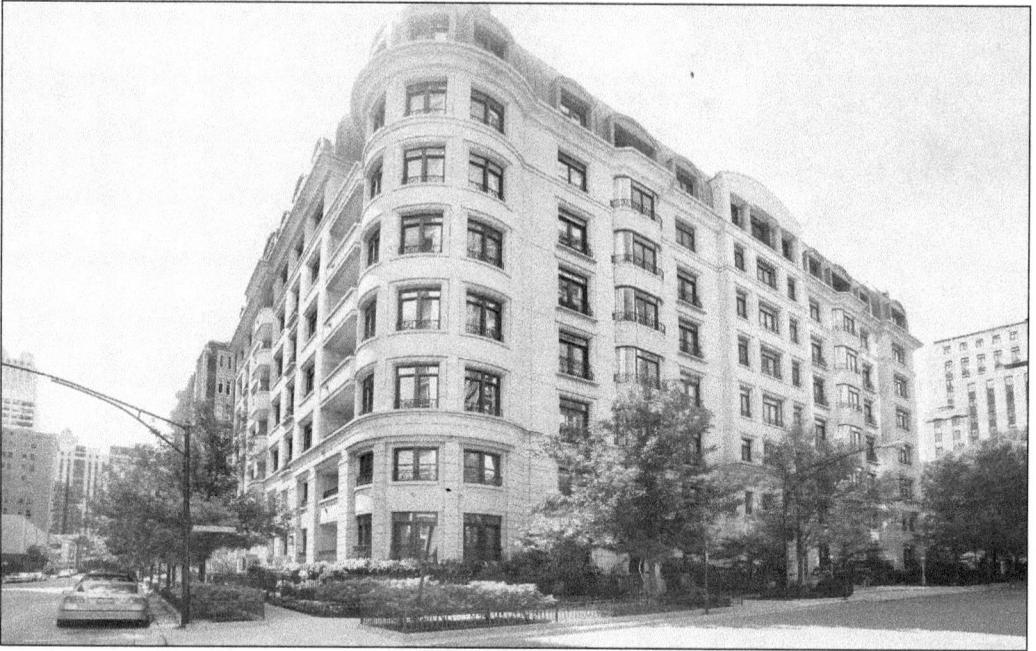

This building, which is one of the crown jewels recently built in the Gold Coast, is located at 65 East Goethe Street. It was designed by architect Lucien Lagrang in 1999 and was built by E.W. Corrigan in 2003. Initially, the developer wanted to build a 32-floor condominium on this site, but after battling with local residents, many from the neighborhood, the final-approved plan resulted in this eight-floor, French-inspired building. There are six maisonettes on the second and third floors, which contain about 8,500 square feet each. There are also about 16 apartments on the remaining floors, except the top floor.

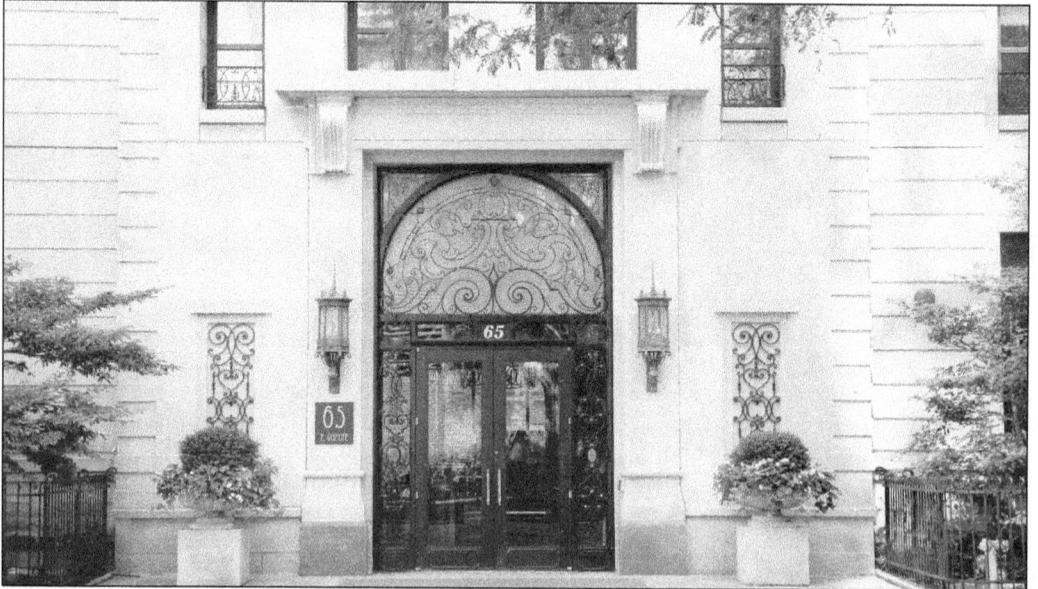

Some of the best amenities offered here include a resident concierge, rooftop garden terraces, underground parking, large rooms in each apartment for grand entertaining, and multiple fireplaces.

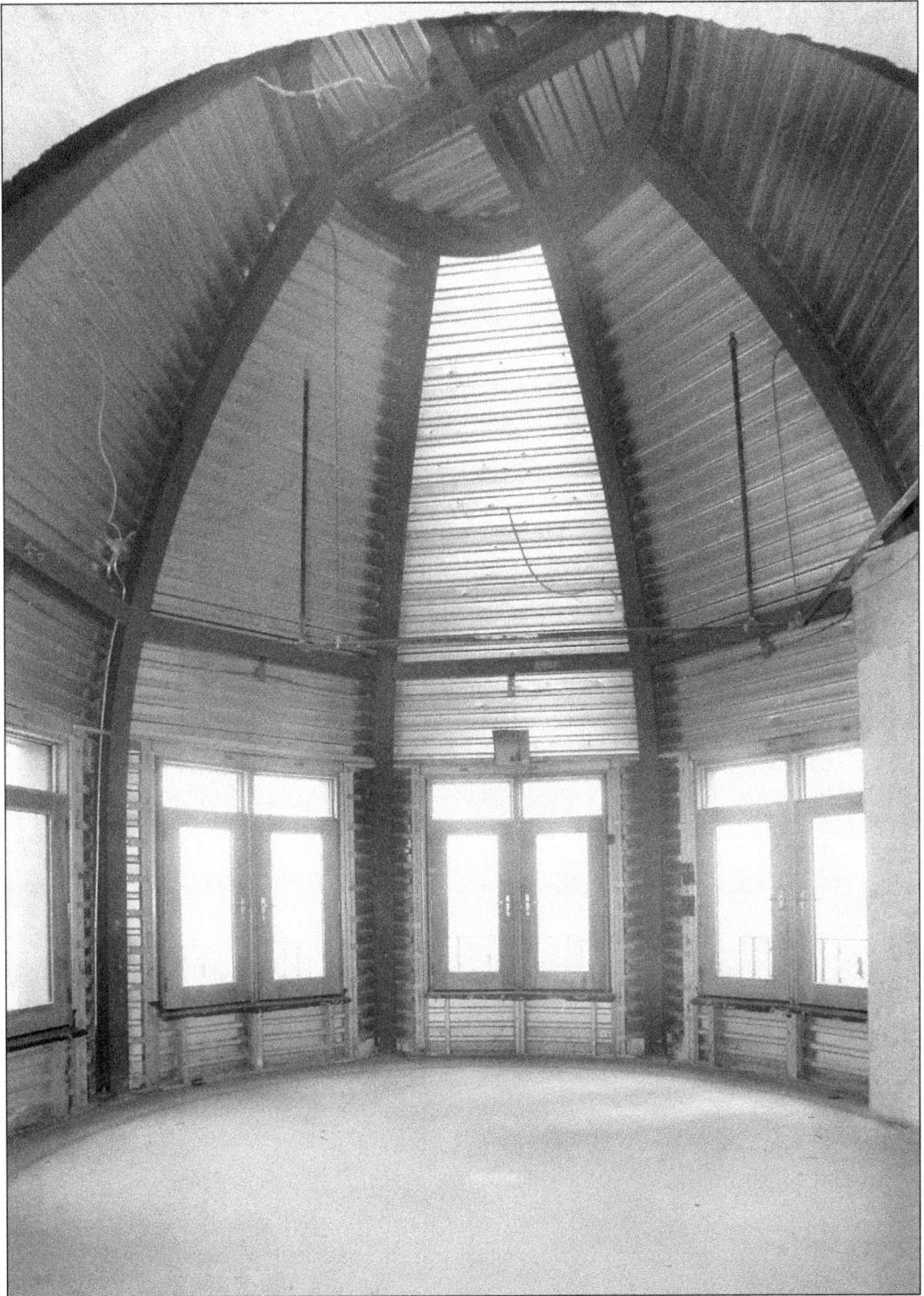

This photograph shows a tiny section of the penthouse at 65 East Goethe Street. There is 13,000 square feet of undeveloped space, purchased in 2003 for $10.1 million. Before the downturn in the real estate market, the buyer listed it (still undeveloped) for $14 million.

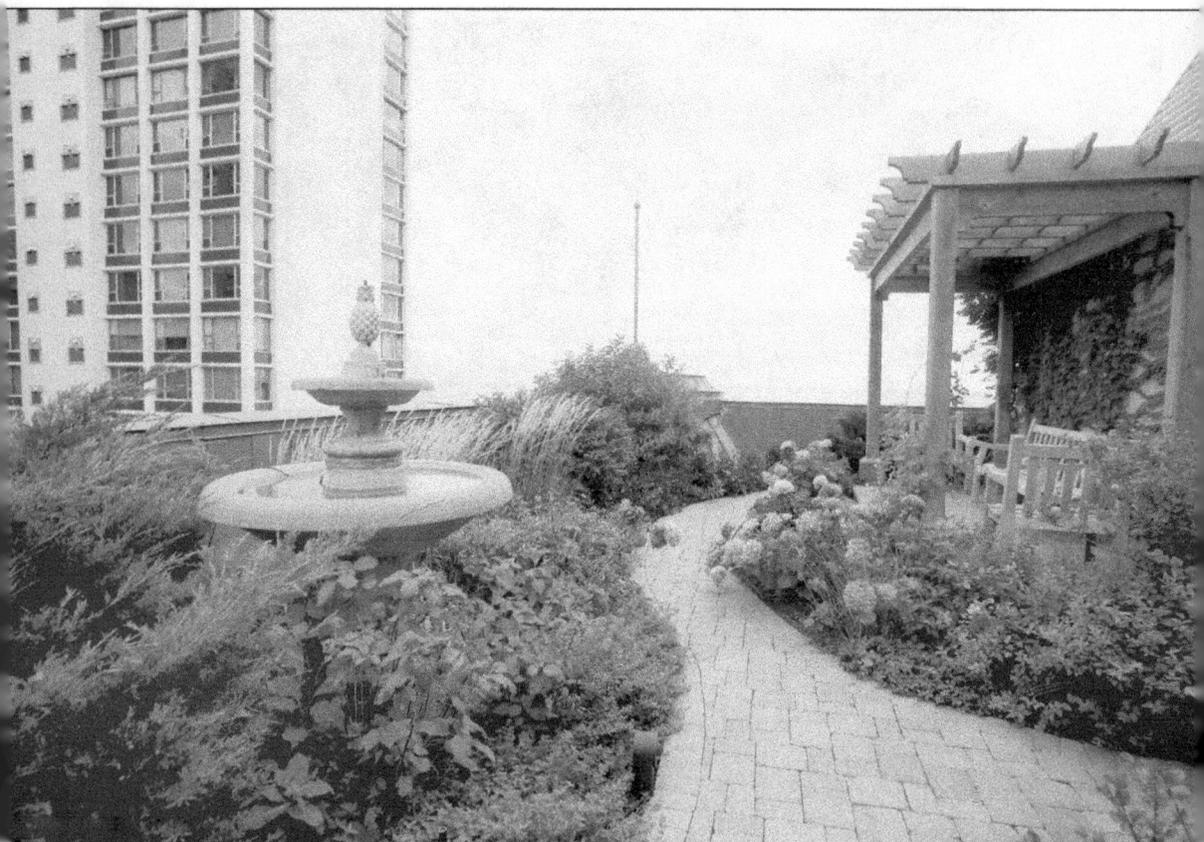

This is a 6,000-square-foot rooftop garden, enjoyed by the residents at 65 East Goethe Street. It has seasonal flowers, a fountain, benches, and breathtaking views of Lake Michigan.

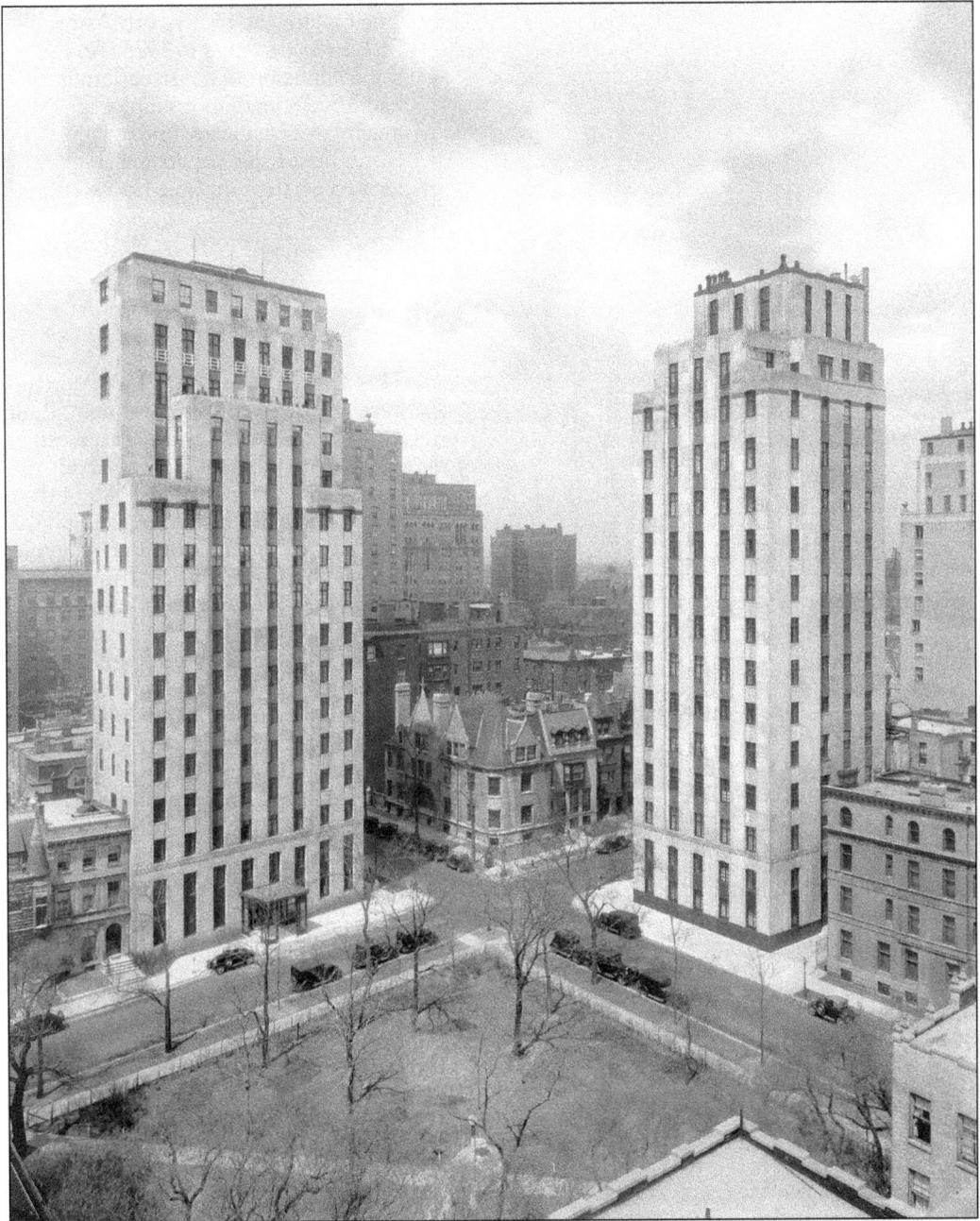

This photograph, taken in 1932, shows a great view of Gold Coast's two Art Deco cooperative buildings. Located on the left side is 1260 North Astor Street, and to the right is 1301 North Astor Street. The structure at 1260 North Astor Street, designed by Philip B. Maher in 1930, contains 16 floors; the top 4 floors are two duplexes. This building is another example of how the wealthy embraced high-rise living. Some of the notable residents were Potter Palmer III, Mr. and Mrs. Charles Stone (whose family home was demolished, so that 1260 North Astor Street could be built), and Robert Hall McCormick.

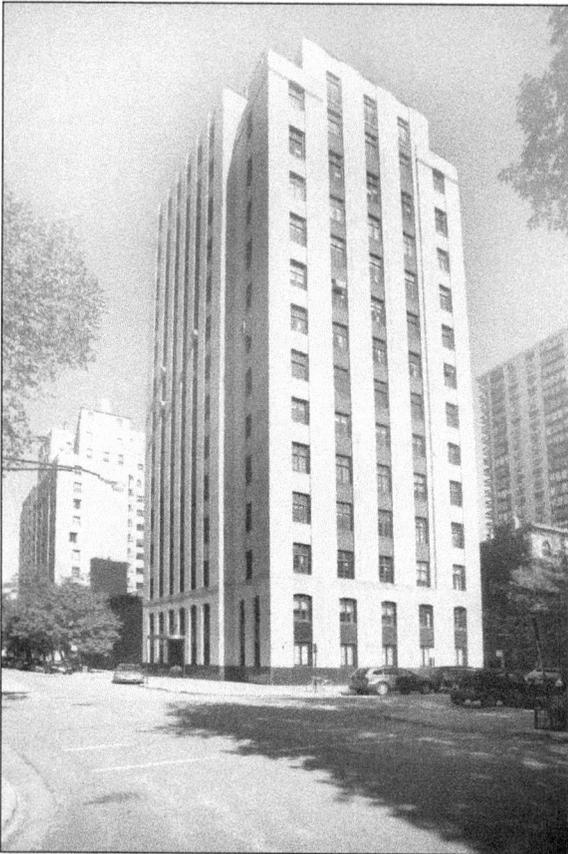

The building at 1301 North Astor Street was designed in 1928. At the completion of construction, it had 3,500-square-foot simplexes, much larger duplexes, and a customized triplex apartment located on the top three floors.

This 41-floor structure is 1300 North Lake Shore Drive Condominium. Built in 1963, it has 142 apartments; most of them are modest-sized two- and three-bedroom apartments. All of the apartments have balconies facing Lake Michigan. This building is an example how modern and large apartment buildings started to offer its residents convenient amenities, not luxury amenities. Some of the 1300 North Lake Shore Drive Condominium amenities include a laundry facility, a party room, valet, cleaners, exercise room, extra storage space outside of the apartment, and a front-door staff.

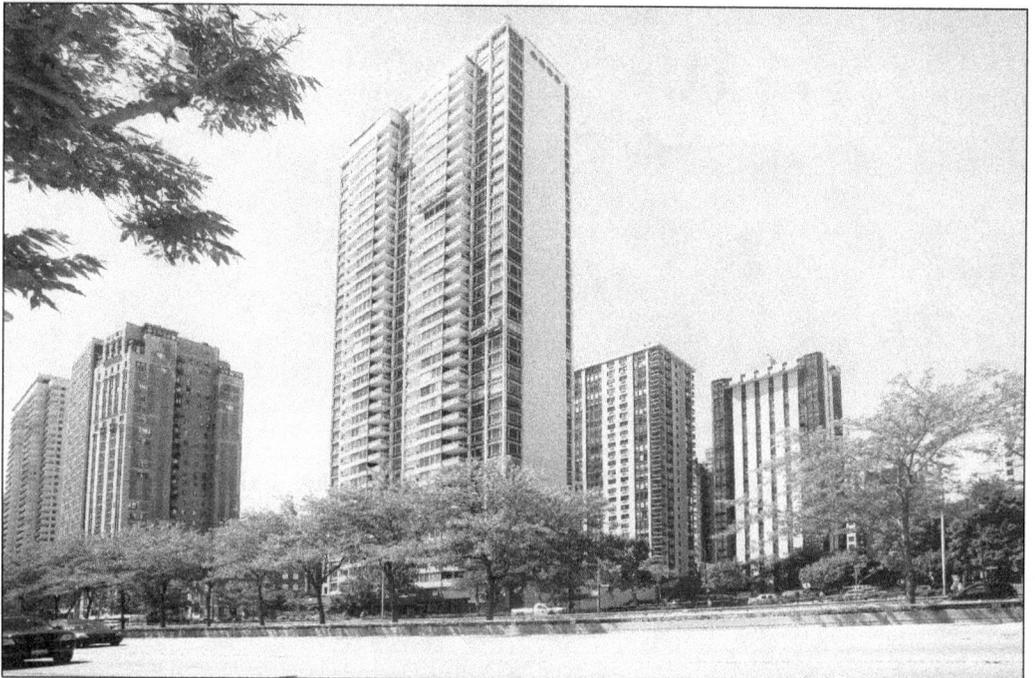

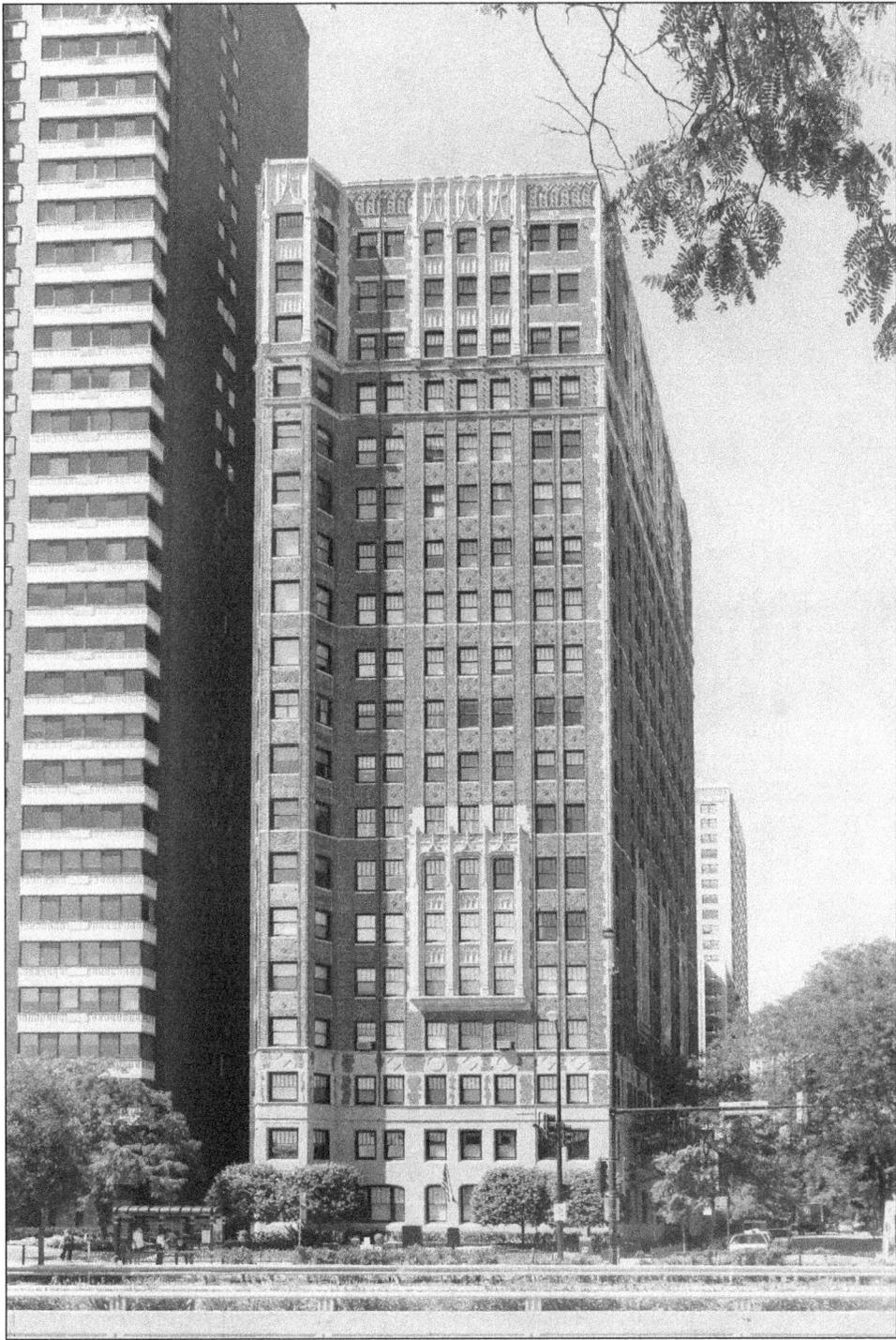

The high-rise at 1448 North Lake Shore Drive was constructed on the site of the Orrin W. Potter (1836–1907) mansion. It was designed by Childs & Smith architects in 1926. There are about 52 units, and several of them have been reconfigured from one to four bedrooms. This structure was erected as a cooperative apartment building and remains as such today.

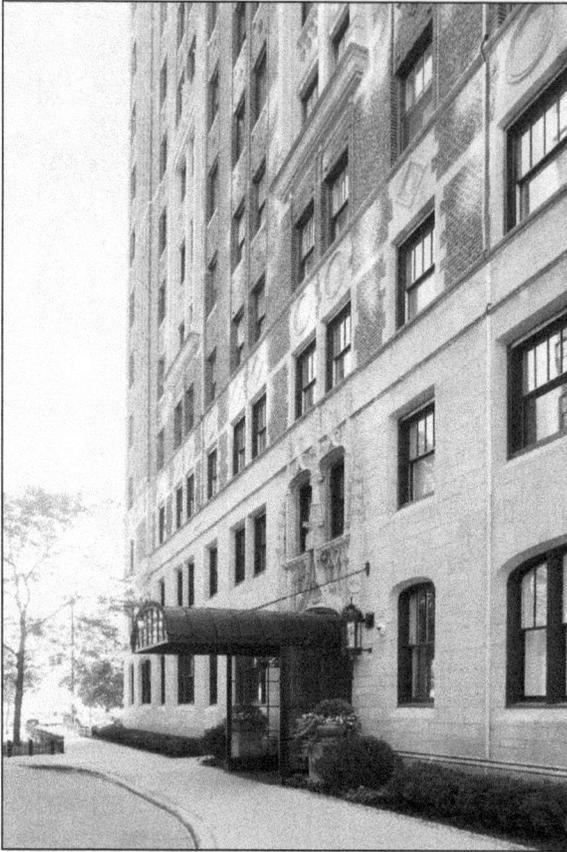

Pictured is the 1448 North Lake Shore Drive main entrance on Burton Place.

Here is a close-up view of the beautiful French Gothic exterior of 1448 North Lake Shore Drive.

Just across the street from 1448 North Lake Shore Drive is another large apartment building, 1500 North Lake Shore Drive. It was designed by McNalley & Quinn architects in 1929 on the site of *Chicago Daily News* owner Victor Lawson's mansion. This building has 25 floors and is one of the few remaining with elevator operators. There are 57 apartments with three per tier. There are also two maisonette apartments and a rooftop 18-room bungalow with an outdoor pool surrounded by seasonal gardens.

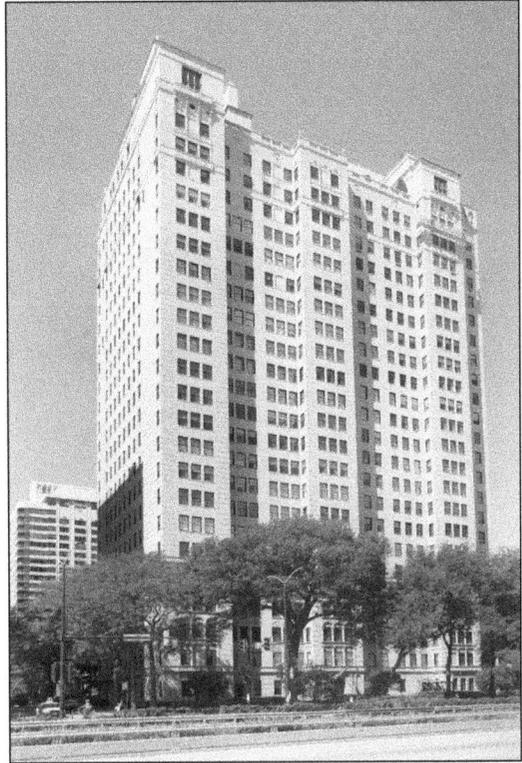

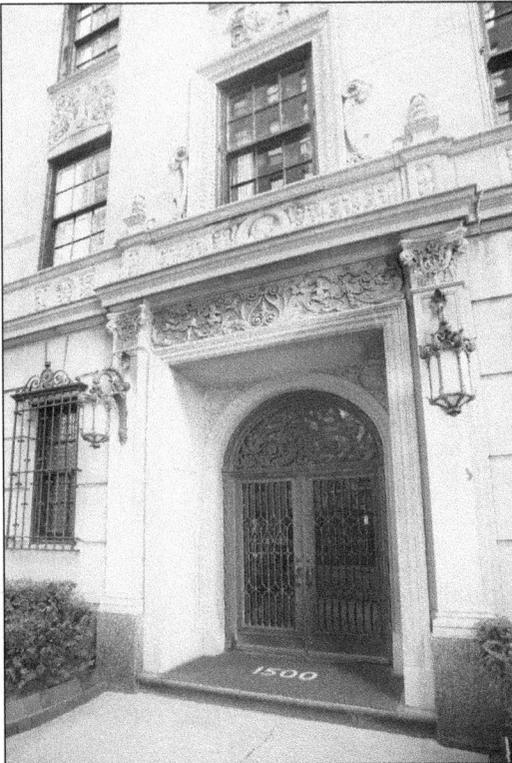

The structure at 1500 North Lake Shore Drive has a rarely used but notable entrance. The main entrance is located on Burton Place, like the 1448 North Lake Shore Drive building.

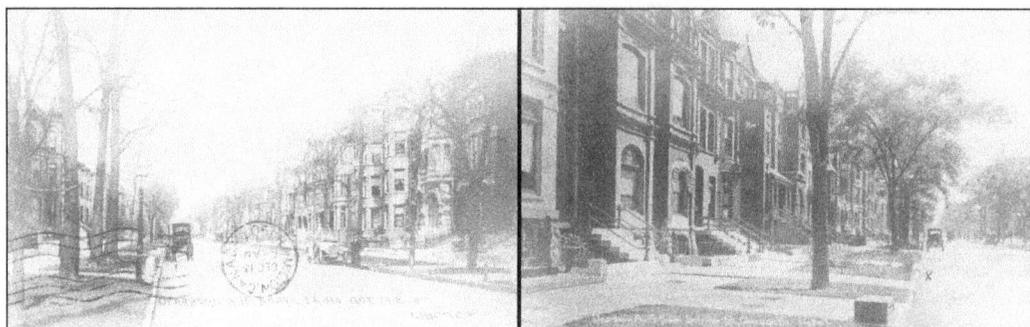

This collection of rare postcards, produced at the turn of the 20th century, shows Dearborn Avenue and Goethe Street lined with greystone and brownstone mansions in 1907. Dearborn Avenue was changed to Dearborn Street after the City of Chicago redistributed addresses and renamed some streets due to population expansion after 1909. The third building shown is 1447 North Dearborn Street, which lasted almost 100 years. It was recently torn down to make way for a similar-style condominium building.

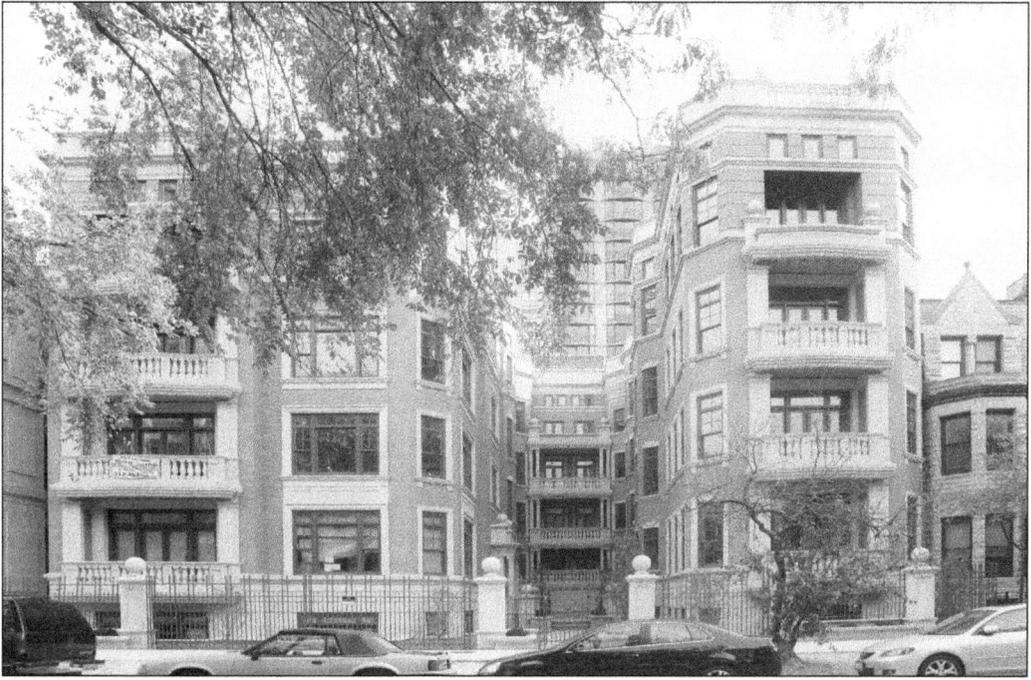

This is the new 1447 North Dearborn
Street building. It is also one of
the newest completed construction
projects in the Gold Coast.

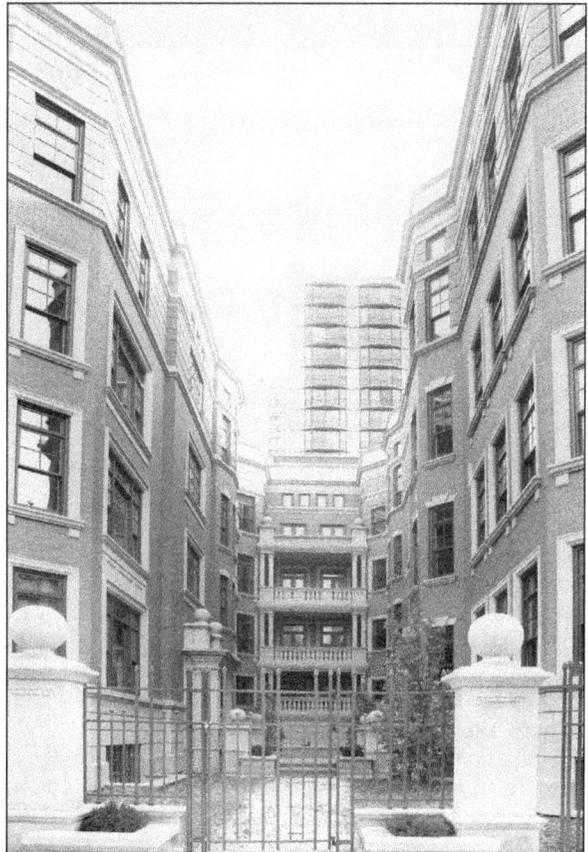

The building at 1447 North Dearborn
contains 13 cooperative apartments.

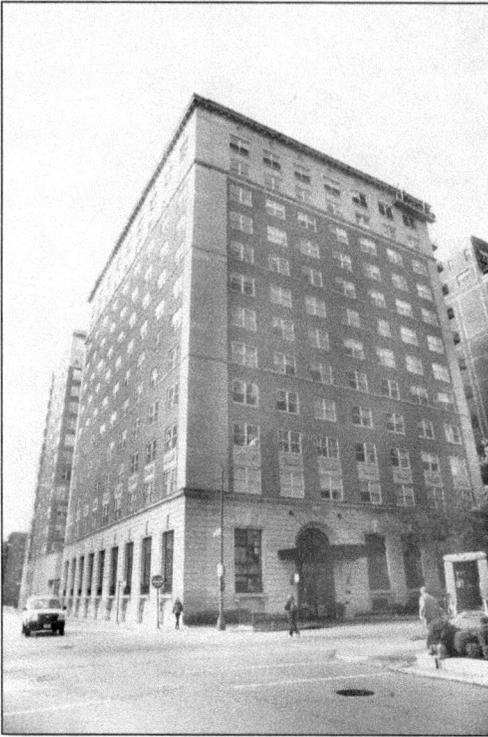

This building is the former Ambassador West Hotel, constructed in 1918 by architects Schmidt, Garden, & Martin. In 2005, it was converted into 38 luxury condominiums; however, its former sister property hotel, the Ambassador East Hotel, remains in operation. A couple of years ago, it was purchased, renovated, and renamed the Public House Chicago, but its signature famous restaurant, the Pump Room, kept its name and remains in the same space.

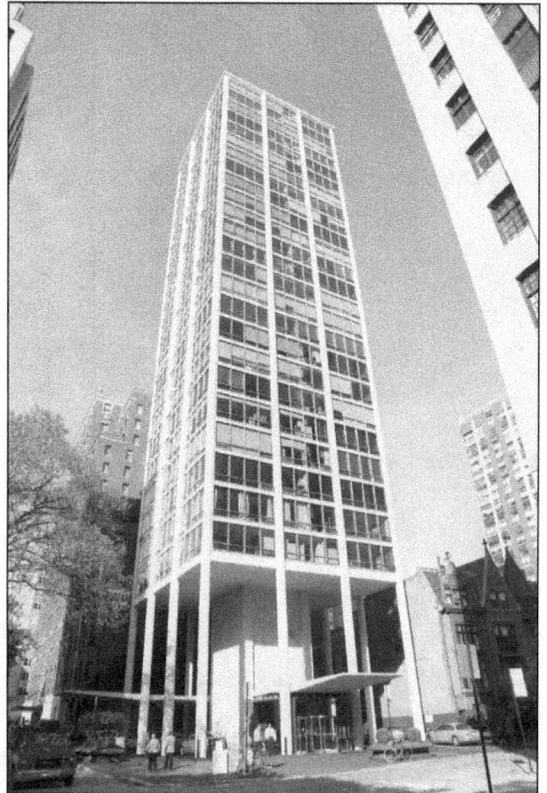

Located at 1300 North Astor Street, this building was completed in 1968. Designed by architect Bertrand Goldberg, it was originally constructed as a boutique hotel that catered to celebrities before it was converted to a condominium in the 1970s and renamed the Goldberg Landmark Astor Tower. Some of the biggest celebrities of the day, including Sammy Davis Jr., Bette Davis, Natalie Wood, and the Beatles, were guests here. In the 1970s, it was converted to condominium apartments and renamed the Goldberg Landmark Astor Tower.

Astor Towers was constructed as the first apartment hotel building in Chicago. Here is a typical living room of the apartments. It is modest and functional.

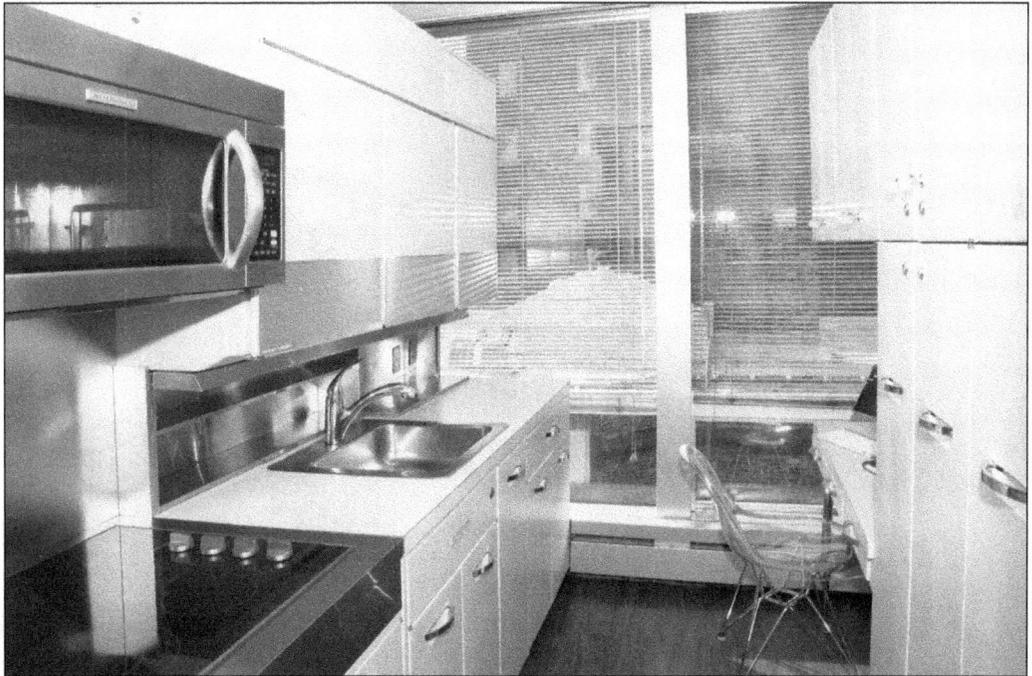

This classical 1960s kitchen is found inside the Goldberg Landmark Astor Tower. Note the cabinets to the left, which are actually the refrigerator and the freezer.

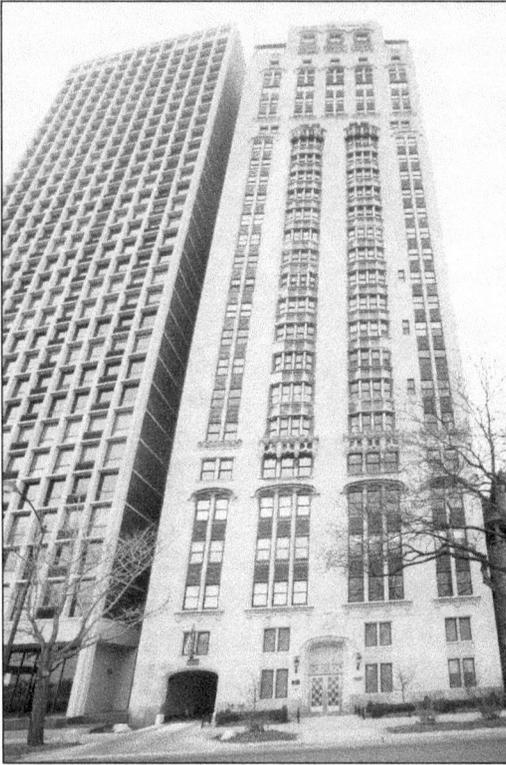

Designed in 1929 by architect Robert S. De Golyer, this 28-floor cooperative apartment is located at 1242 North Lake Shore Drive. Originally designed as 35 apartments, many of them were duplexes containing 8 to 11 rooms.

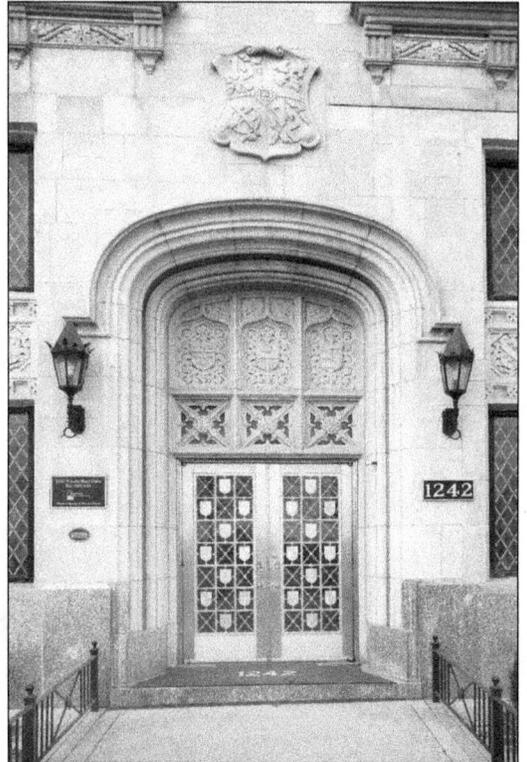

This is the main entrance of 1242 North Lake Shore Drive. The building displays designs of Tudor and Gothic influences on the limestone facade.

Three

THAT'S ENTERTAINMENT!
HOTELS, CLUBS, RESTAURANTS, SCHOOLS, PLACES OF WORSHIP, AND FACES IN THE NEIGHBORHOOD

The Gold Coast is a neighborhood affluent with rich culture. Several private homes have been converted into libraries, museums, and places of worship. Residences that once were homes to Chicago's leaders in industry and society are now house priceless artifacts, memorabilia, and historical treasures. Several of these homes were mentioned in the first chapter, including the Graham Foundation for Advanced Studies in Fine Arts, the International College of Surgeons Museum, and the Architectural History Society.

Clubs like the Three Arts Club, Maxim's, and the Fortnightly Club were organizations and places in which locally known and world-renowned artists, philanthropists, intellectuals, and scientists came together to inspire one another. They joined these clubs to collaborate on many projects and with institutions that served and influenced the Greater Chicago area.

The Greek Orthodox, Roman Catholic, Jewish, and Episcopalian faiths were some of Chicago's many religious traditions that have an enriching presence in the Gold Coast.

The nightlife continues to be very active in this neighborhood, thanks to the popular Rush Street. This one-way street runs about a mile between State Street and Wabash Avenue. Its notoriety goes back to the 1830s; even then, it was lined with entertainment businesses and luxury residences. Today, it is mostly filled with prominent bars, restaurants, spas, and top-rated hotels.

Some of the best schools are located in the Gold Coast, including the Latin School, Ogden School, and the Catherine Cook School, situated in the nearby neighborhood of Old Town.

Of course, some of the country's best shopping can be found on the famous Oak Street. Well-known posh stores such as Barneys New York, Prada, Hermes of Paris, Jimmy Choo, Jil Sander, Paul Stuart, Tods, Kate Spade, and Vera Wang can be found on this street in a one-block radius, starting from Michigan Avenue to Rush Street.

For well over a century, some of Chicago's top entertainers, industry leaders, and entrepreneurs continue to make the Gold Coast their home. It is not uncommon to stroll the streets on any given day and spot professional sports players, talk-show hosts, and hotel tycoons.

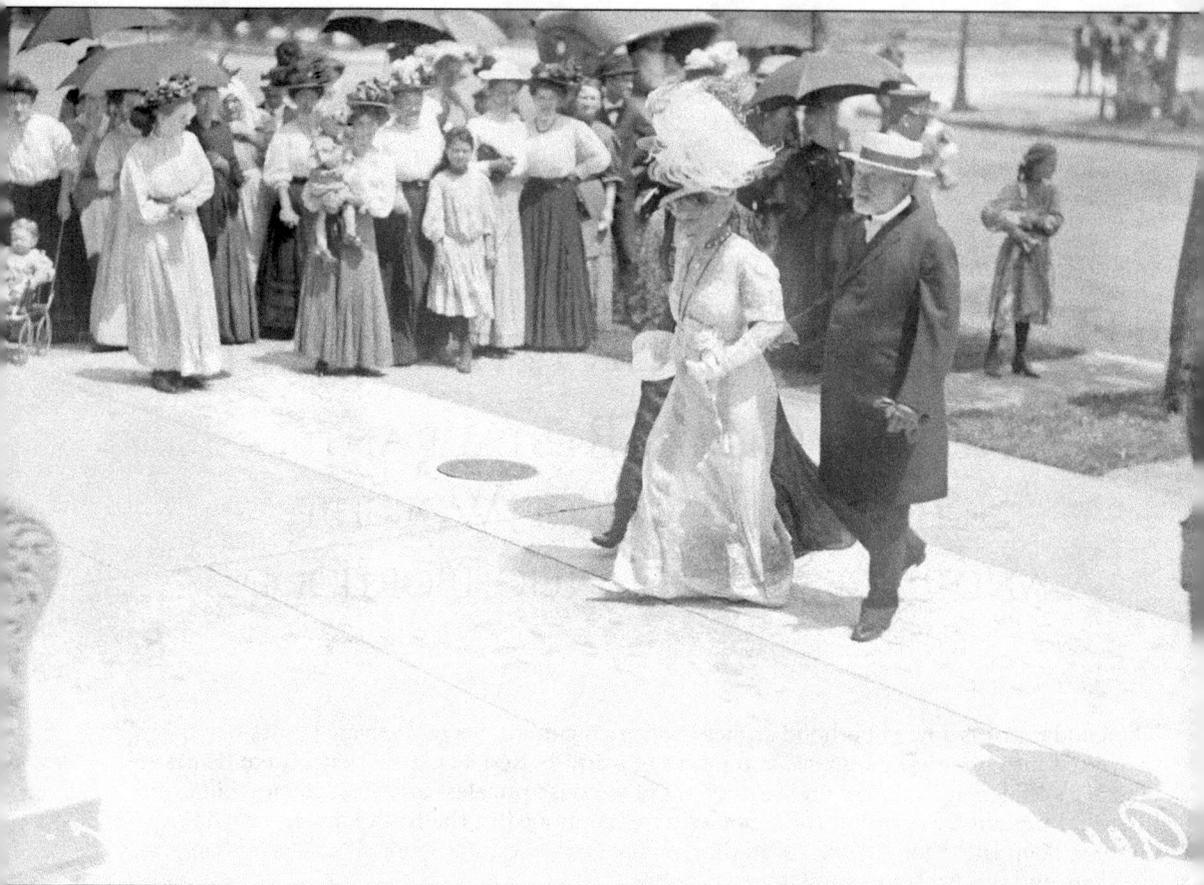

Bertha Palmer is escorted to an event at the Art Institute of Chicago by Ida and Gen. Dent Grant in the early 1900s.

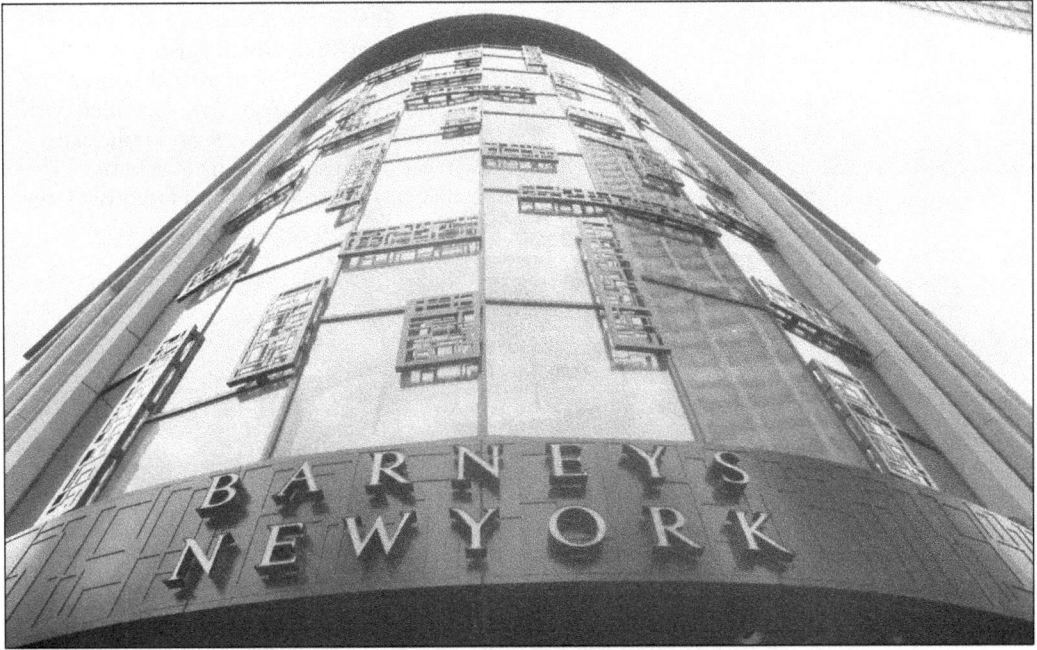

In 2009, one of Chicago's first green department stores opened. Barneys New York, located at 15 E. Oak Street, contains 95,000 square feet of luxury space. The exterior design of the building has references to the 19th century work of Louis Sullivan. This retailer offers its customers personal shopping and in-house concierge services.

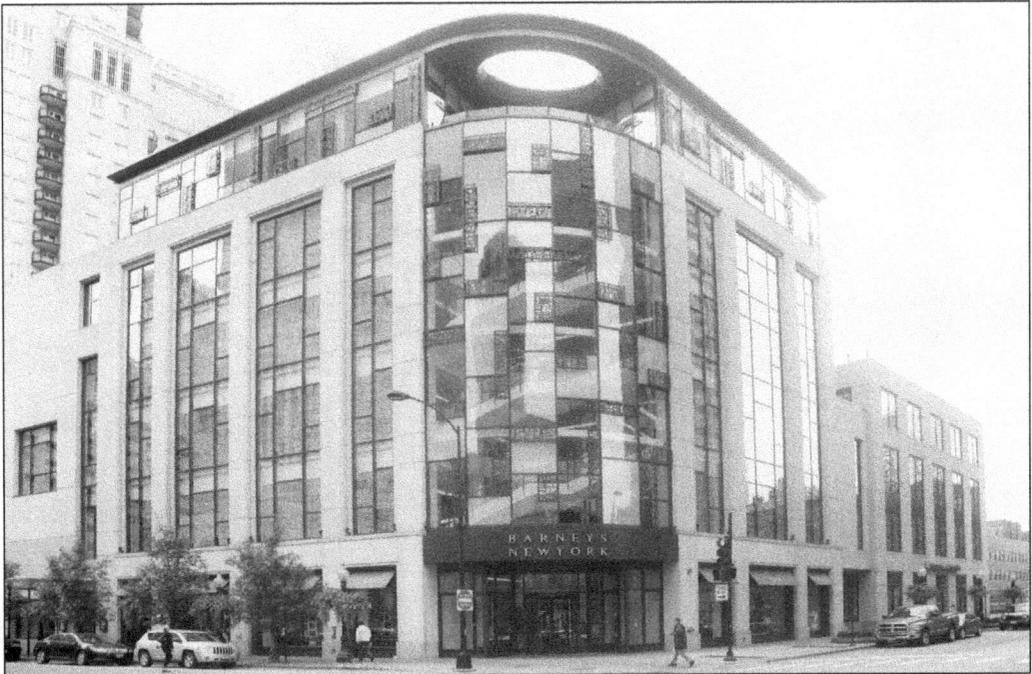

Barneys New York has six floors. On the penthouse level is Fred's Restaurant, which takes up about 5,000 square feet of the store's space. Locals enjoy dining on the terrace in the summer months, as the views of Lake Michigan are breathtaking.

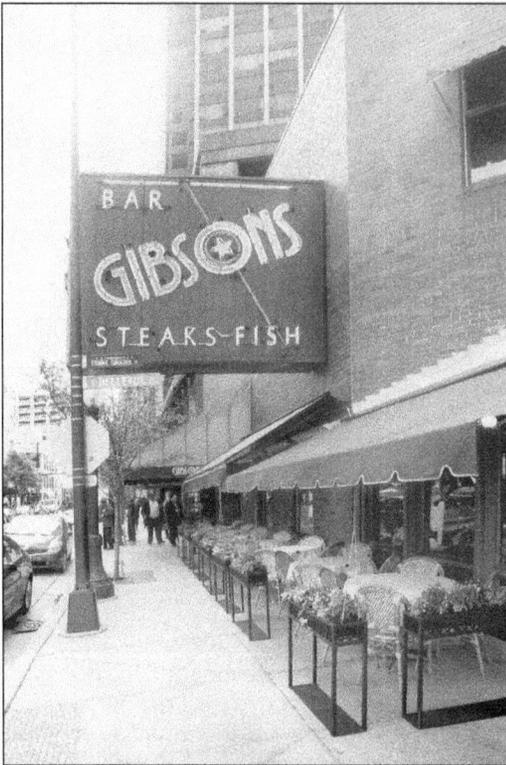

Gibsons Bar & Steakhouse's flagship location is at 1028 North Rush Street. It is one of the most popular steakhouses in America. On any given day, it is filled with local residents, celebrities, and politicians. Signature items include its excellent steaks, large side dishes, and famously large martinis.

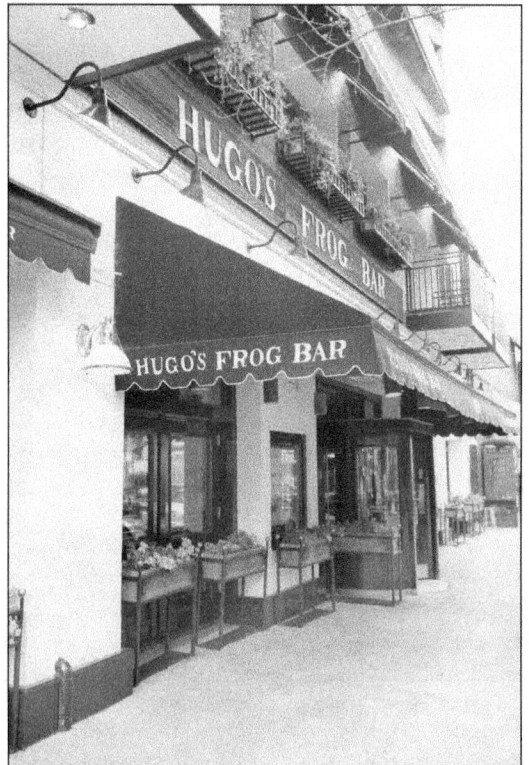

Hugo's Frog Bar and Fish House is located at 1024 North Rush Street. Situated next door to Gibsons, it is also operated by Gibsons Restaurant Group. Diners come here to partake in some of the best seafood in the country while enjoying the sophisticated ambiance and the live, nightly piano.

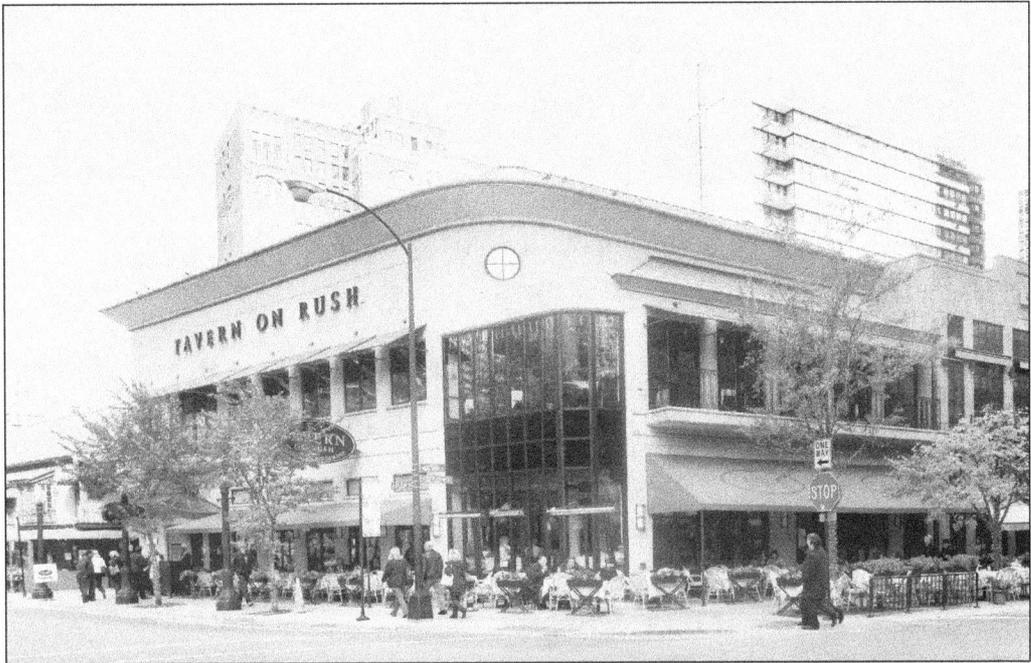

Tavern on Rush is another one of Chicago's famous restaurants. Its popular horseshoe-shaped bar and seasonal patio café is one of the most popular dining experiences in the Gold Coast and has been voted the best outdoor dining destination in Chicago by several magazines.

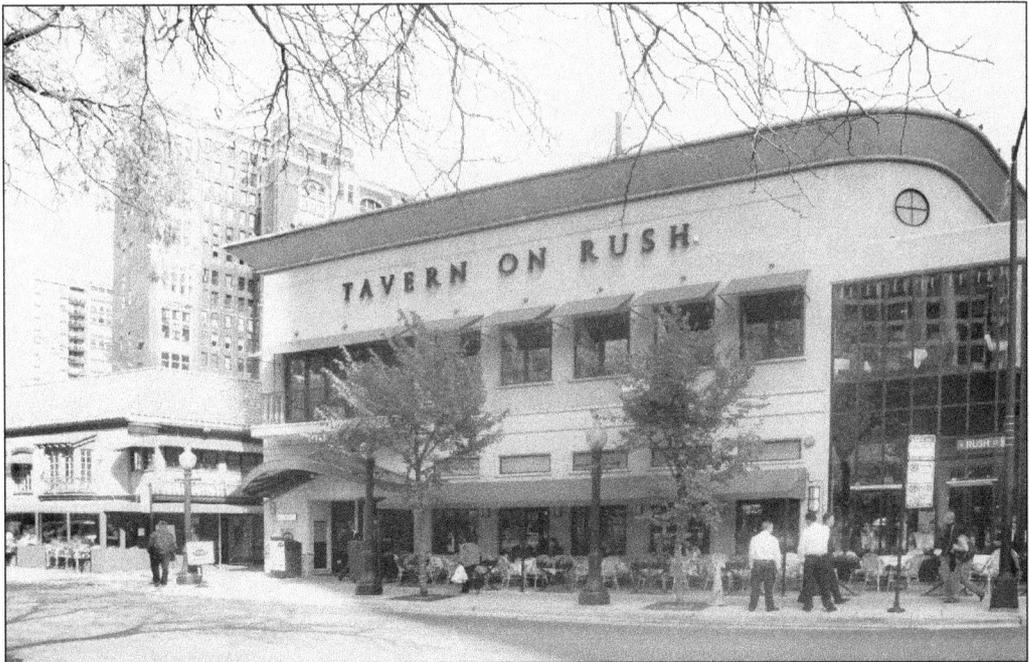

During the summer months, nearly every restaurant on Rush Street offers its customers alfresco dining, which allows time for people watching.

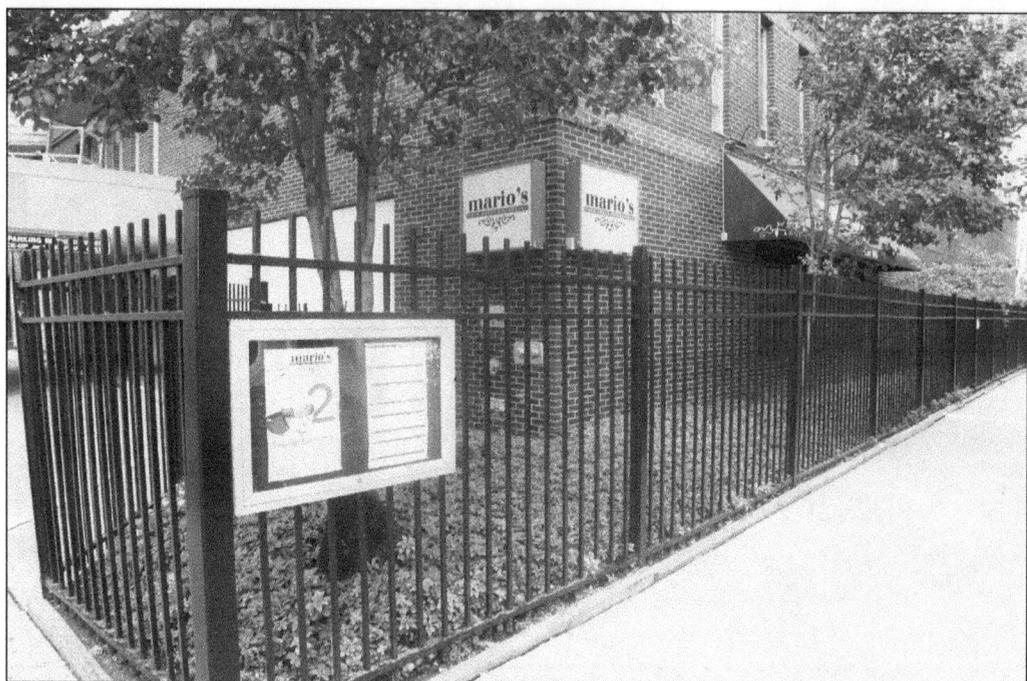

Mario's Gold Coast Ristorante is located on the garden level at 21 West Goethe Street. For more than a decade, it has been one the neighborhood's favorite dining spots, called the "Cheers" of the Gold Coast.

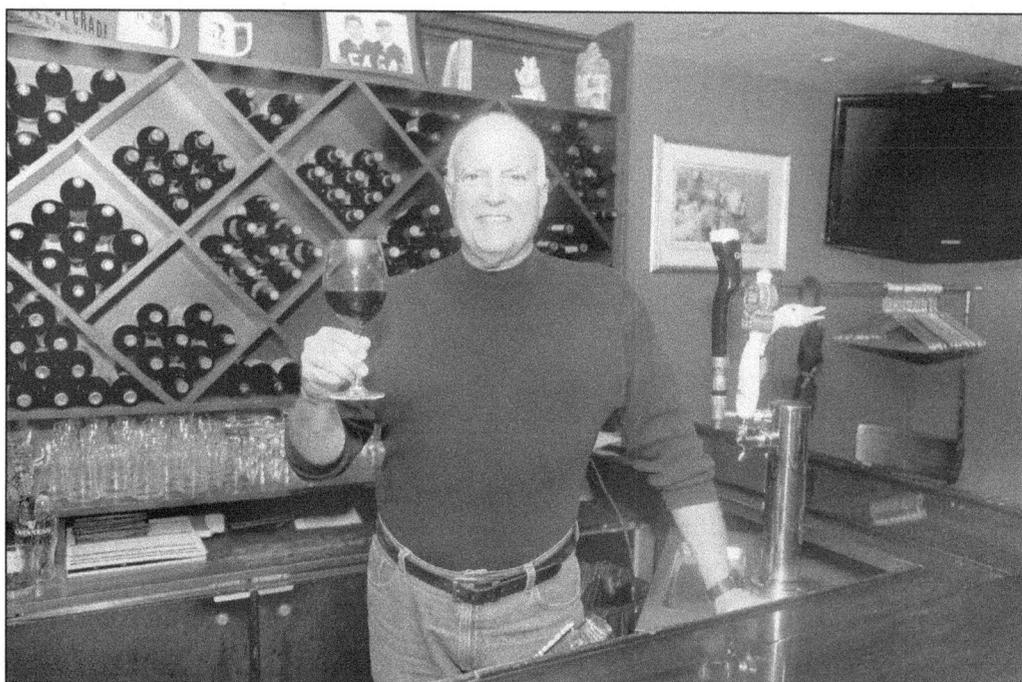

At Mario's, owner Mario Stefanini offers his customers a large selection of signature Italian dishes and fine Italian wines.

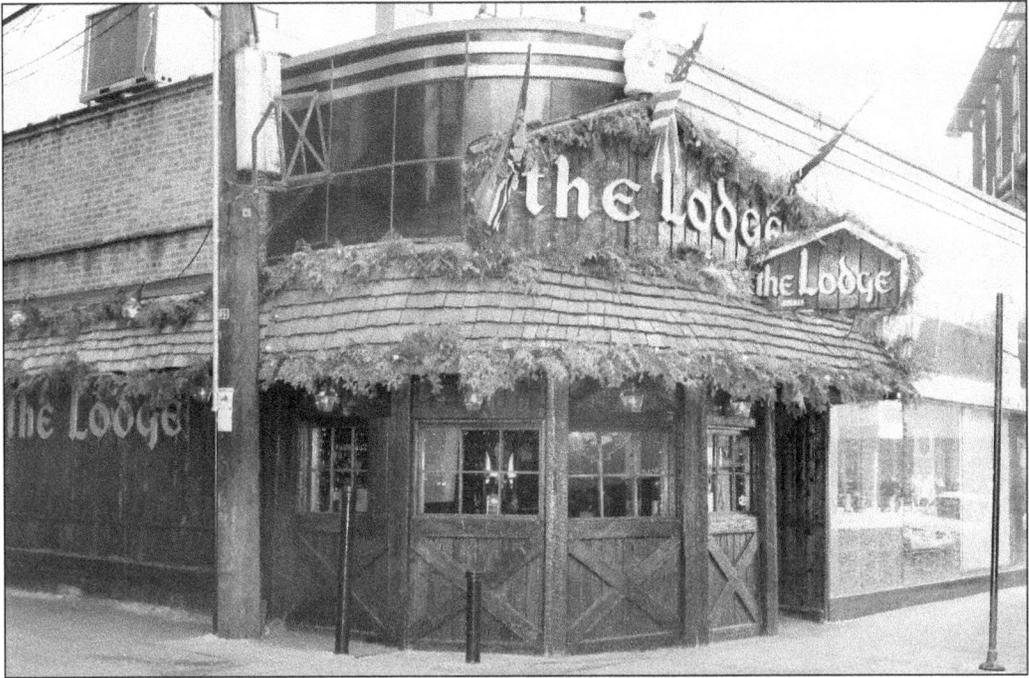

The Lodge Tavern, situated at 21 West Division Street, has been at this location since it opened in 1957 and has been serving cold beer and peanuts to the college crowd ever since. The exterior looks like a Swiss bar. The owners are proud of the original interior and exterior, unchanged since it opened.

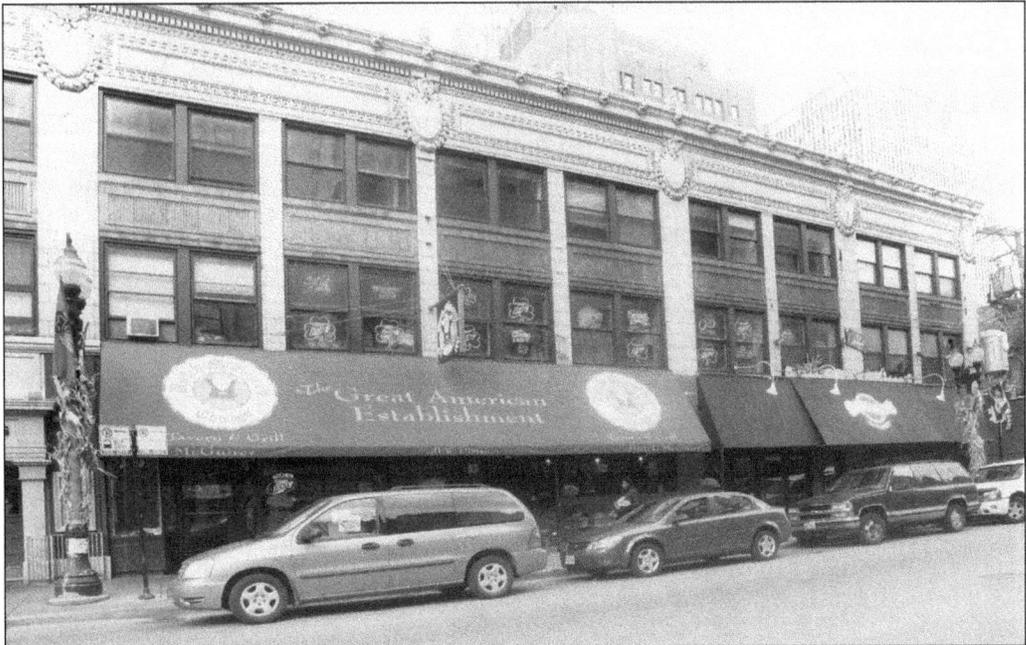

Located across the street from the Lodge Tavern is Butch McGuire's at 20 West Division Street. Open since 1961, this bar takes credit for being the first singles bar in America. Rumor has it that over 5,000 couples met here and married.

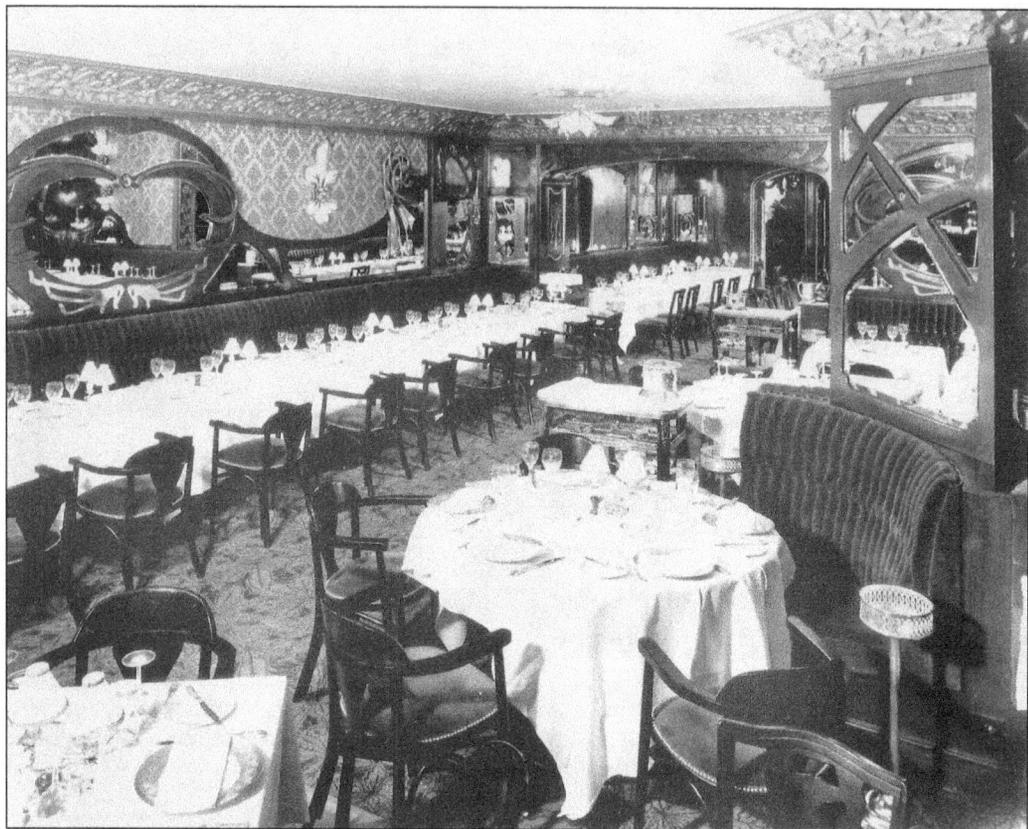

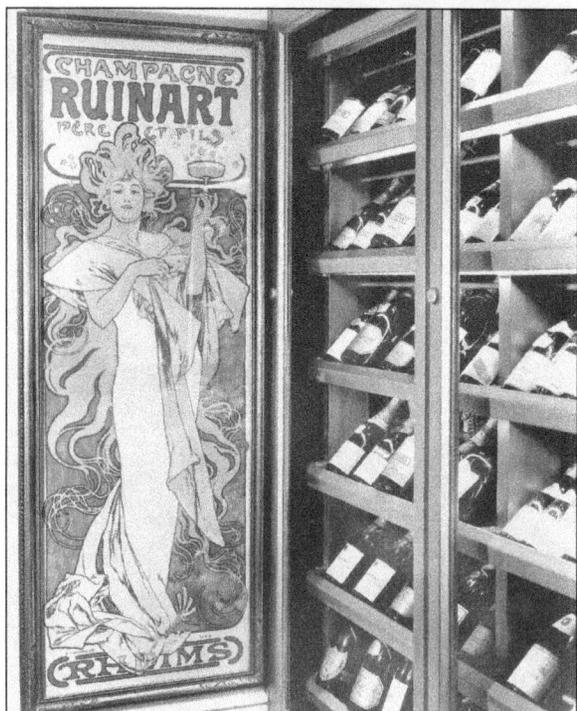

Maxim's de Paris is located on the lower level of the now Astor Tower at 1300 North Astor Street. It opened in 1963. Its decor is an exact replicate of the famed Maxim's de Paris in France. For decades, this was one of the most visited places by celebrities and well-heeled tourists.

There are several French vintage murals and posters displayed throughout Maxim's. There was a time when Maxim's had an in-house staff of chefs and waiters. Today, a list of approved caterers is used to serve its guests all the food and beverages.

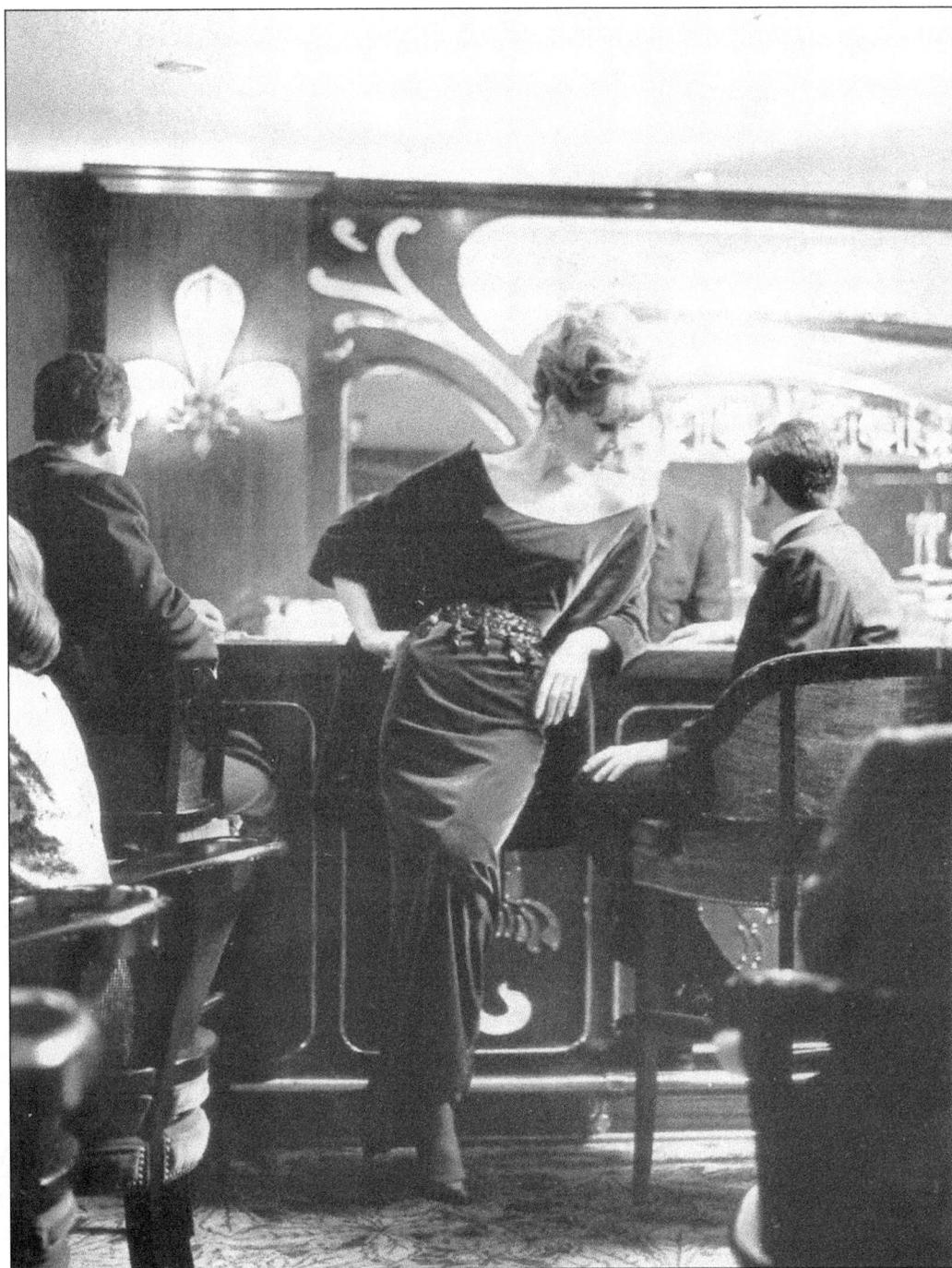

Over the years, some of the biggest names in show business have enjoyed coming to Maxim's, including Audrey Hepburn, Woody Allen, and Liza Minnelli. The woman in the photograph is an unidentified model.

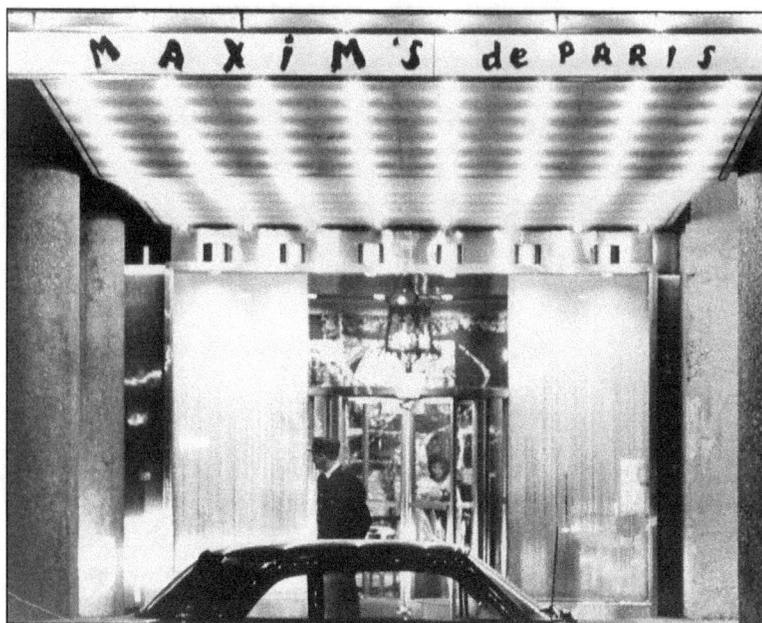

In 2000, Maxim's was bequeathed to the City of Chicago by former owner Nancy Goldberg's family.

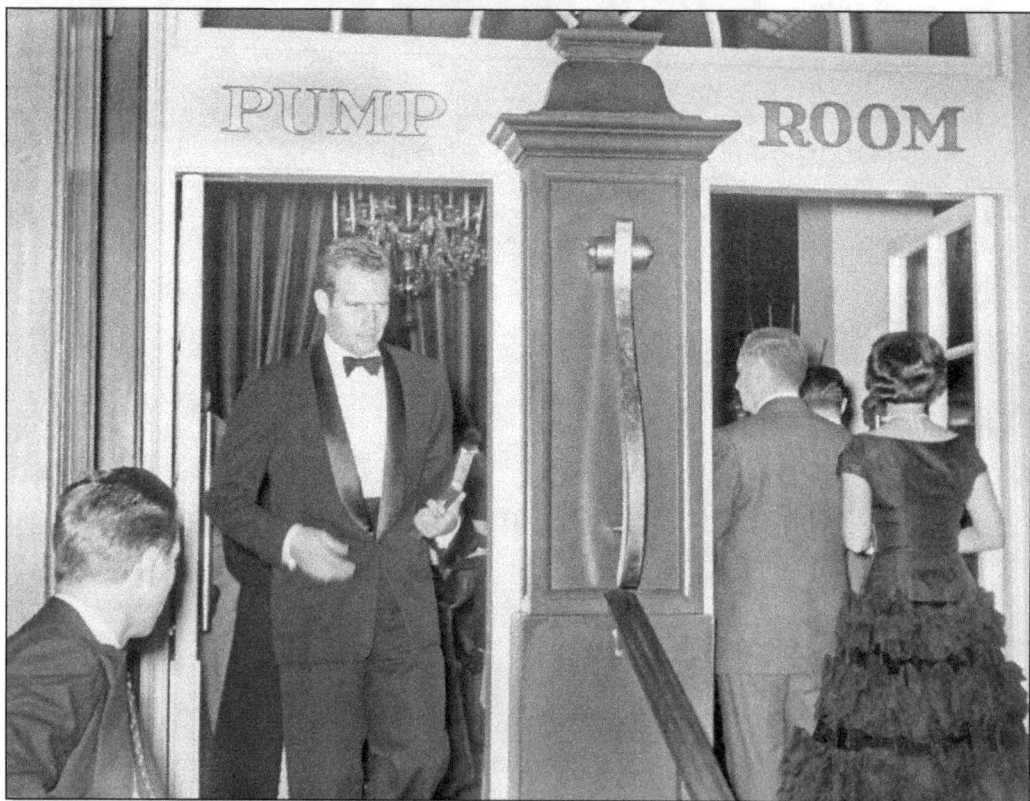

Owner Ernie Byfield opened the legendary Pump Room on October 1, 1938. Located inside of the Ambassador East Hotel at 1301 North State Parkway, it was named after a famous 18th-century spa in Bath, England. This November 1956 photograph shows the handsome film star Charlton Heston leaving the Pump Room after dinner.

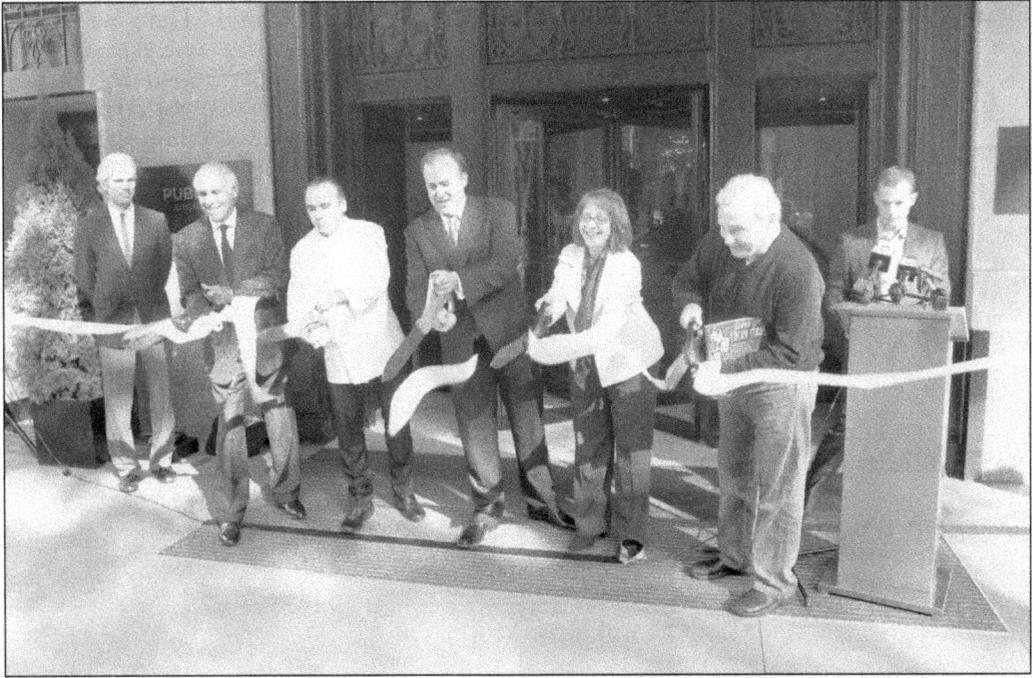

In 2010, the Ambassador East Hotel and the Pump Room were purchased by hotel magnate Ian Schrager. Both were renovated and reopened in September 2011. Pictured here is the Pump Room ribbon-cutting ceremony on October 11, 2011. Cutting the ribbon from left to right are restaurant developer Phil Suarez, chef Jean-Georges Vongerichten, Alderman Brendan Reilly, Alderman Michele Smith, and hotel owner Ian Schrager.

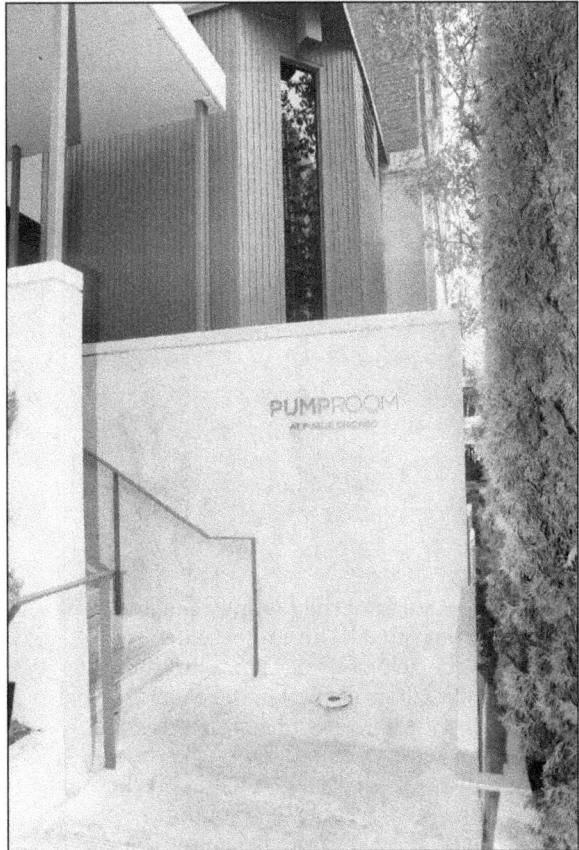

This is the newly designed entrance of the Pump Room, located on North State Parkway.

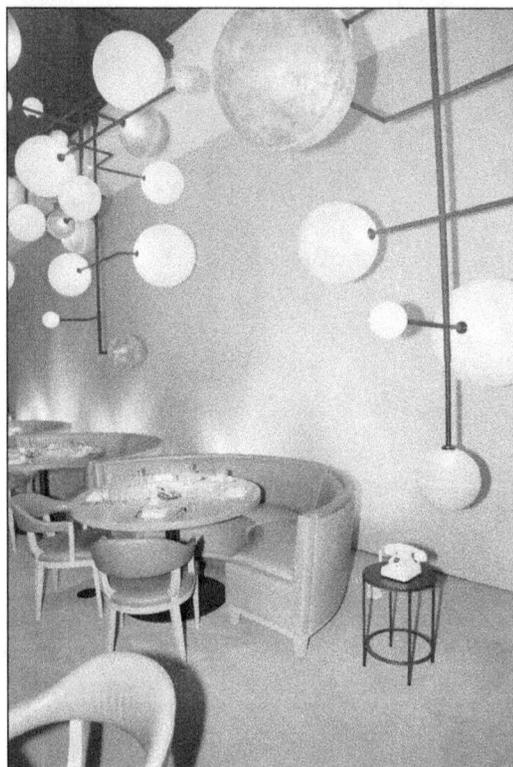

Most of the items from the Pump Room were sold; however, a few were kept and placed in the new Pump Room, such as the telephone shown here that was originally located in booth no. 1. Celebrities like Frank Sinatra, Mickey Rooney, Marilyn Monroe, and hundreds of others received or made calls using this phone.

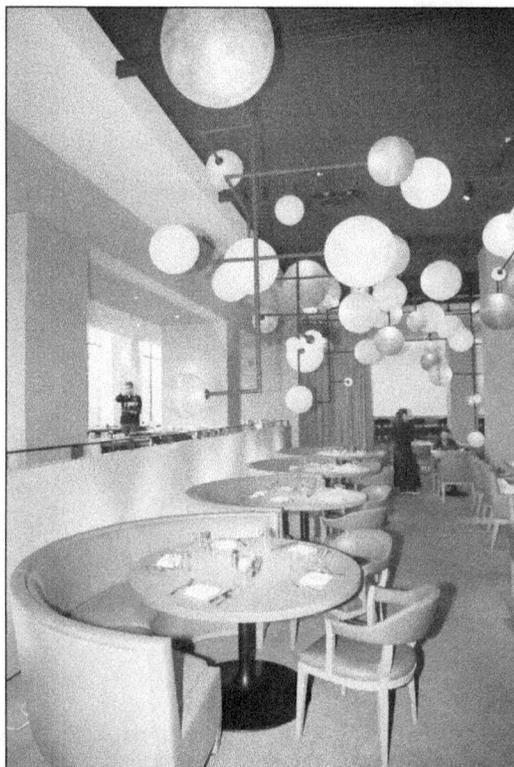

The interior design of the Pump Room and hotel was completed by an in-house design team with the help of owner Ian Schrager. Many regular guests of the Pump Room inquired about what would happen to the hundreds of celebrity photographs that hung on the walls. Now they can be found on the walls of the lower level of the restaurant, along with the former Pump Room sign.

Note the comfort and elegance of the Pump's Room sitting area.

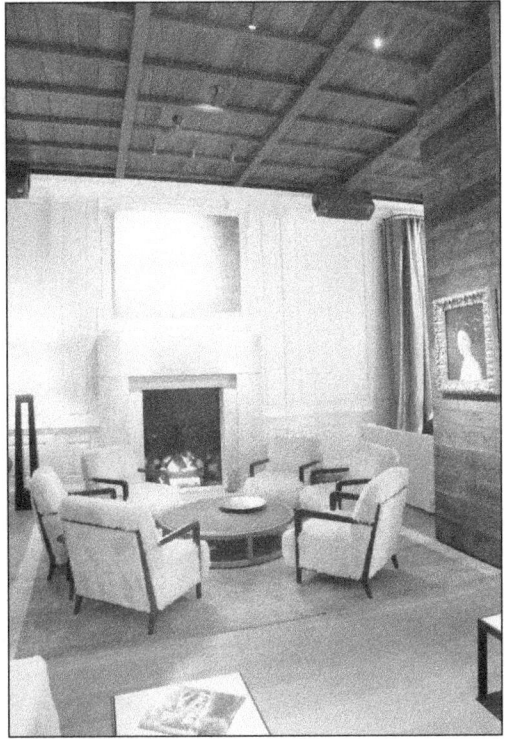

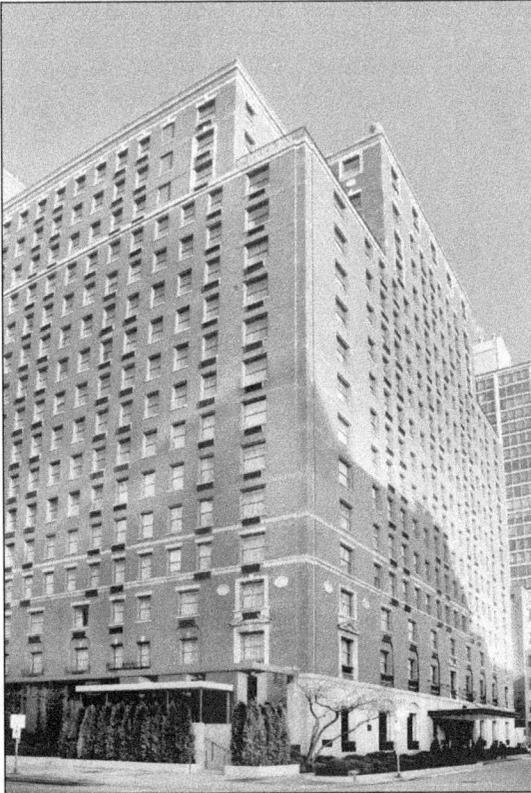

Here is the former Ambassador East Hotel, now the Public Chicago Hotel. Owner Ian Schrager incorporated sophistication, personalized service, and comfort at affordable prices. Guest rooms start at a mere $165 per night. More Public Hotels are due to open in New York, Los Angeles, and London.

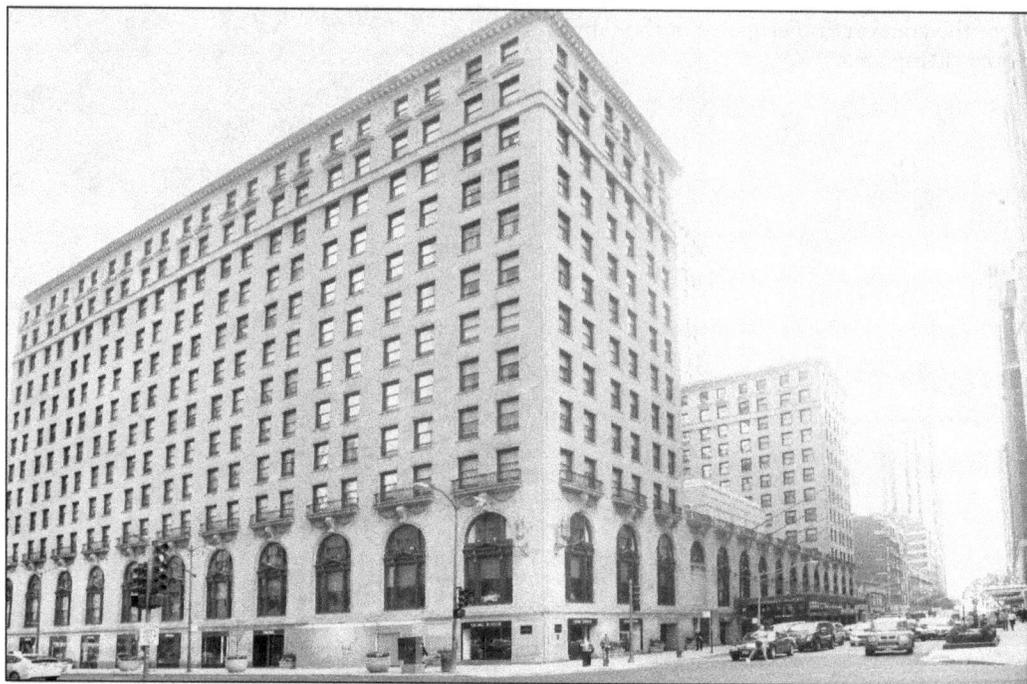

The Drake Hotel at 140 East Walton Place was built in 1920 by the Marshall & Fox architectural firm. The design is considered classic Italian Renaissance. There are 530 rooms, 74 suites, and a presidential suite.

For generations, the Drake was the choice hotel for many heads of state, European aristocracy, celebrities, international personalities, and local wealthy residents who lived their last days out at the establishment, such as Edith Rockefeller McCormick.

In 2006, the Drake became part of the Hilton Hotels Corporation and the Hilton family of hotels. Since then, many luxury upgrades have been added to the guest rooms. The public rooms remain just as breathtaking as when the hotel opened in 1920.

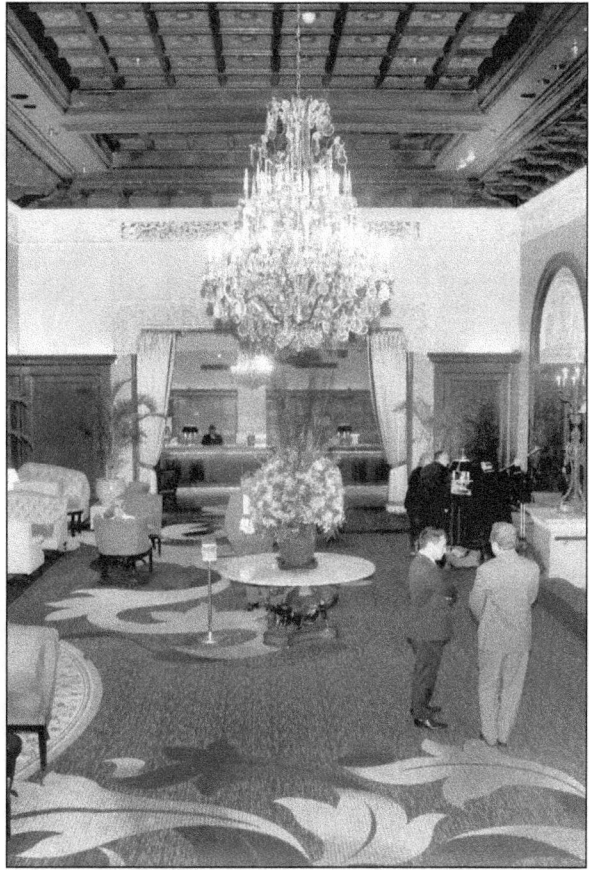

Chicago's famous skyline, seen here from Oak Street Beach, is dominated by the John Hancock Building. The Drake sits directly in front of the Hancock and the Art Deco Palmolive, formerly the Playboy Building, and its illuminated Lindberg Beacon.

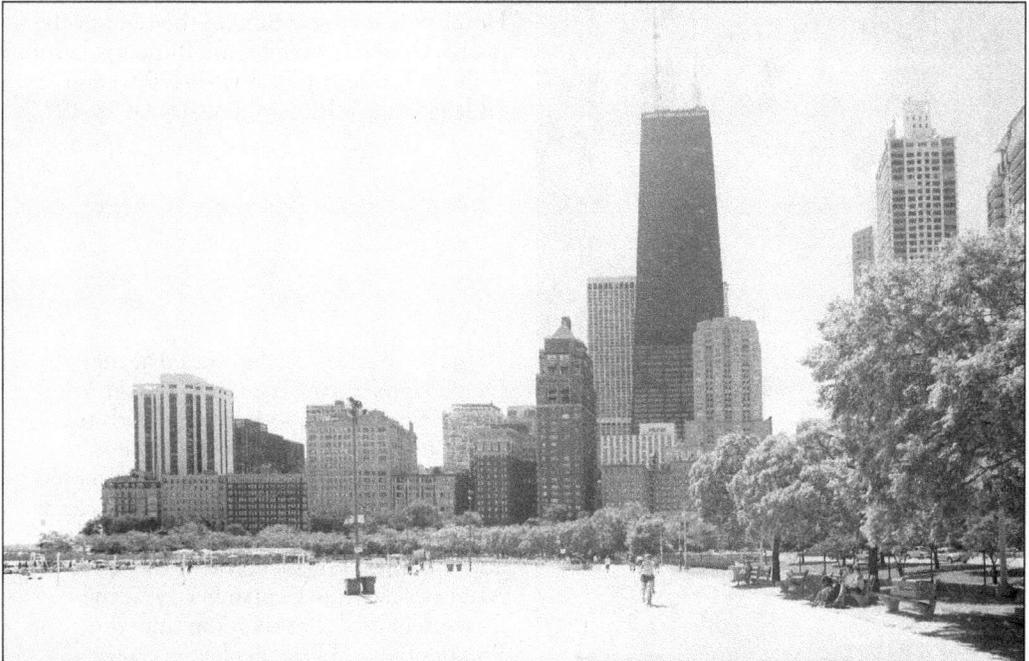

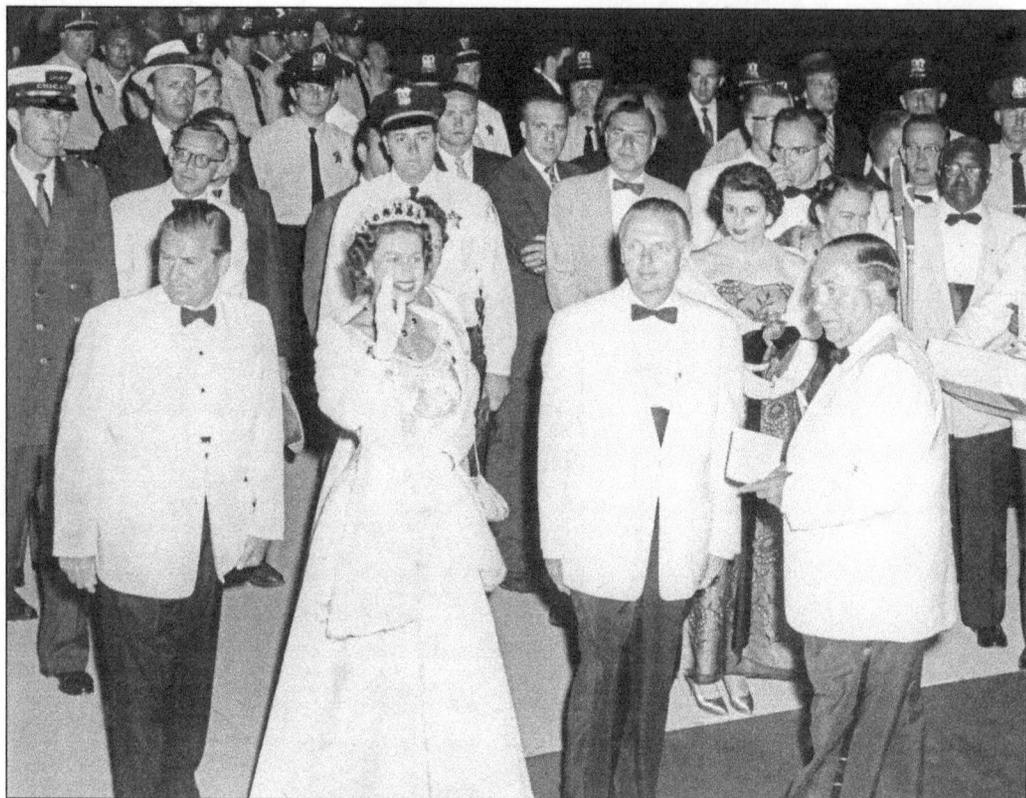

During Queen Elizabeth's visit to Chicago in 1959, there were a host of parties and events in her honor; one of them was held at the Drake Hotel. The men standing to the right of the queen, from left to right, are Illinois governor William Grant Stratton (1914–2001) and Chicago mayor Richard J. Daley (1902–1972).

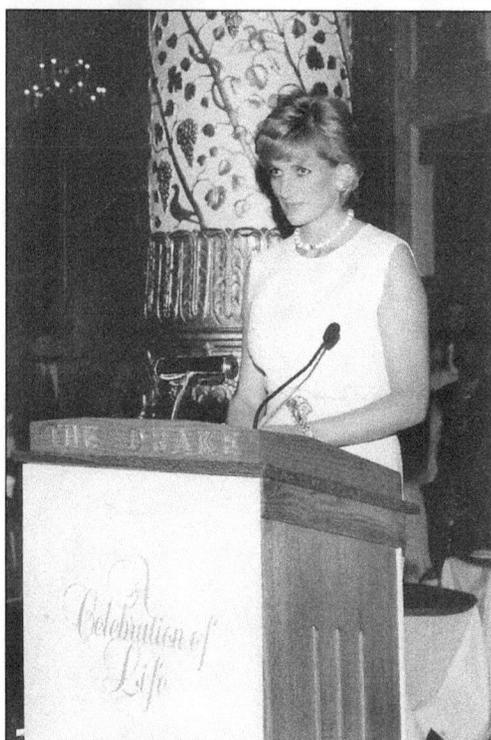

Diana, Princess of Wales, stayed at the Drake Hotel during her Chicago visit in June 1996. She was so impressed with the hotel staff and beautiful presidential suite overlooking Lake Michigan, it was rumored she called several international friends and talked about how much she loved Chicago and the warm hospitality from the hotel. After her death in September 1997, the Drake renamed that six-room suite the Presidential and Princess Diana Suite.

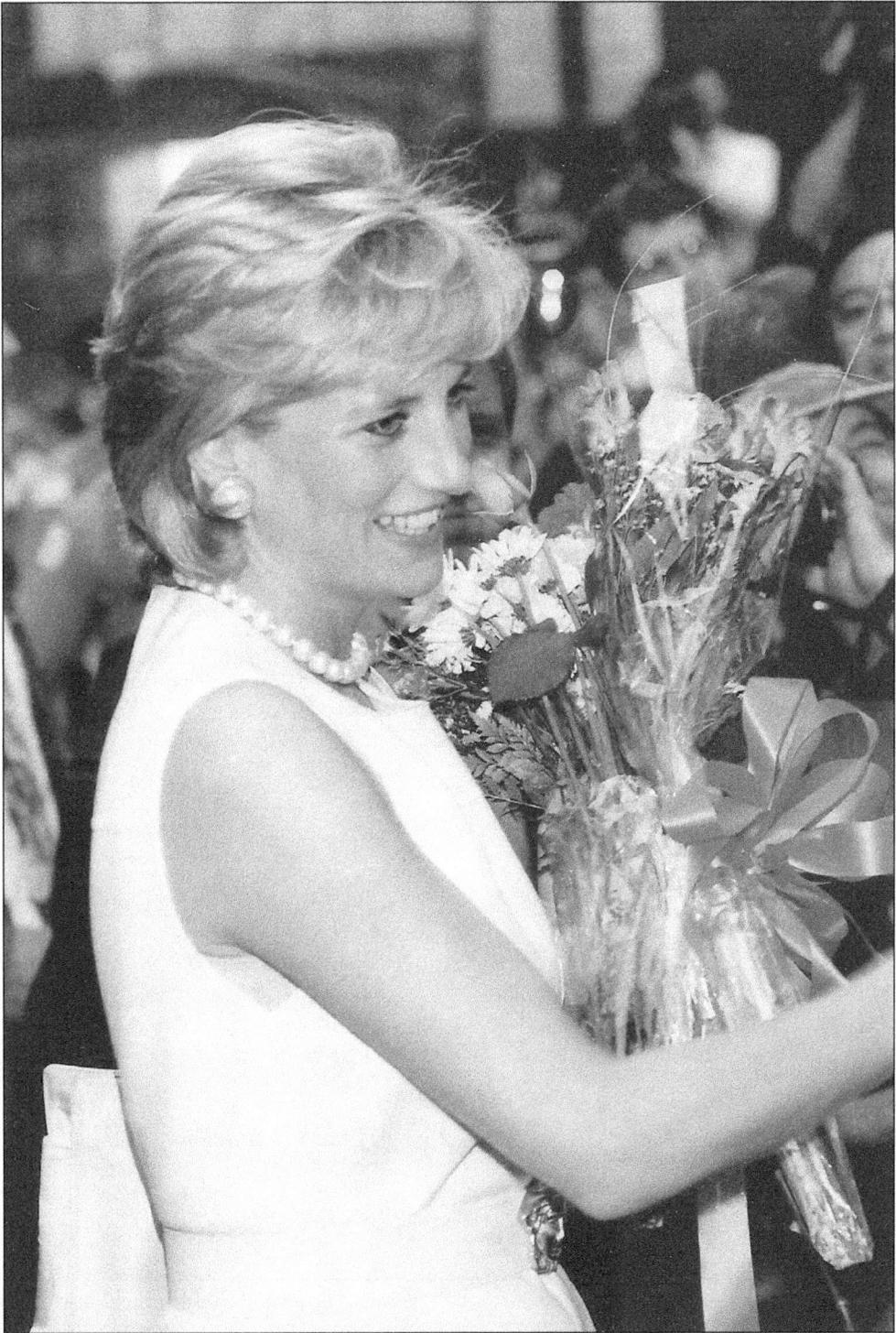

During her visit to Chicago, Princess Diana (1961–1997) made public comments about how beautiful Chicago was and the kindness of people. This was her first and final trip to Chicago. Just one year later, the world stood still after hearing of her tragic death.

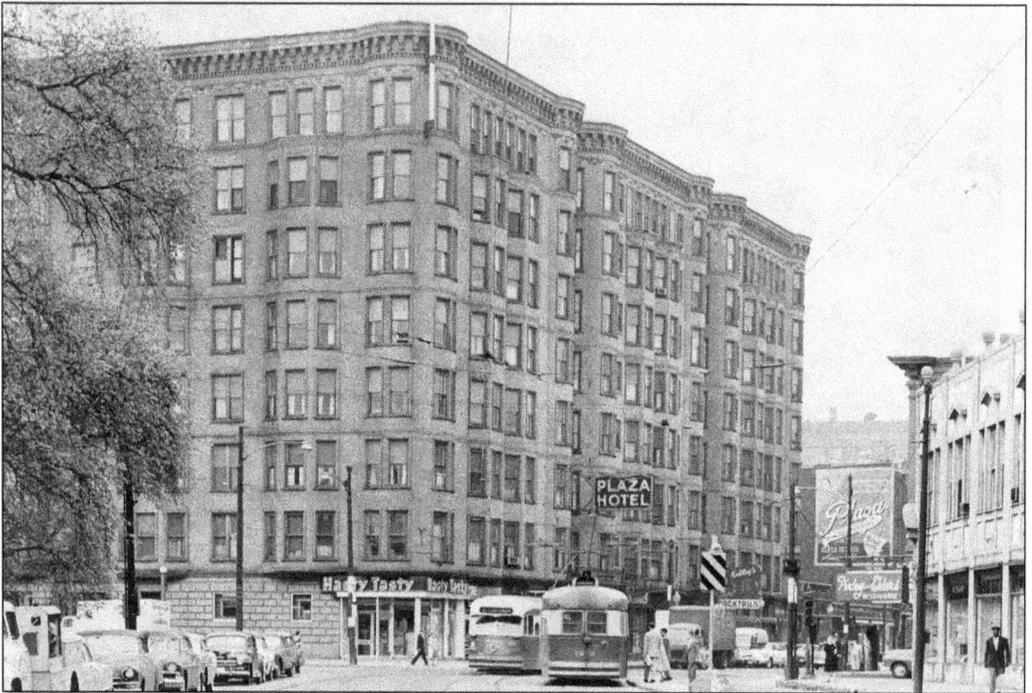

The eight-floor Plaza Hotel at 1553 North Clark Street was designed by architect Clinton J. Warren in 1892. It was another luxury hotel in the Gold Coast. In 1965, it was torn down to make room for the expansion of the private, independent Latin School.

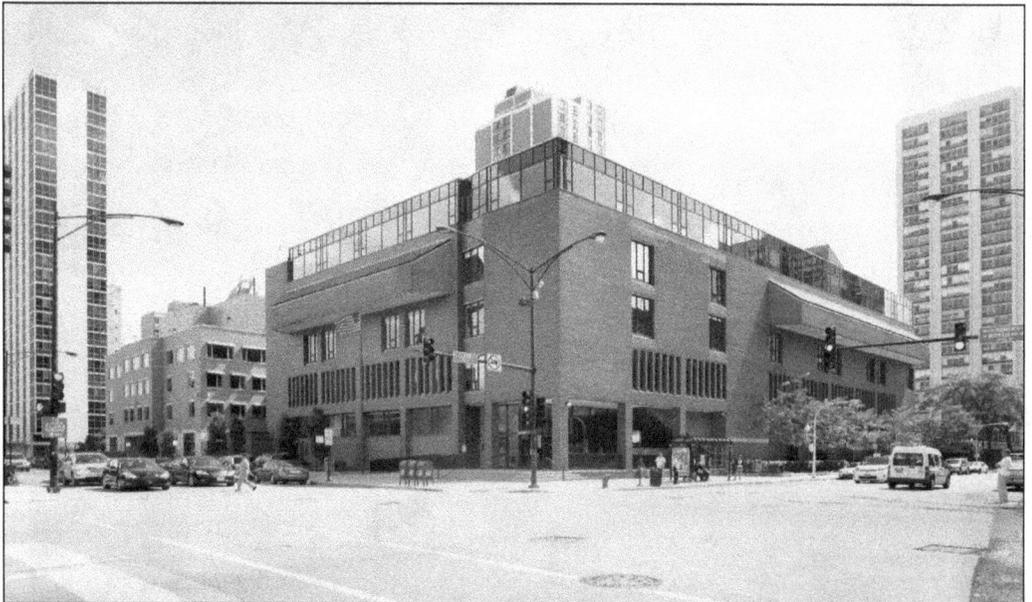

The Latin School was founded in 1888. After being housed at several sites throughout the Gold Coast, this modern building is the home of the Latin School, located at 59 West North Avenue, where it moved to accommodate an increased enrollment. Some of its famous alumni are former first lady Nancy Davis Reagan (1939), industrialist William Wrigley (1950), and Illinois attorney general Lisa Madigan (1984).

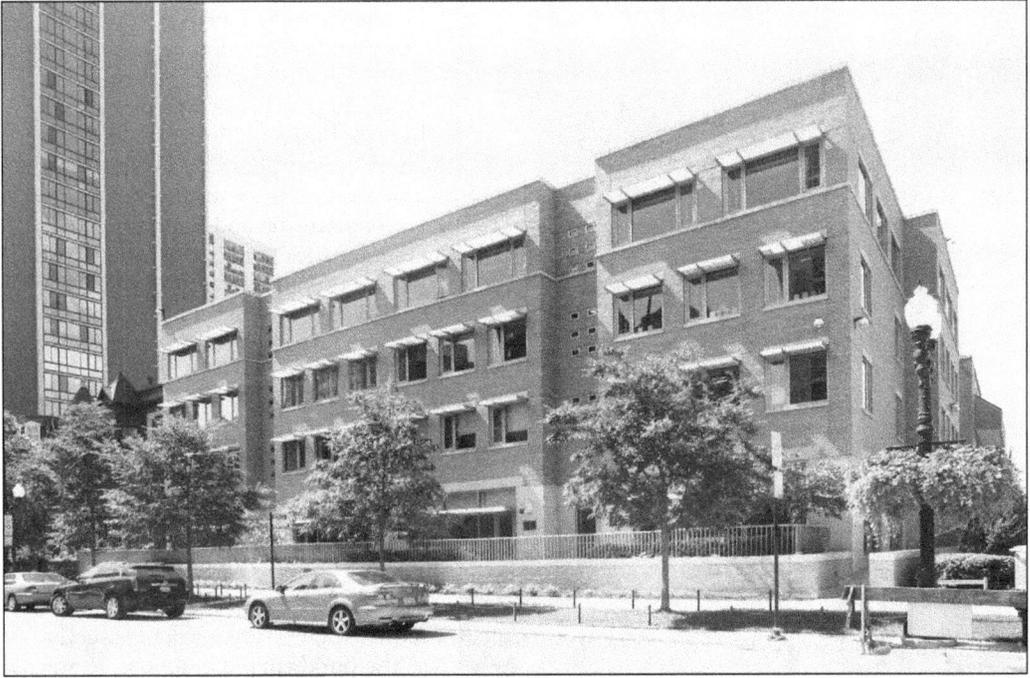

The building is the newest addition of the Latin School, located at 1531 North Dearborn Parkway, one block east of the North Avenue building. This was the former site of the Eleanor Club, founded in 1898 and managed by the nonprofit Eleanor Women's Foundation, which assists many women with building their careers.

The Latin School accommodates kindergarten through 12th grade. This building is the middle school for fifth through eighth grades.

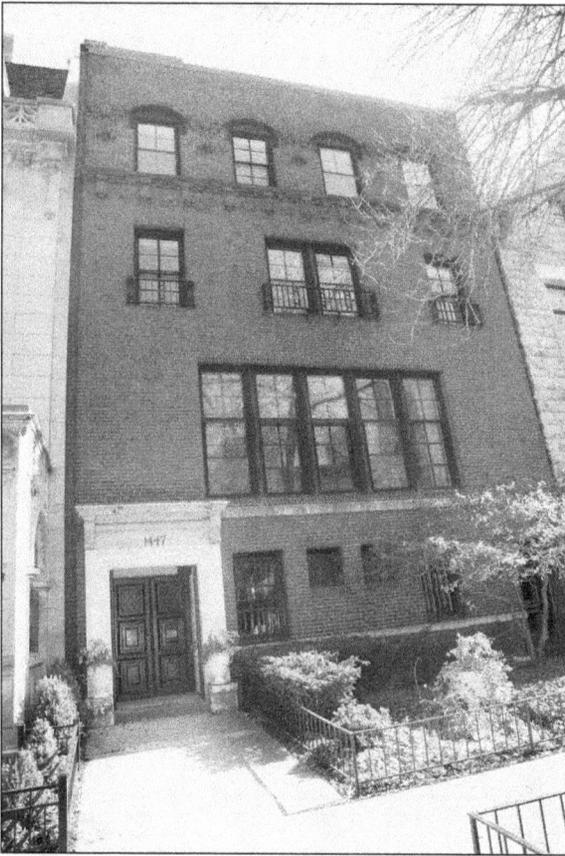

Located at 1447 North Astor Street, this mansion was donated to the Junior League of Chicago in 1953 by Lydia (Thatcher) Wheeler in memory of her late husband, Robert C. Wheeler, an investment banker. The national organization is for women committed to volunteering and improving communities. Since 1954, this home has been used by the Junior League of Chicago to host numerous civic activities, meetings, and receptions.

The Wheeler mansion has remained mostly intact. Interior details such as the hand-carved moldings, the walnut paneling in the library, the stained-glass window overlooking the garden, the hand-painted watercolor wallpaper, and some of the unique pieces of antique furniture can still be found in the mansion.

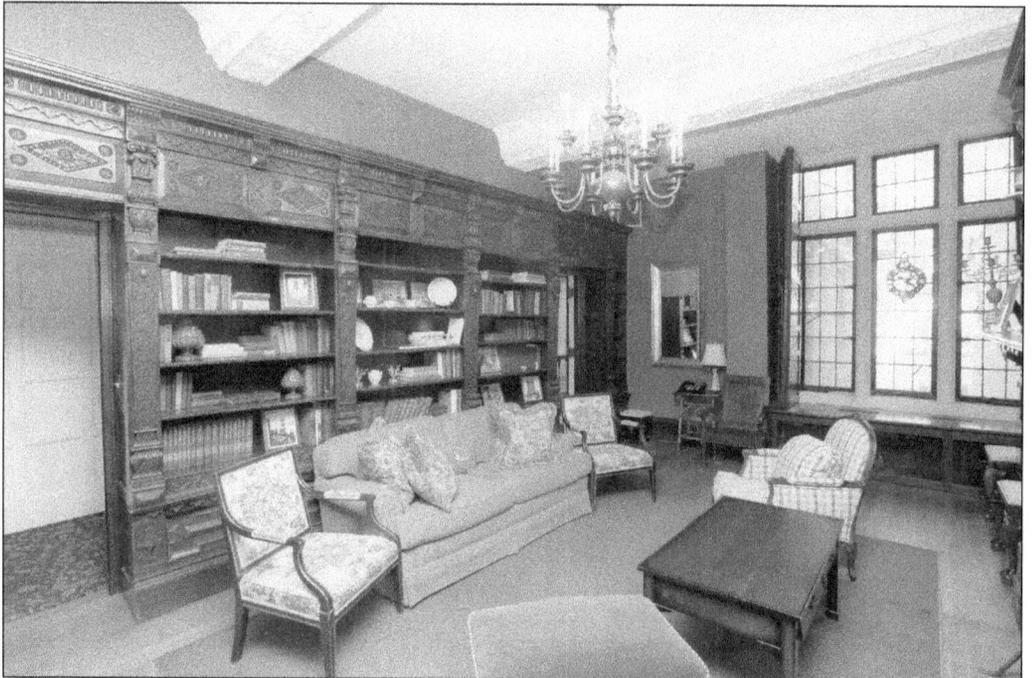

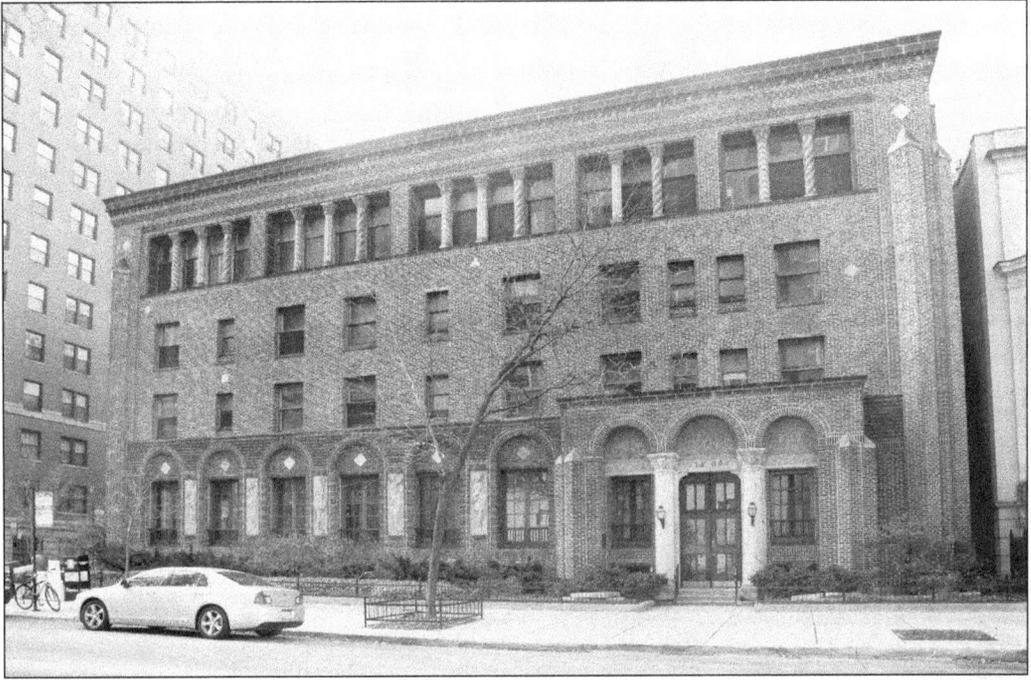

The Three Arts Club, located at 1300 North Dearborn Street, was designed by the architectural firm of Holabird & Roche in 1914. It was a safe, supportive, and economical residence for young women studying the arts. The club remained in this building until 2003. Over 13,000 women were served by the club.

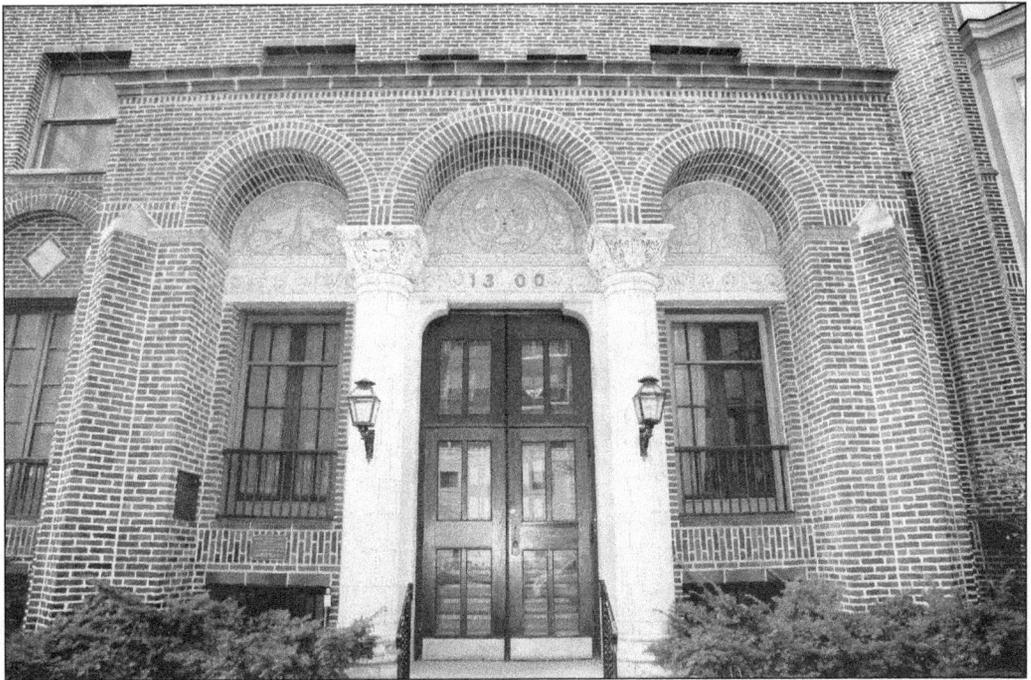

Here is a close-up view of the front door entryway to what was once the Three Arts Club.

In 1981, the City of Chicago named the Three Arts Club a landmark, and it was also placed in the National Register of Historic Places by the US Department of the Interior. The club had 92 single and double rooms.

Here is a rare photograph of the dining room of the Three Arts Club. There was also a tearoom, which was traditionally used every Sunday afternoon.

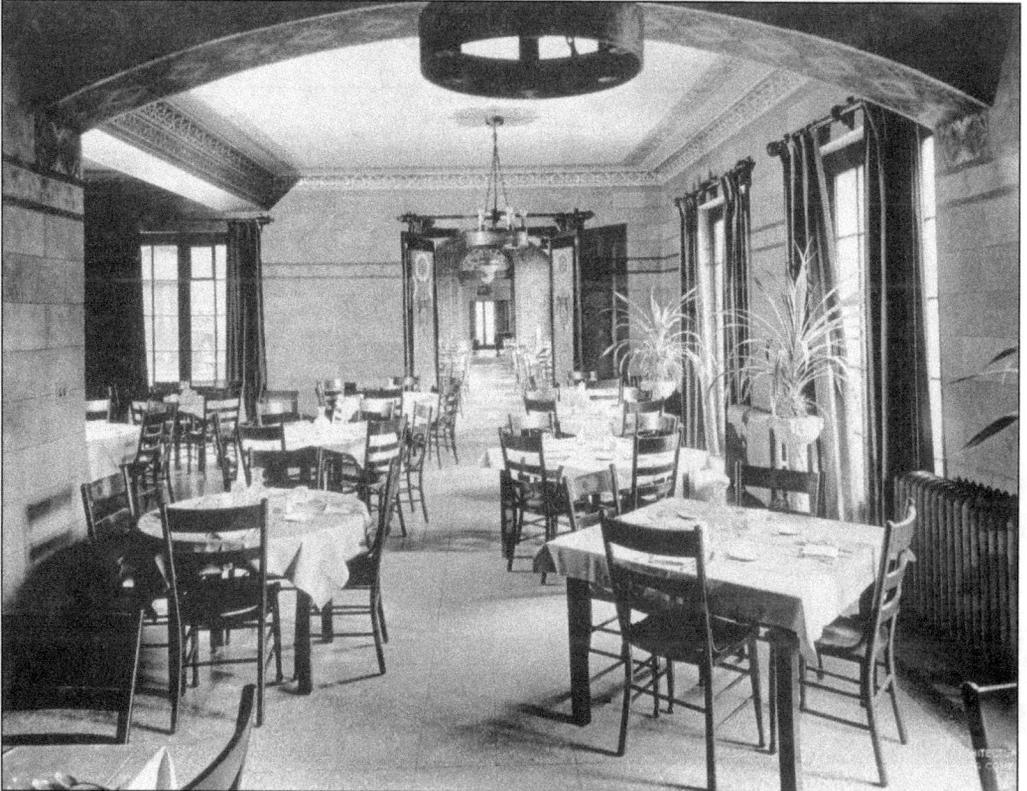

Chicago's Downtown Chabad is located inside of a late-1800s townhouse at 1236 North Dearborn Parkway. This is a community center that offers classes, services, and special events related to Jewish life.

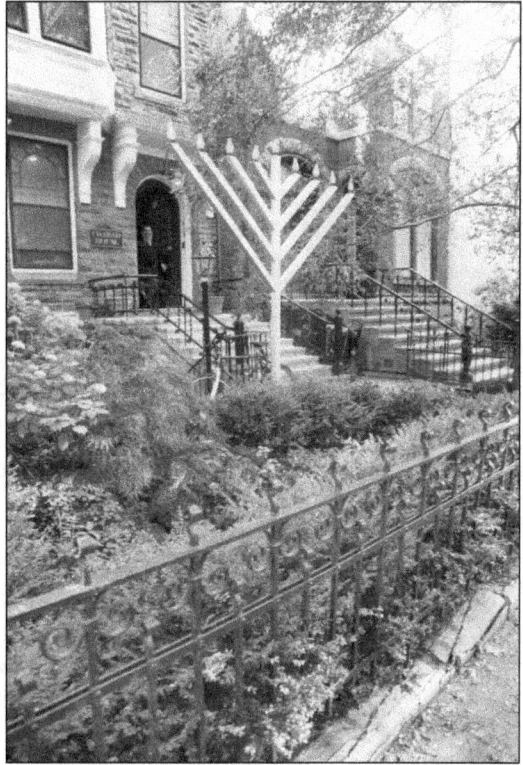

Chicago's Downtown Chabad offers Shabbat holiday services, meals, and preschool classes, among other services. There is also a gift shop inside.

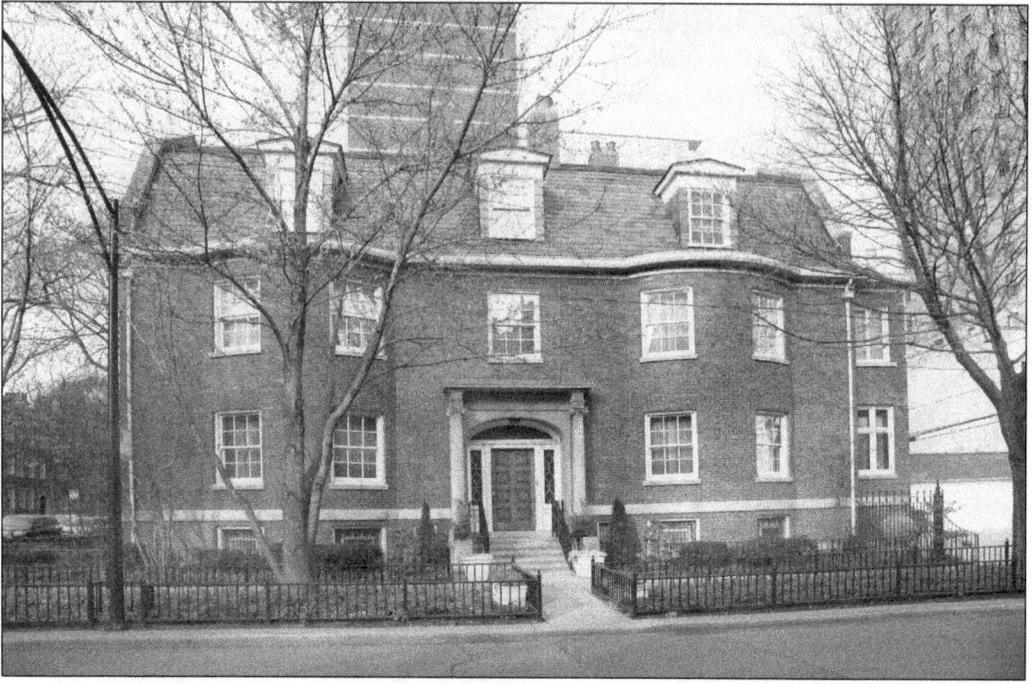

In 1958, the Greek Orthodox Metropolis of Chicago purchased this mansion at 40 East Burton Place. Like the Cardinal's Residence at 1555 North State Parkway, there is a chapel inside.

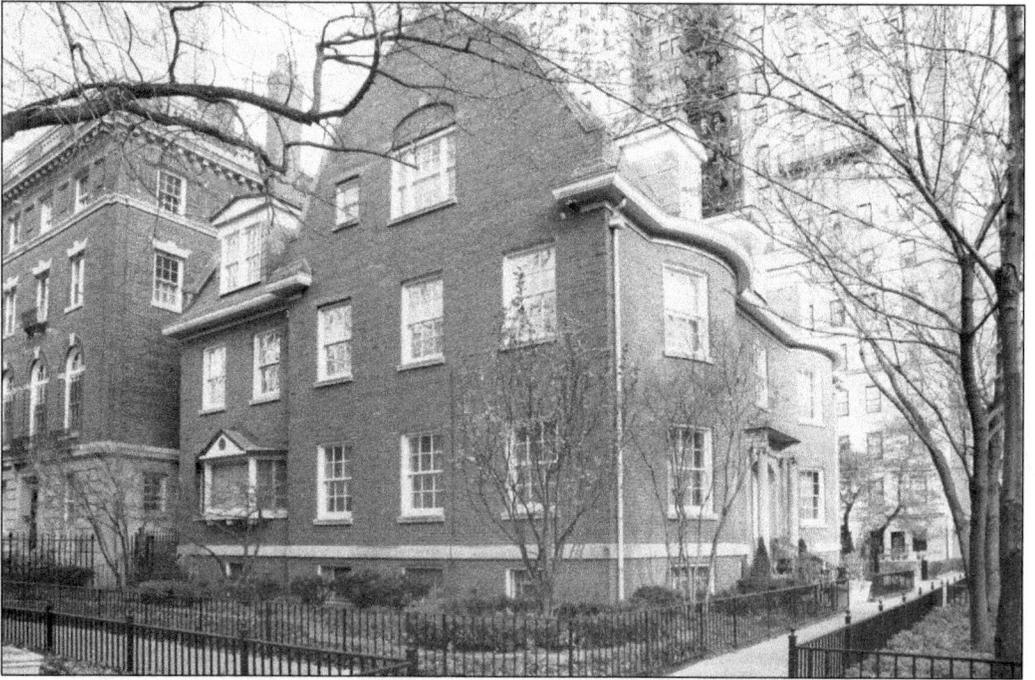

Since May 1, 1976, Metropolitan Lakovos was enthroned as the bishop of Chicago. The Greek Orthodox Metropolis of Chicago oversees the states of Illinois, Wisconsin, Iowa, north Indiana, and eastern Missouri. It services about 26 million total in population.

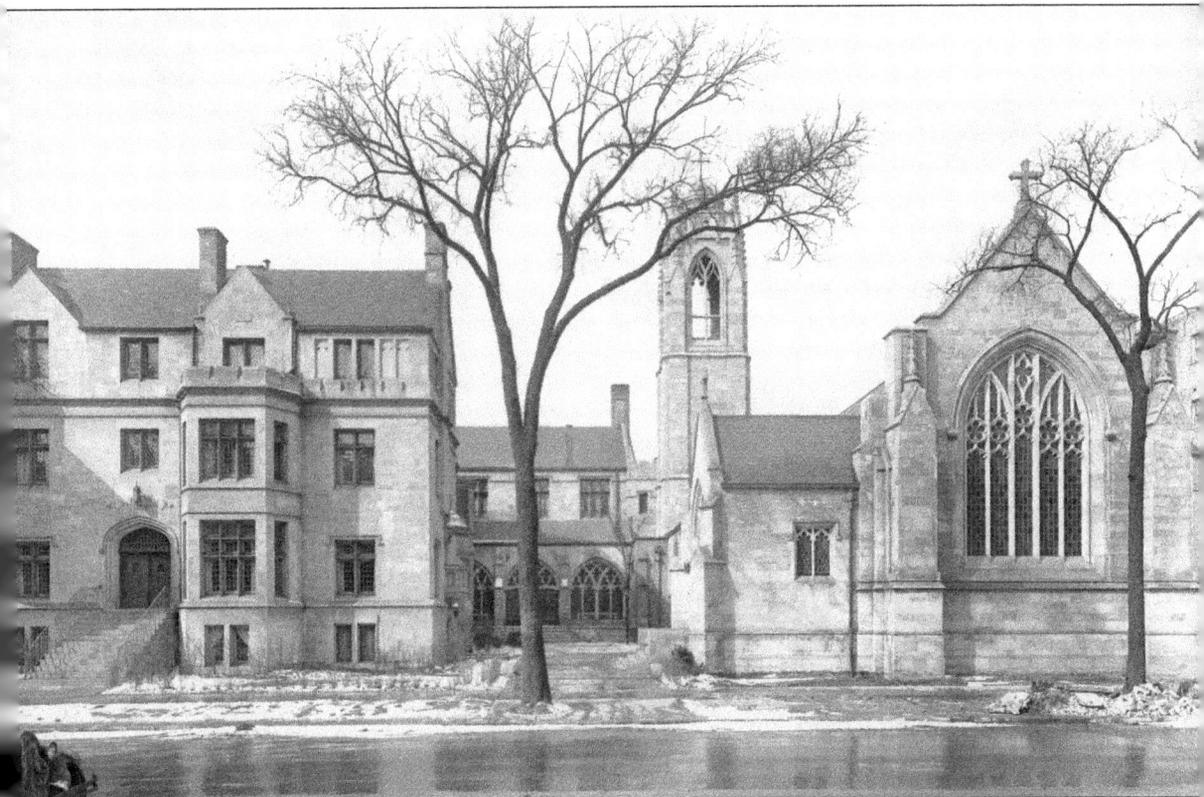

Located at 1424 North Dearborn Parkway, the Episcopalian Diocese of Chicago was built in 1898. For well over a century, it has been active in the Gold Coast with numerous community programs. One of the most popular programs is the day school, launched in 1974 for children two to five years old.

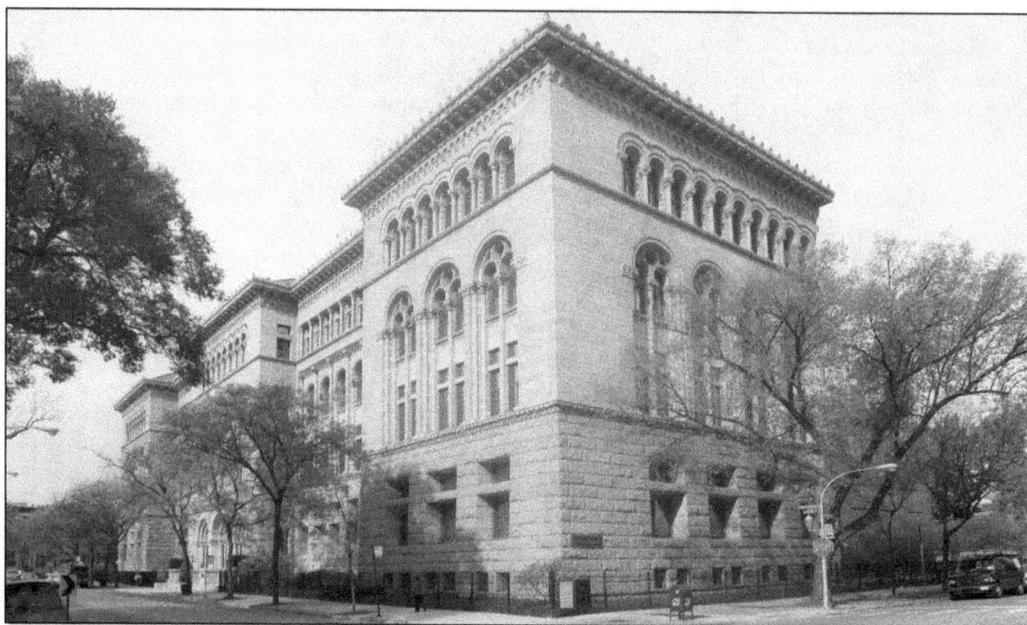

The Newberry Library, located at 60 East Walton Street across from the beautiful Washington Square Park, was designed by William Frederick Poole and architect Henry Ives Cobb in 1893. An independent research library specializing in humanities and social sciences, it is privately endowed and noncirculating; however, it is open and free to the public.

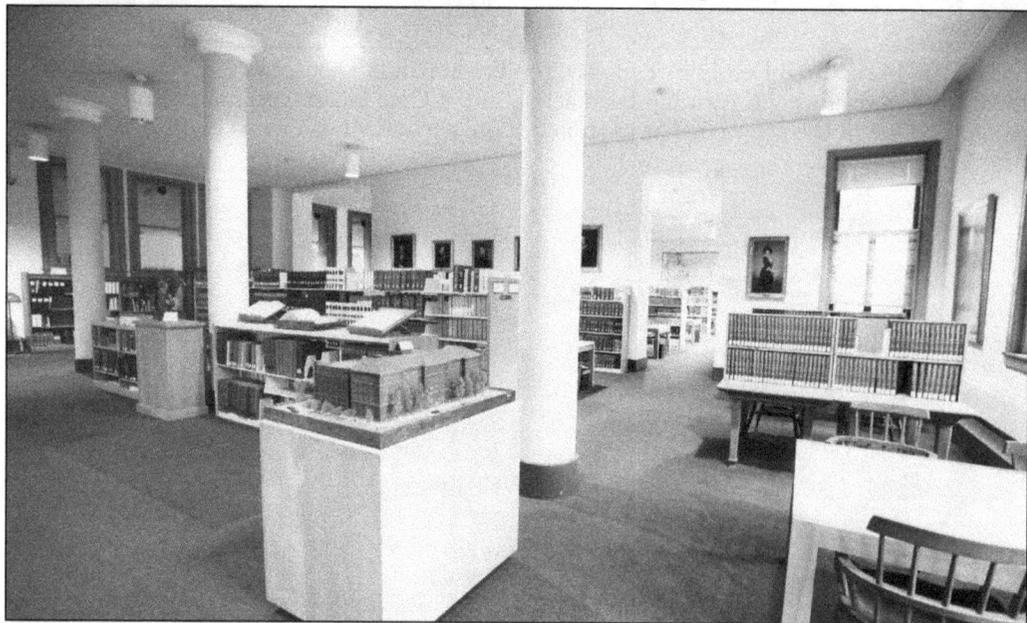

There are collections of maps, manuscripts, sheet music, and other printed ephemera in the Newberry Library. In 1983, architect Harry Weese oversaw restoration of the interior of this building and designed an addition with temperature-controlled rooms that now stores more than 1.5 million books, 5 million manuscripts, and over 300,000 maps. Although this building has been the home of the Newberry since 1893, there's a collection of genealogy and local history materials that dates back to 1887.

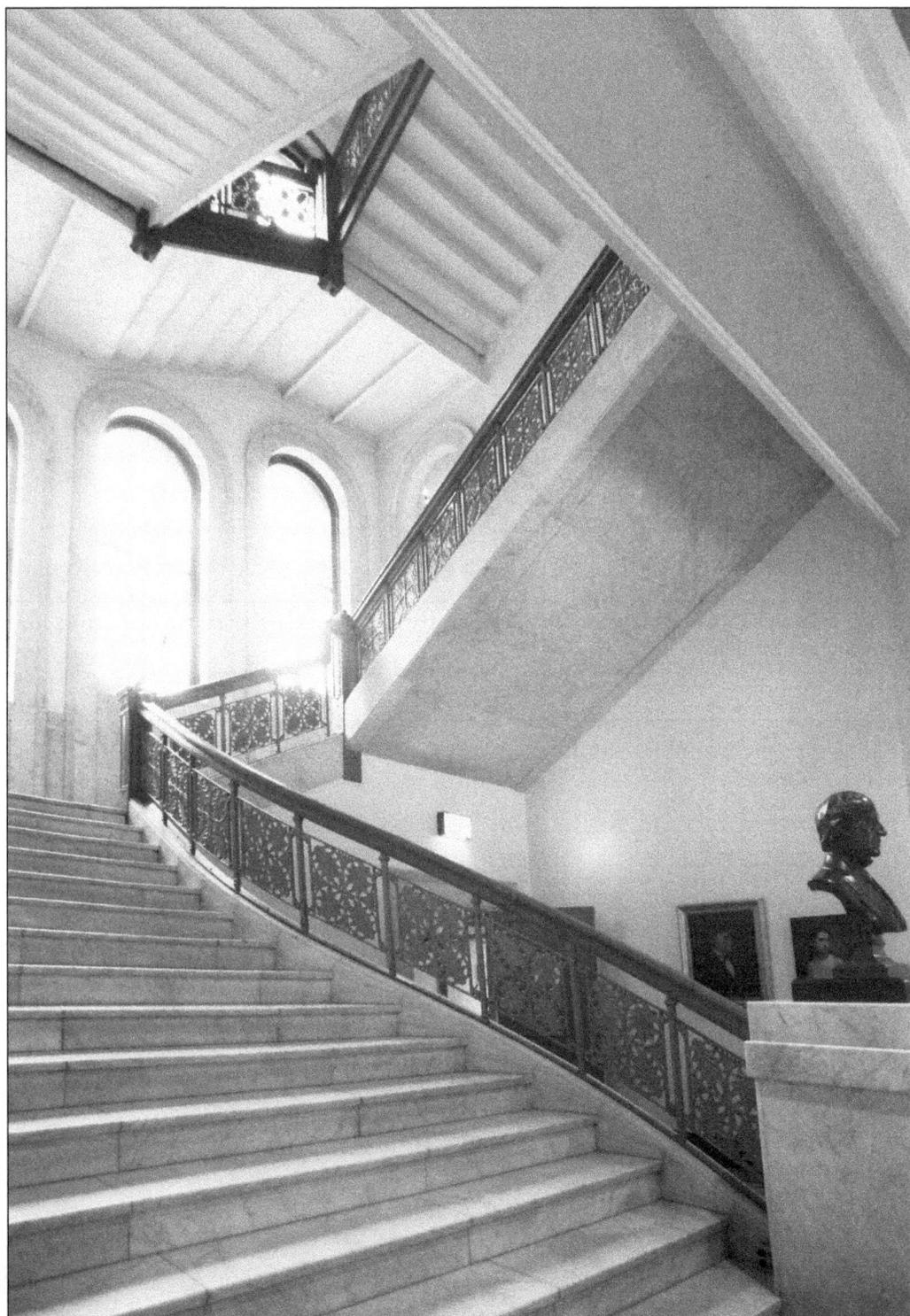

The beautiful marble staircase and ornate wooden banister were also part of the centennial restoration.

During 1993, in honor of its centennial, the Newberry Library restored the main lobby to its 1893 grandeur, as seen here.

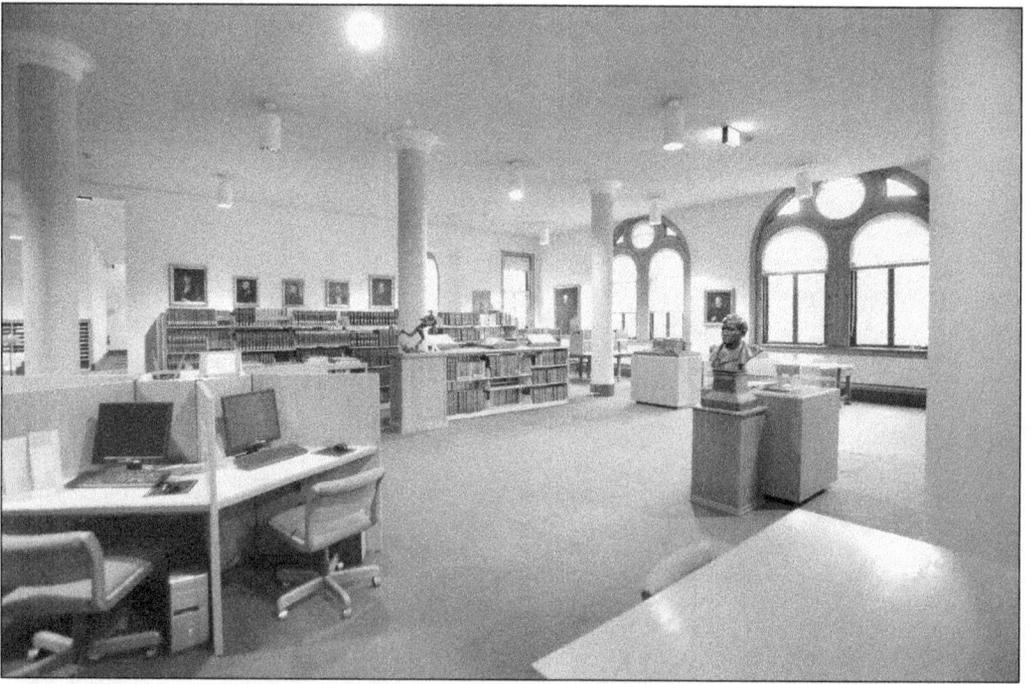

This is one of the reading rooms equipped with 21st-century technology but surrounded by old artifacts, paintings, and sculptures.

This Victorian-era second empire greystone mansion, located at 1150 North Dearborn Parkway, was originally built for John and Helen DeKoven in 1874 by architect Edward Burling; however, it is most famous for the restaurants that set up shop inside of it. In 1964, it opened as a public restaurant called Biggs. In 2003, it was purchased, renovated, and renamed Biggs Steakhouse, Seafood & Wine Bar. A few years later, it was purchased by the upscale Italian restaurant chain Il Mulino. In September 2011, rumors started circulating across the country about the mansion possibly becoming a Playboy Club.

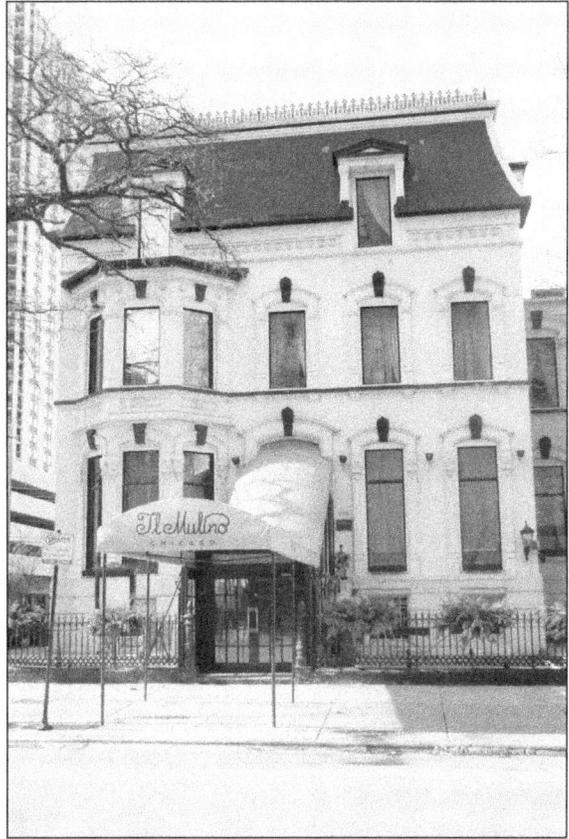

Here is the cast iron gate to the DeKoven House that welcomed visitors in the 1930s.

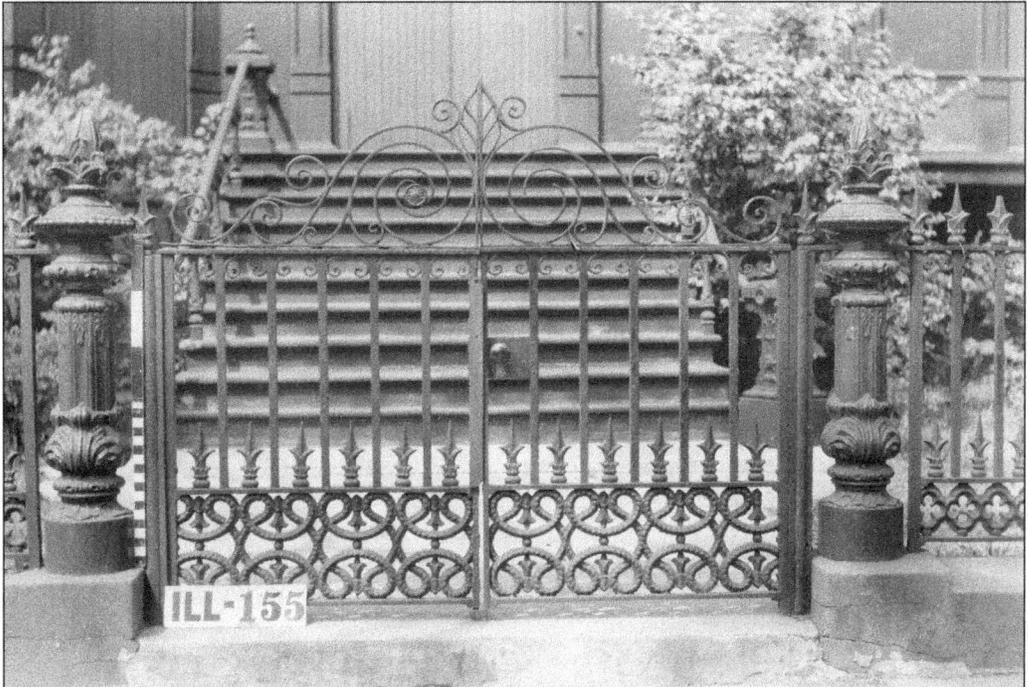

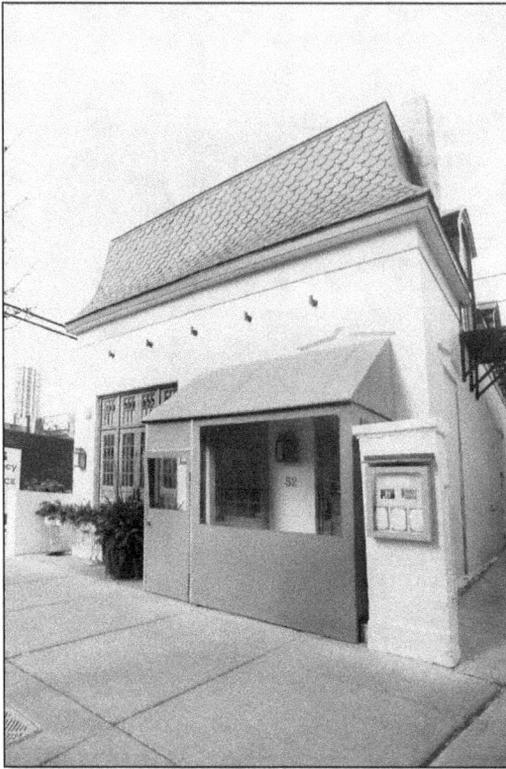

Celebrity chef Art Smith, Oprah Winfrey's former personal chef, opened his first restaurant inside of this coach house located behind the Il Mulino restaurant in 2007 at 52 West Elm Street. Before taking over the space, it was the home of Albert's Cafe & Patisserie. Now Smith draws some of the biggest public figures in the country to his small eatery Table Fifty-Two. His customers have included Pres. Barack Obama and First Lady Michelle Obama, as well as musical artists Lady Gaga, Mary J. Blige, and the Black Eyed Peas.

The Stanford Arms takes up the entire bock at 1164 North Dearborn Street. There are several retail businesses on the first floor. This is also the location of Gold Coast's popular coffeehouse Starbucks. Many locals enjoy one of the signature coffees named after the neighborhood. In fact, a few years ago, the Starbucks Coffee Company developed a Gold Coast blend of coffee for its retail product line: "Like its namesake, this is one lavish coffee—as sophisticated as the neighborhood itself. Serving suggestion: A slice of chocolate cheesecake and a view of Lake Michigan."

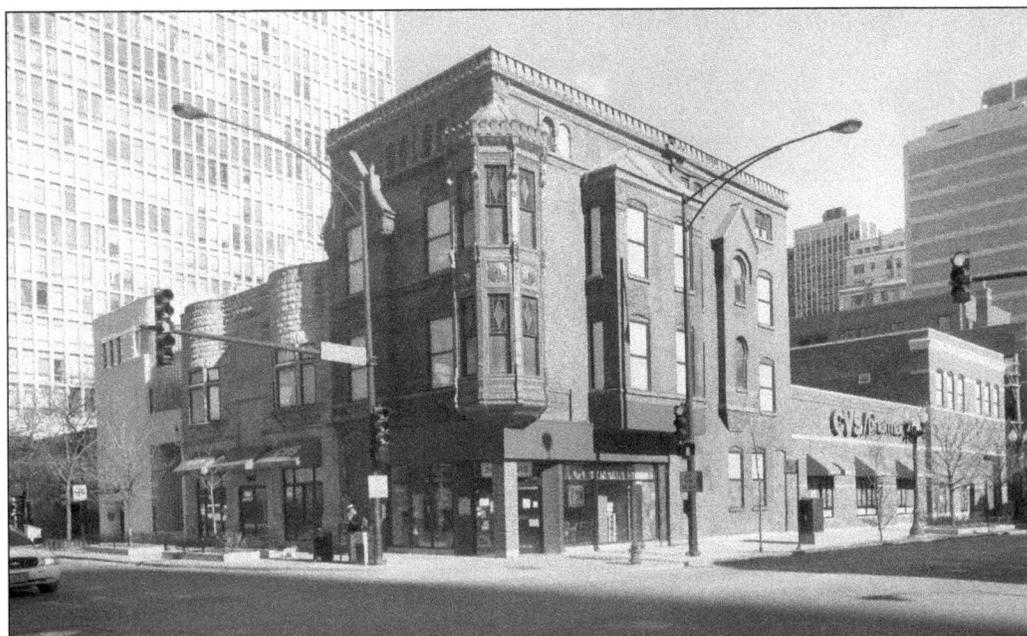

This Victorian building at 1201 North State Parkway was constructed in 1881. When national retailer CVS decided to open one of its stores here, renovation was carefully executed to assure the exterior of the building was not altered or changed.

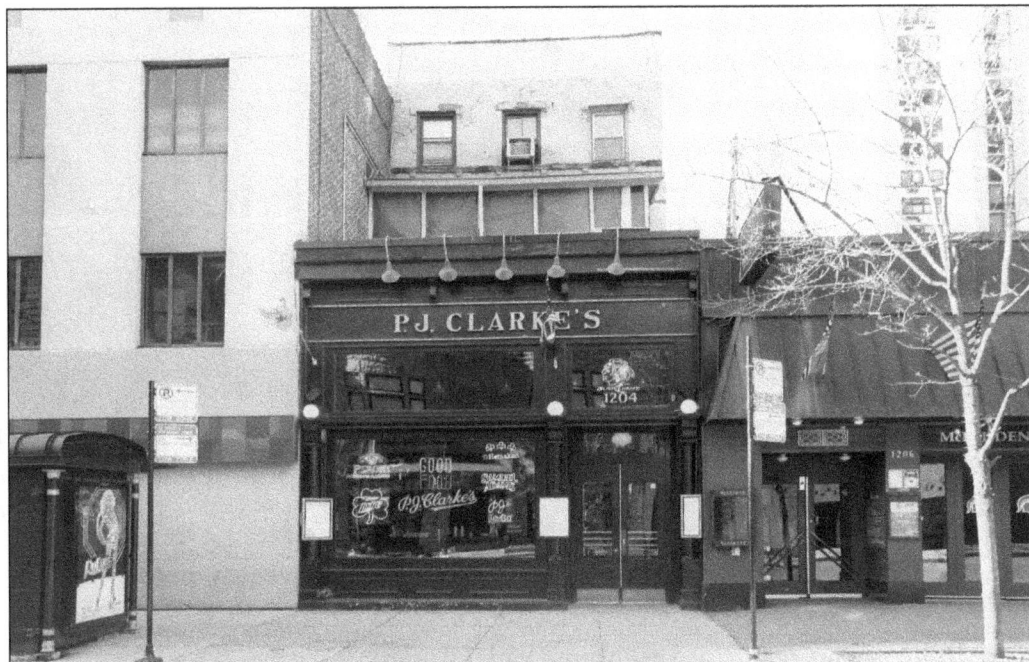

PJ Clarke's Gold Coast, located at 1204 North State Parkway, has been a neighborhood favorite since 1986; however, its flagship location is New York City, which is over 130 years old. There are several Irish dishes on the menu, but one of the local favorites is the Gold Coast Appetizer Platter, a combination of buffalo chicken tenders, chicken quesadillas, mini-burgers, small onion strings, and fried calamari.

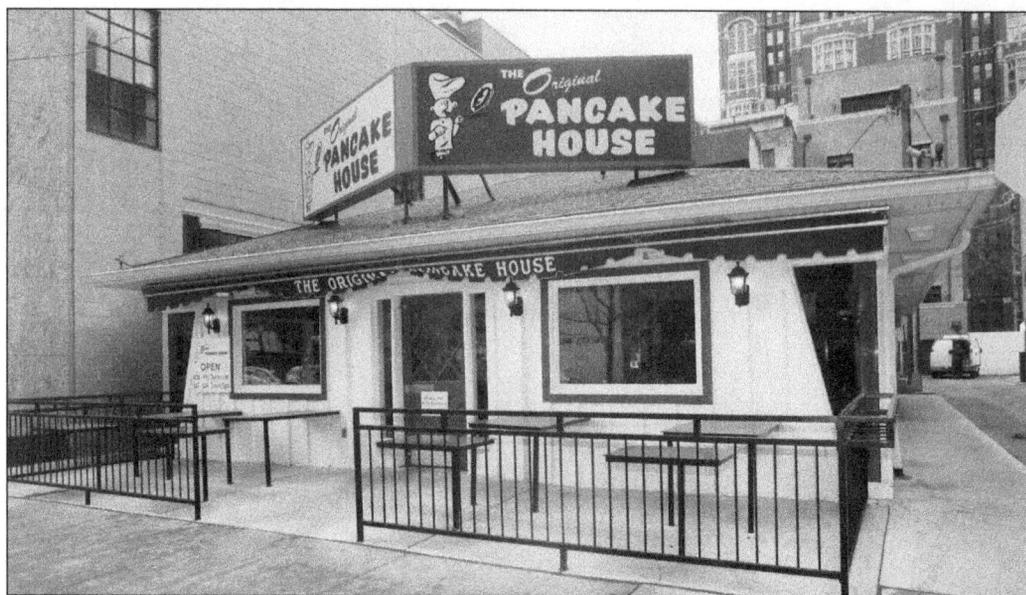

The Original Pancake House is the most popular place to eat breakfast in the Gold Coast. For over 50 years, it has been in this small house-shaped structure at 22 East Bellevue Place. As many locals will attest, it can easily take an hour or longer to be seated for the weekend breakfast and brunch; nevertheless, many will agree that the signature apple pancake is worth the wait.

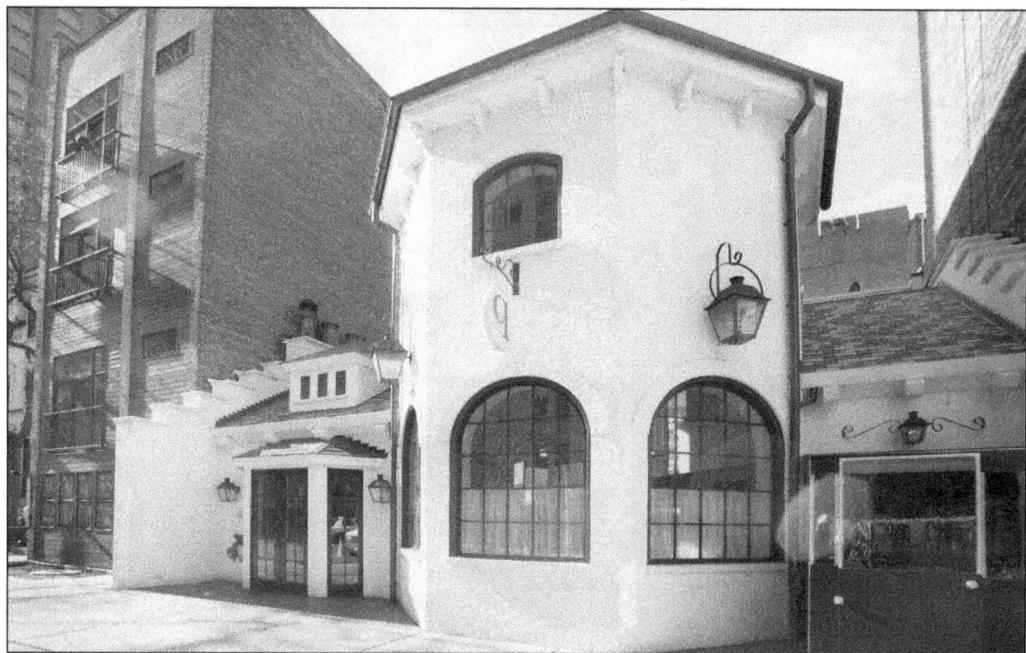

Chicago q restaurant, located at 1160 North Dearborn, is one of the newest restaurants in the Gold Coast. Since its construction in 1981, the building has housed several eateries, including a former sushi bar restaurant. Chicago q has been at this location since 2010. This southern-flavored barbecue restaurant has a stylish touch to its decor, as well as the menu. Side dishes are served in small cast iron skillets. The Kobe brisket, cooked with wood-burning smoke, is a local favorite, and the prix fixe lunch menu is quite popular.

118

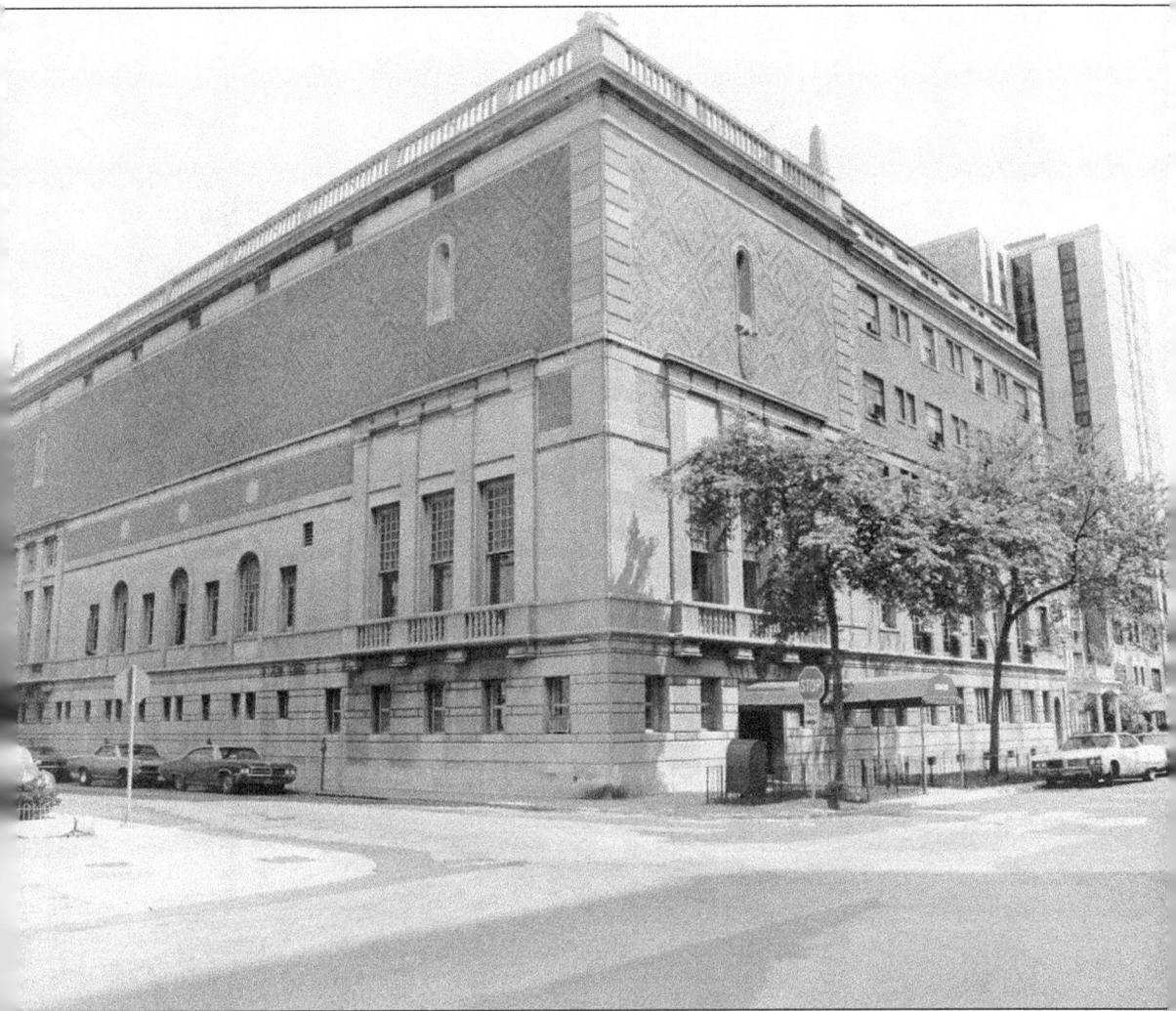

This building at 1365 North Dearborn Street was designed in a Classical Revival style by architect Andrew Rebori in 1923. It is now home to the Racquet Club of Chicago, a private social club and athletic club. Inside, there are five squash courts, two racquet courts, and one indoor tennis court.

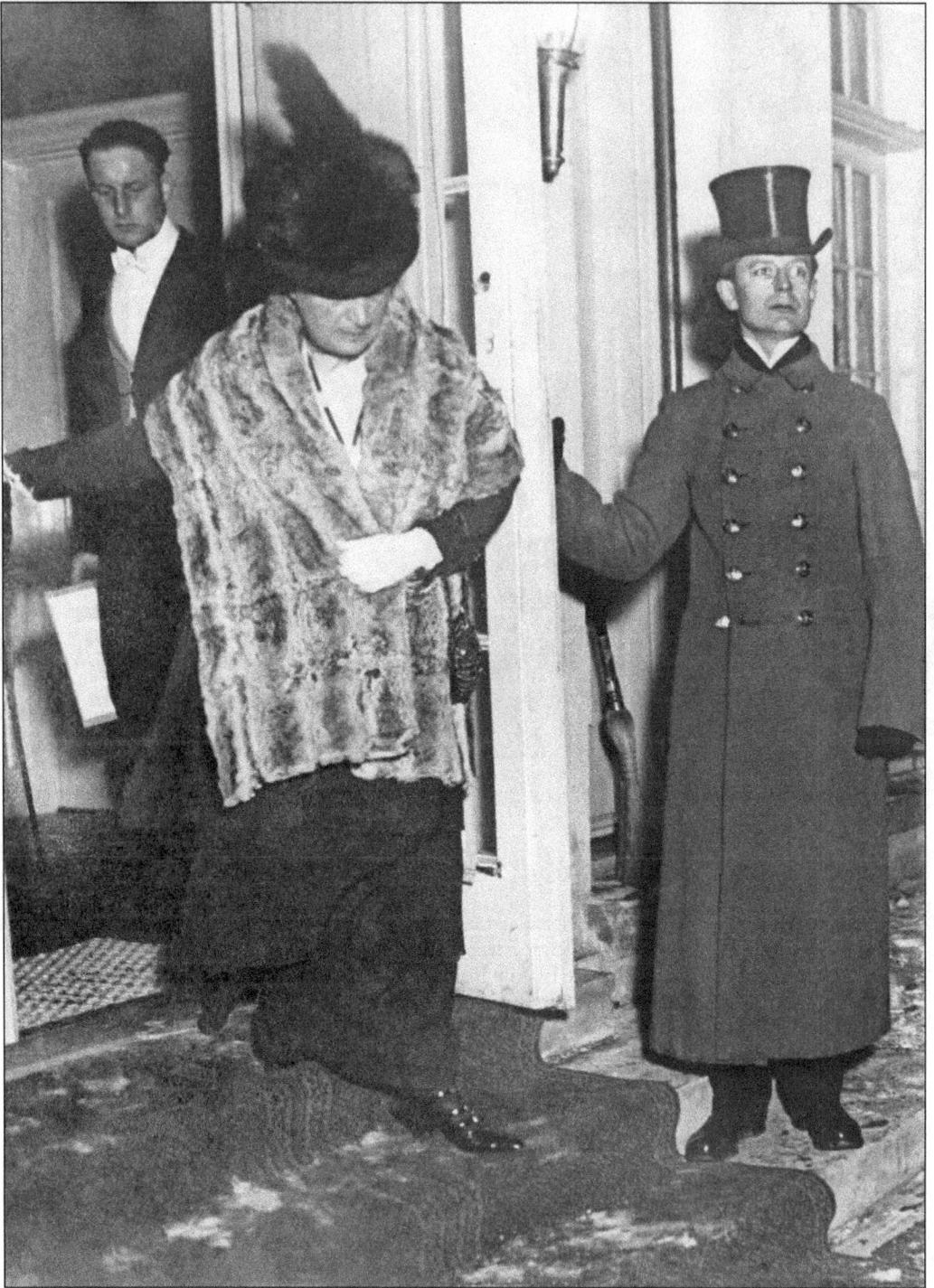

Bertha Palmer attends the opening of the Casino Club, located at 167 East Delaware, on December 12, 1914. On opening night, there were five Palmers, 11 McCormicks, six Armours, 11 Blairs, and five Carpenters in attendance. Today, the Casino Club is at 195 East Delaware Place.

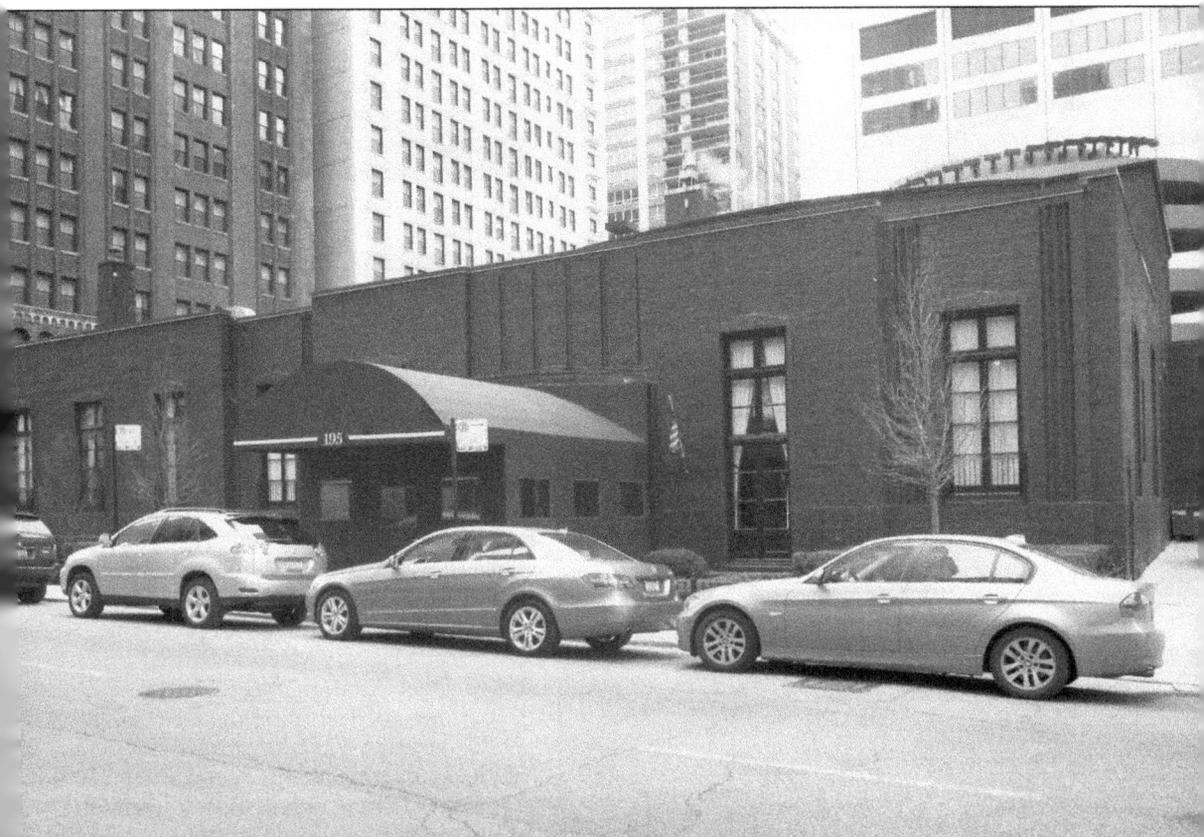

This is a photograph of today's Casino Club, located at 195 East Delaware Place. Tradition continues, as there are no signs posted on the building and no public telephone number listed—privacy remains paramount.

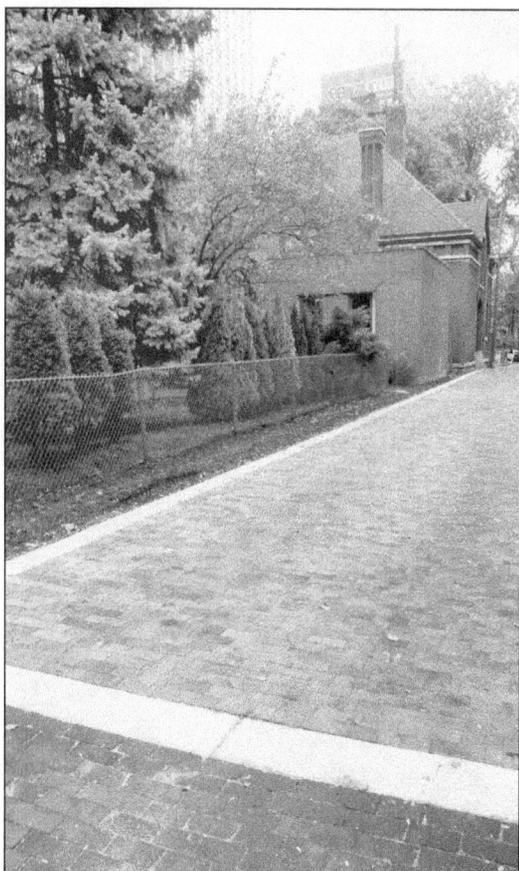

Built in 1909, this is one of the few remaining wooden alleys found in Chicago today. During the late 19th and early 20th century, most of the entire city of Chicago was paved with Belgian blocks in a Nicholson pavement style; however, most of the lumber to make the blocks came from Wisconsin. This alley can be found behind the archbishop's residence, located between the 1500 block north on State Parkway and Astor Street. On May 22, 2002, it was placed in the National Register of Historic Places. In 2011, it was completely restored.

On October 22, 2011, a ribbon-cutting ceremony was held to celebrate the restoration of the wooden alley. From left to right are Audrey Gallery of the Gold Coast Neighbors Association, president of Chicago History Museum Gary Johnson, executive vice president of Chicago History Museum Russell Lewis, Janet Attarian of the Chicago Department of Transpiration, former 43rd Ward alderman Vi Daley, former president of Gold Coast Neighbors Association Maureen O'Brien with grandson Jeremiah Willis, and former president of Gold Coast Neighbors Association Tom Thilman.

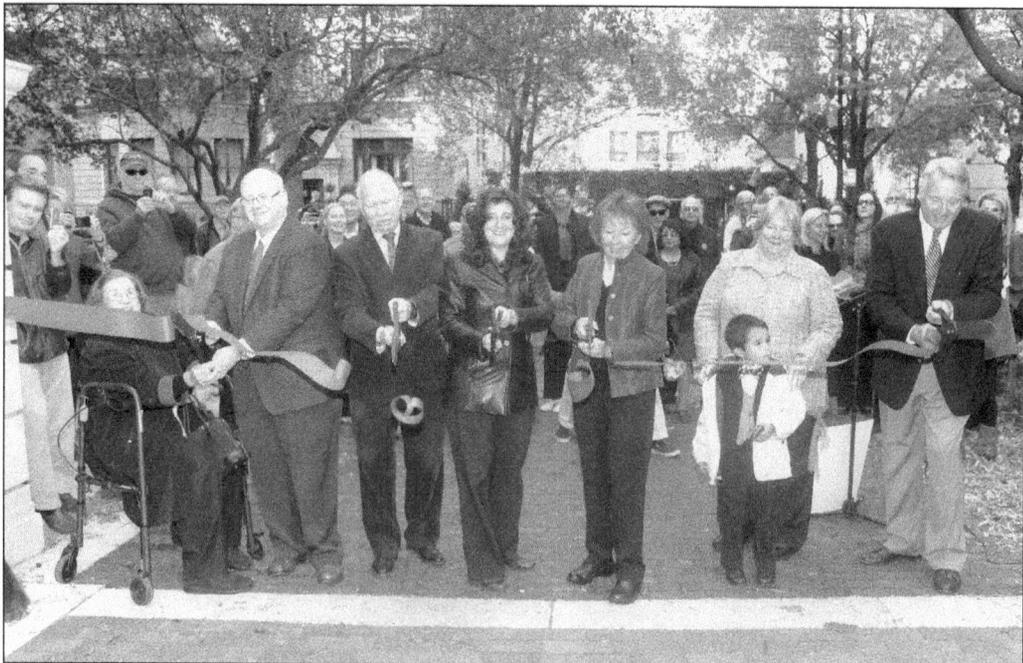

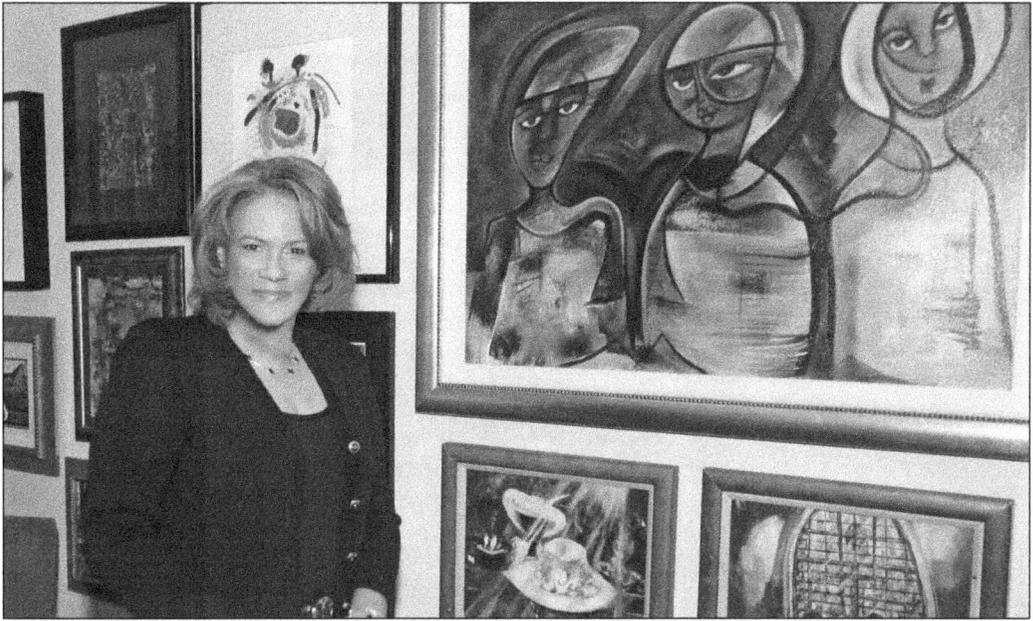

An Emmy Award winner and AIDS activist, Rae Lewis-Thornton graced the cover of *Essence* magazine as the first African American woman to tell her story nationally. She has been featured on the covers of other publications such as *O*, *Glamour*, *Woman's Day*, and *Ebony*. She has also been featured on CNN, ABC's *Nightline*, NBC's *Dateline*, and the *Oprah Winfrey Show*. She lectures across the country on HIV/AIDS and designs bracelets for her line the RLT Collection. A resident of the Gold Coast, Lewis-Thornton says, "I've lived with HIV for 29 years and AIDS for 20 years. Living with AIDS, I've tried to live the best life that I can. When you're staring death in the face, life becomes a precious gift. With each passing day, I do my best, and I seek the best—and Chicago's Gold Coast is the best! On my lowest days, all I have to do is take a walk in my neighborhood and be reminded of the beauty that surrounds me and how wonderful it is to be alive, no matter what I'm facing."

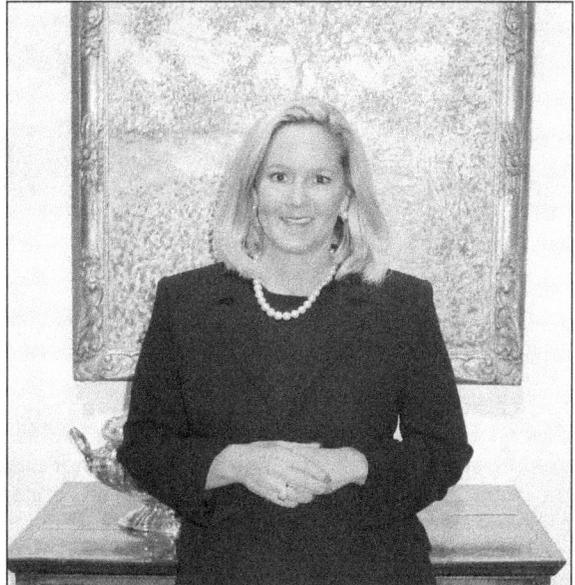

Leslie Hindman owns auction houses in Chicago's Gold Coast; Milwaukee, Wisconsin; and Palm Beach, Florida. She says, "How do I describe my neighborhood? The Gold Coast has everything to offer. We have one of the greatest lakefronts in the world, outstanding cultural institutions, and incredibly friendly neighbors."

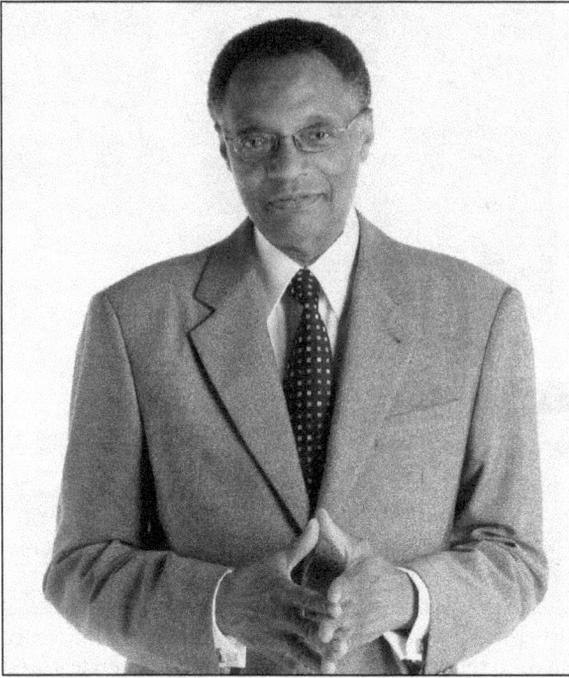

Ramsey Lewis is one of America's leading jazz composers, pianists, and radio personalities. He has recorded over 80 albums. He says, "I consider this neighborhood [the Gold Coast] to be the best of both worlds. It's city living, but I live on a quiet block. It's convenient to walk to some of the best restaurants, theatres, and retail shops. I also live close to some of the world's best cultural centers to enjoy music and the arts, just as the Joffrey Ballet, Symphony Center, and a host of museums. Nowadays, Europeans and other international music lovers come to Chicago to enjoy great music."

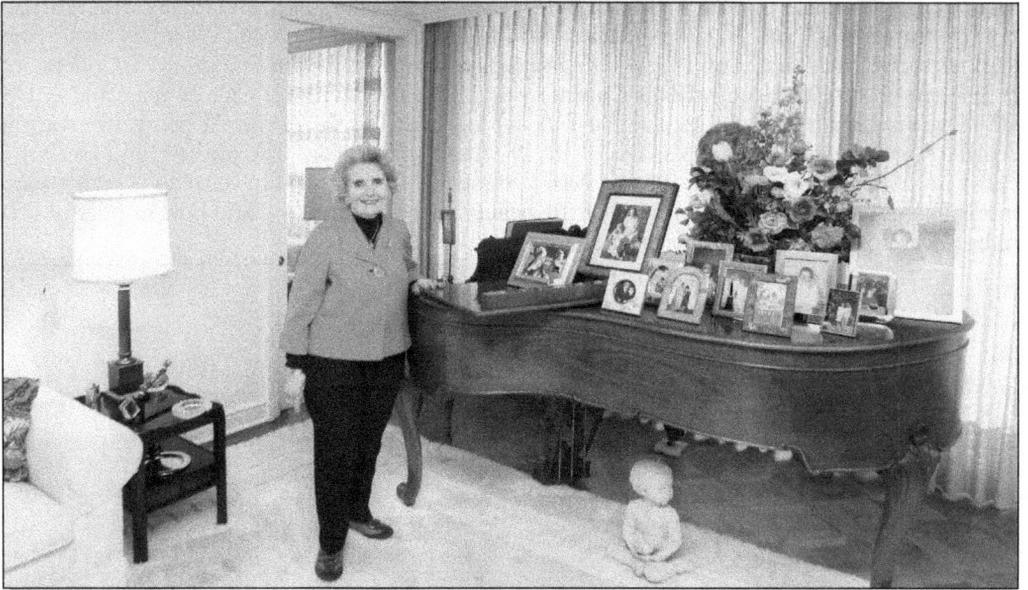

Gold Coast resident Marion E. Simon has been one of Chicago's top fundraising patriots for the National Kidney Foundation of Illinois, Lincoln Park Zoo, Roosevelt University, Patient Advocacy, and a host of other worthy causes. This young 93-year-old, who held the 1939 Miss University of Chicago beauty queen title, has raised millions of dollars over the past 70 years. In 2012, she decided to retire and work on her memoir. She says, "After raising my family in Winnetka, Illinois, making the decision to move to this neighborhood was not a difficult transition from the suburbs. I love to hear the sounds of birds and look at a beautiful landscape of trees. My apartment view allows me to enjoy these things. It's like living in the suburbs, but having all the wonderful amenities offered by the city. I've been a resident of the Gold Coast since 1978."

124

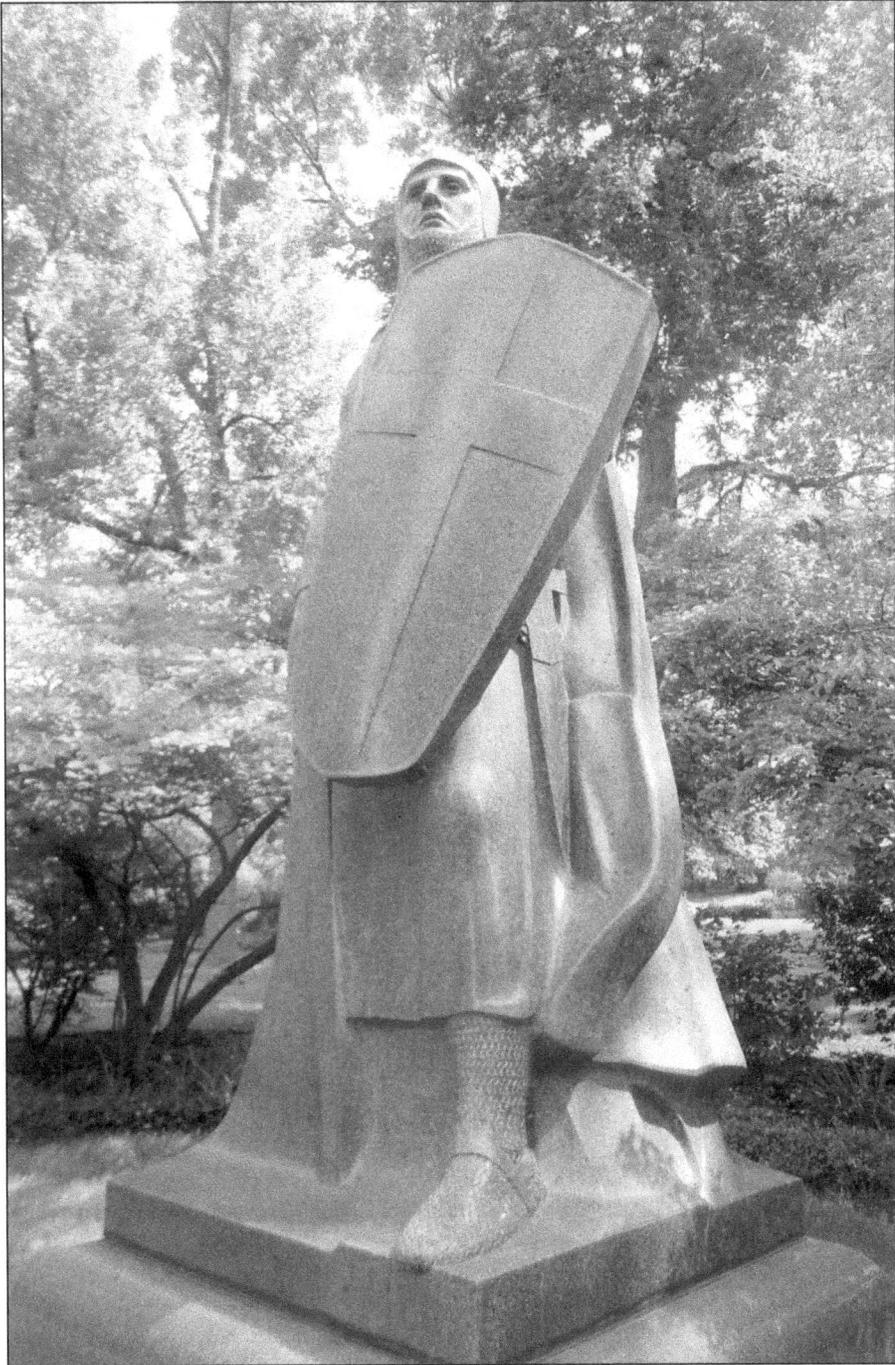

Prominent Gold Coast resident Victor F. Lawson (1850–1925) was the publisher of the *Chicago Daily News* from 1876 to 1925, president of the Associated Press from 1894 to 1900, and well known as one of Chicago's top philanthropists. He died of heart failure and was buried in Chicago's Graceland Cemetery. This medieval knight on his gravesite was designed and created by famous American sculptor Lorado Taft (1860–1936). It is located a mere stone's throw from the more monumental burial site of Gold Coast founders Potter and Bertha Palmer.

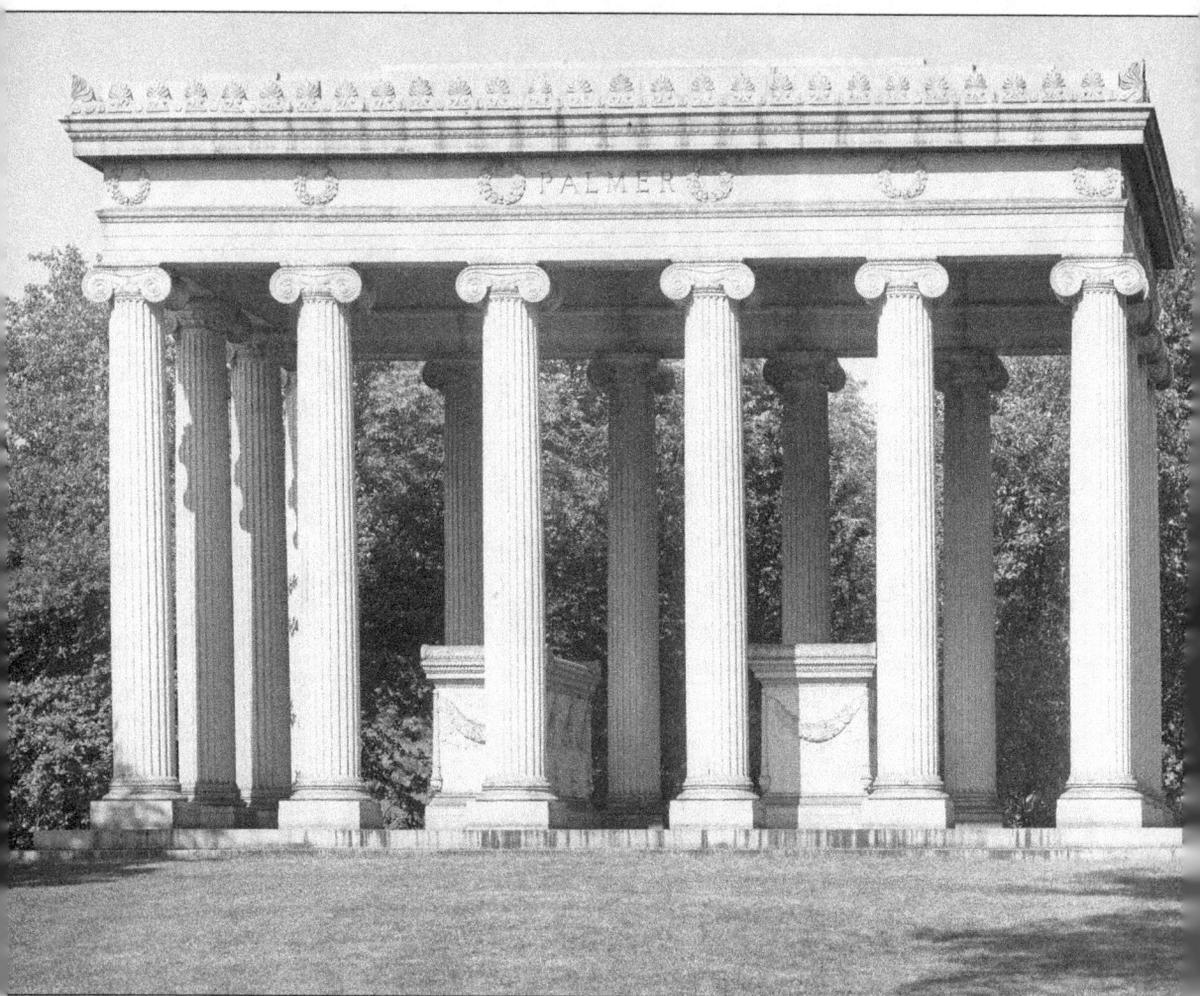

The Gold Coast thanks Potter and Bertha Palmer for their vision and courage to start a new frontier venture when they moved to one of the most undesirable areas in the city of Chicago. Their gravesite is located in the beautiful Graceland Cemetery in the Uptown neighborhood of Chicago. Many of the Palmers' friends and associates are also buried in Graceland, including Cyrus McCormick; Edith Rockefeller McCormick; George Pullman; Marshall Field; Victor F. Lawson; William Kimball; Joseph Medill; Augustus Dickens, the brother of Charles Dickens; Fred A. Bussee, mayor of Chicago from 1907 to 1911; John Peter Altged, governor of Illinois from 1893 to 1897; and architects Daniel H. Burnham, David Adler, Howard Van Doren Shaw, Louis Sullivan, and Ludwig Miles van der Rohe.

ABOUT THE AUTHORS

Wilbert Jones is the president of the Wilbert Jones Company, a food product development and marketing company founded in 1993. He has authored three award-winning cookbooks and was the host of the PBS television series *Healthy Heritage Kitchen* in 2008. Since 1998, Jones has been a contributing editor for *Prepared Foods* magazine. He is currently working on the television series *A Taste of Africa: Culture and Cuisine from Casablanca to Cape Town*. Jones has lived in Chicago's Gold Coast since 1998.

Maureen Veronica O'Brien is a licensed real estate broker in the states of Illinois, Indiana, and Michigan. She is an active member of the Gold Coast Neighborhood Association (GCNA) and past president of GCNA. In Illinois, she is a broker associate with RE/MAX premier properties, and in Indiana and Michigan she is the owner and managing broker of O'Brien Realty & Management LLC. O'Brien has lived in the Gold Coast since 1963.

Kathleen Willis Morton grew up in the Gold Coast. She is the author of *The Blue Poppy and the Mustard Seed: A Memoir of Loss and Hope*. She has also been anthologized in *The Best Buddhist Writing of 2009* and published in *The Shambhala Sun* magazine among other publications. Morton teaches creative writing at Grub Street, Inc. in Boston and is a freelance writer and writing consultant. In addition, she is a Buddhist chaplain intern in Boston. Her book *Driving the Lotus Fast: Mindfulness, Movement, Meditation, and Motion Beyond the Limits* is forthcoming next year. Morton lives in Somerville, Massachusetts, with her two children.

Visit us at
arcadiapublishing.com

www.ingramcontent.com/pod-product-compliance
Lightning Source LLC
Chambersburg PA
CBHW080610110426
42813CB00006B/1467